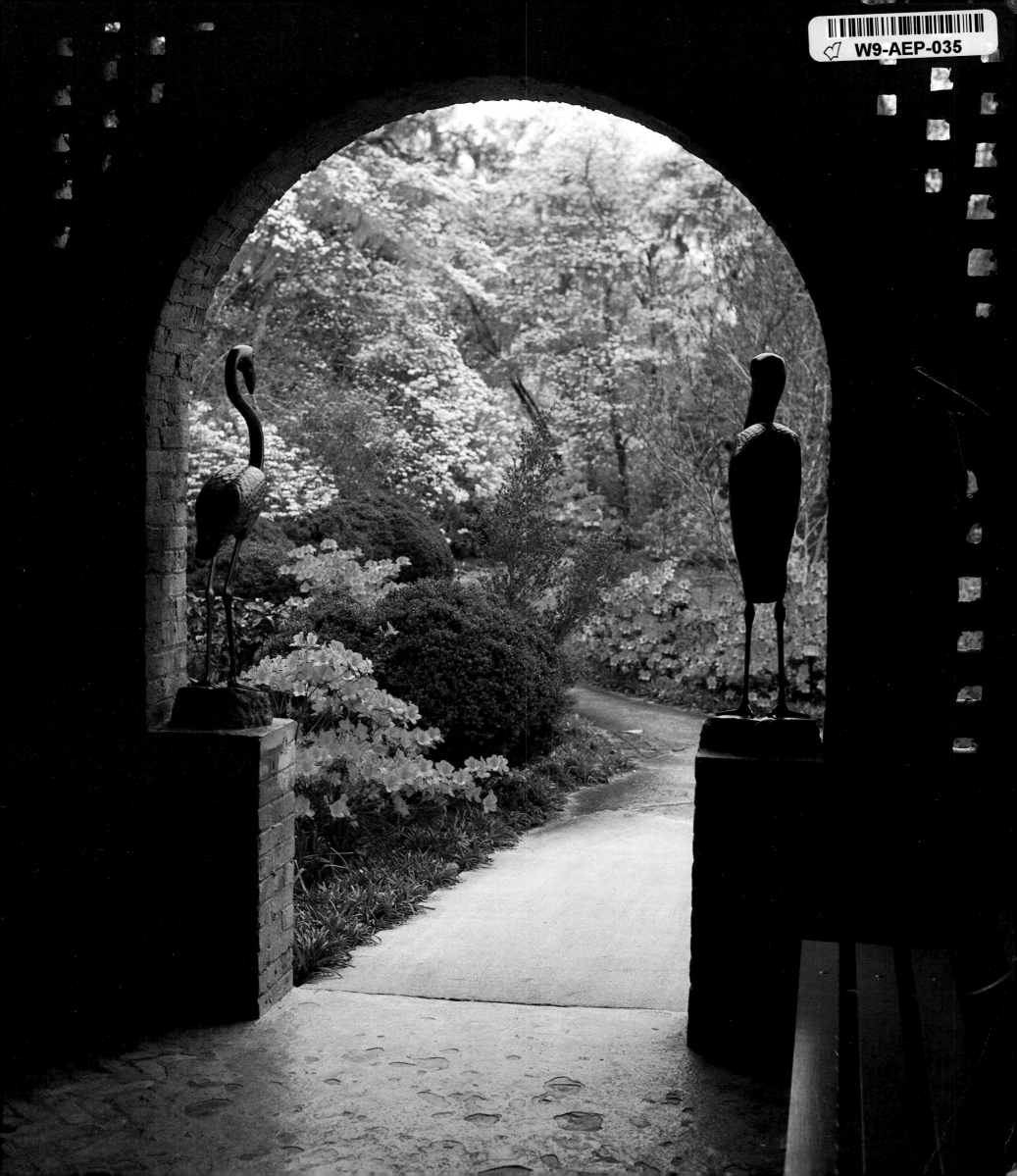

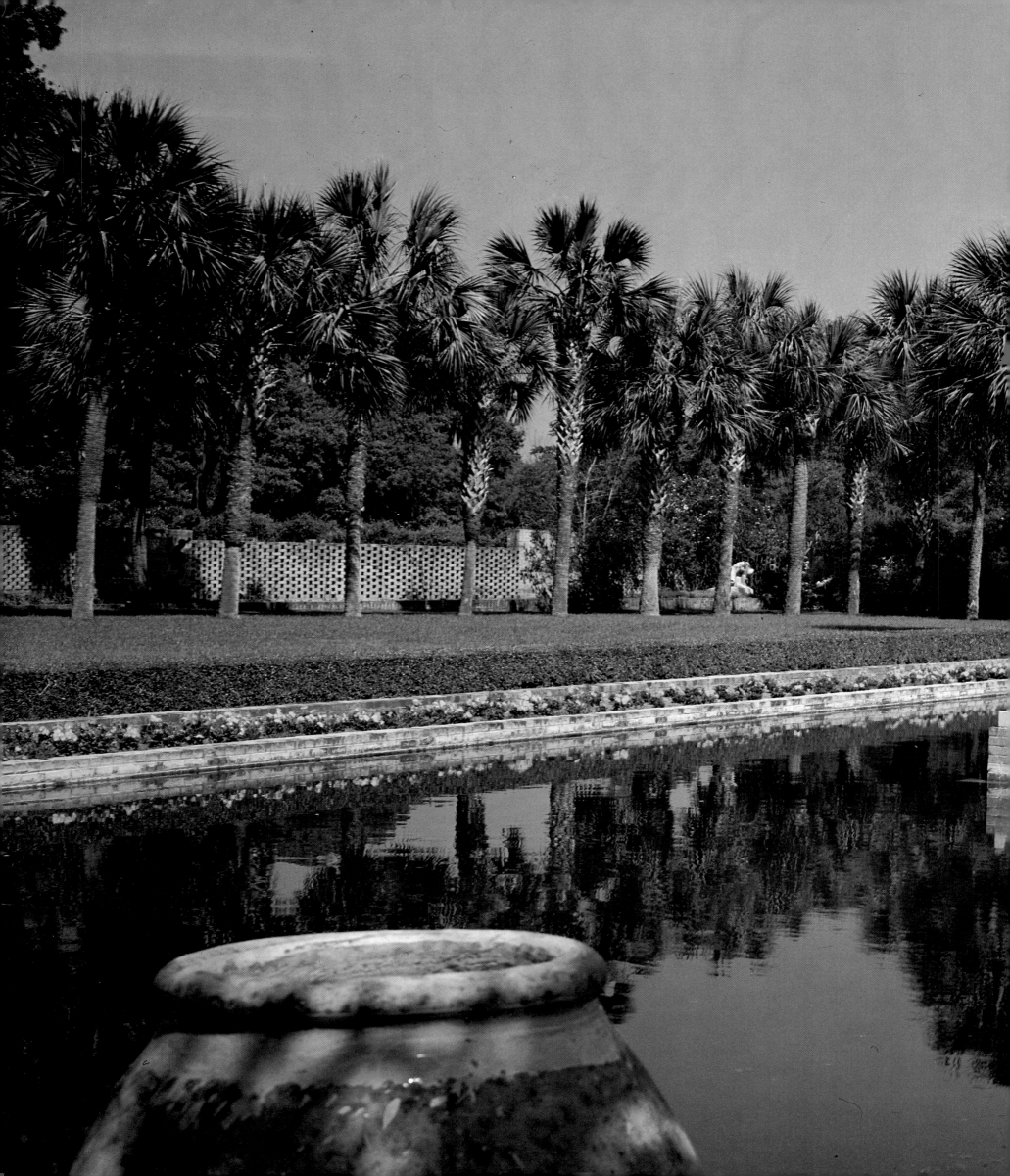

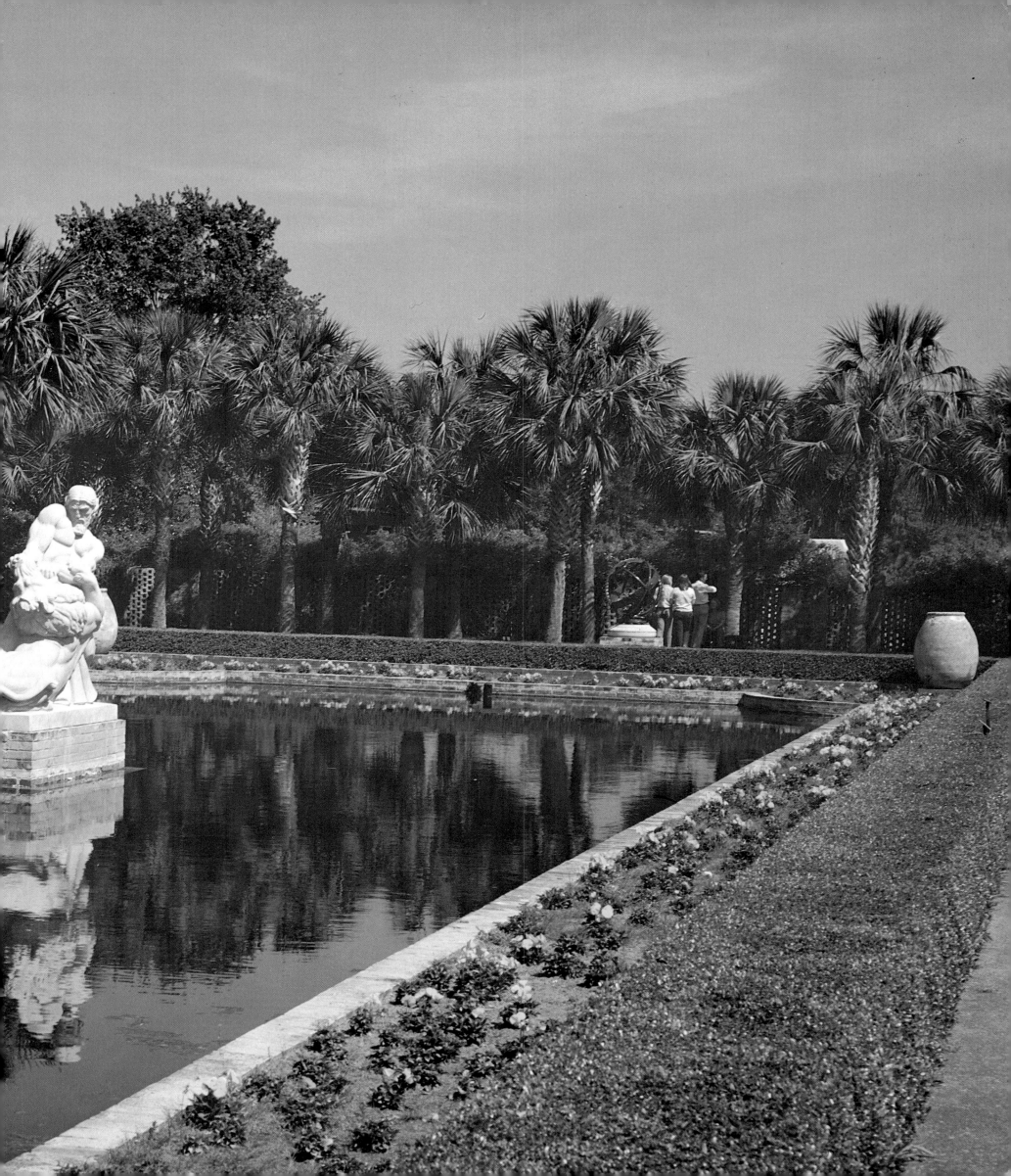

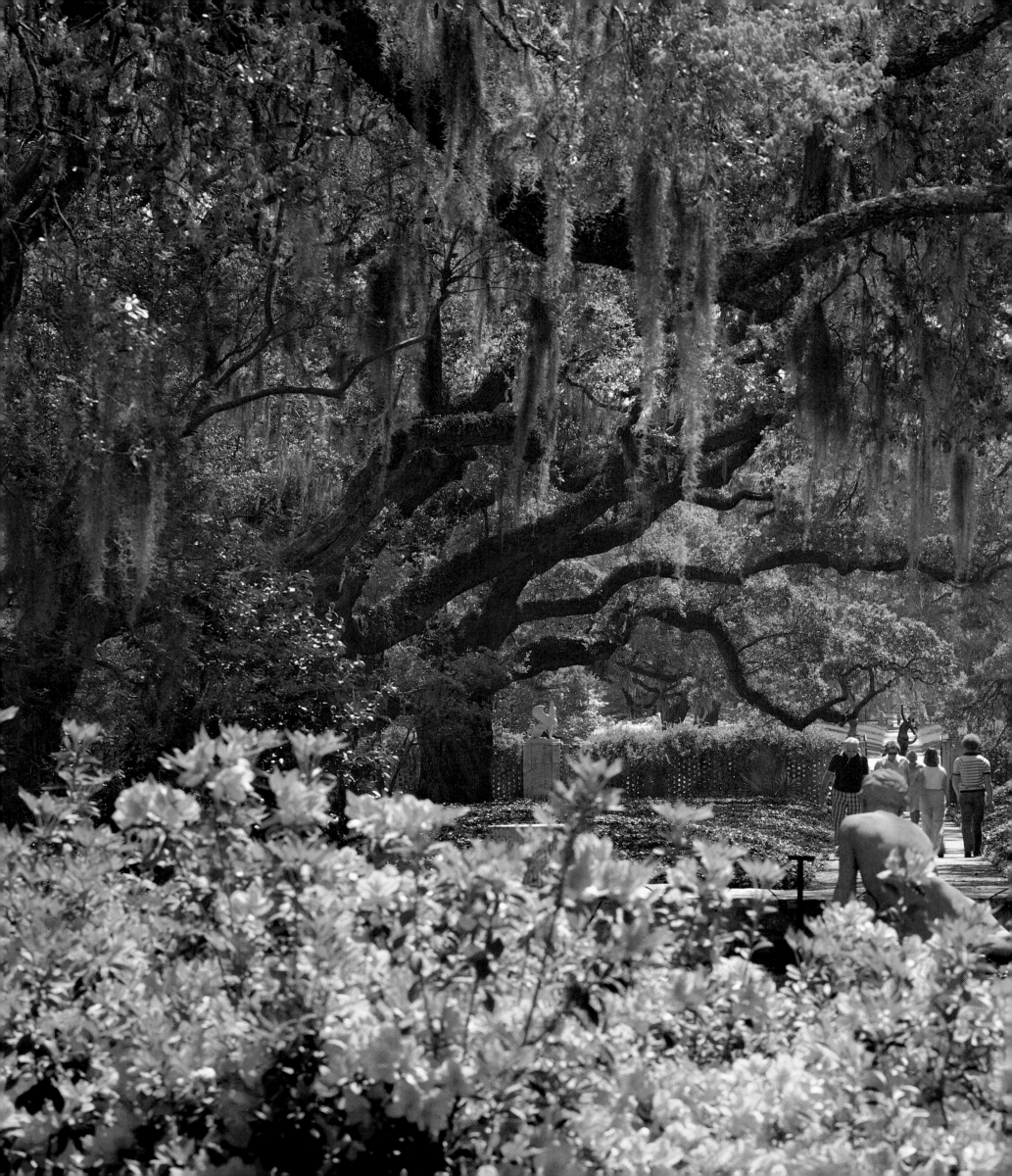

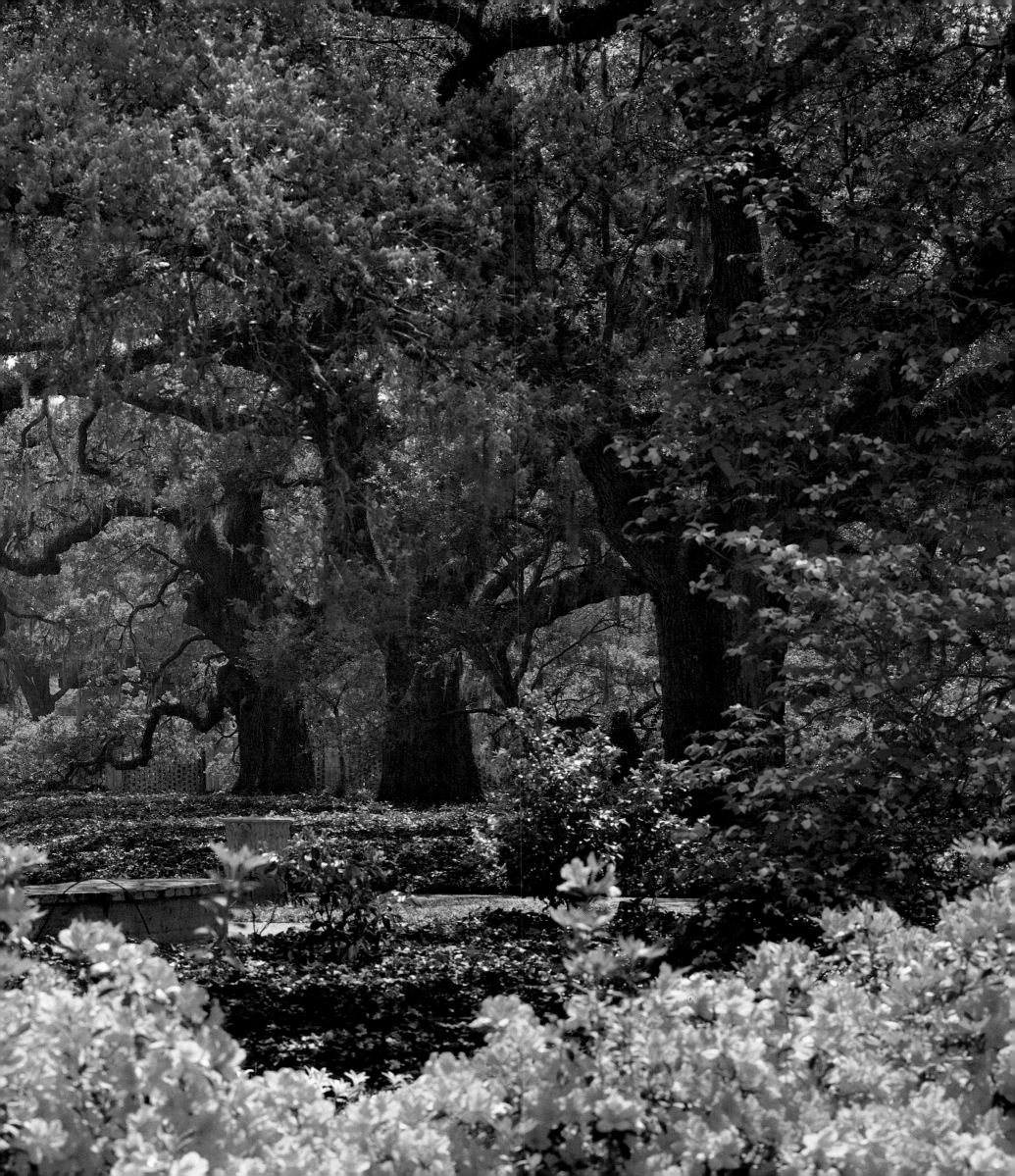

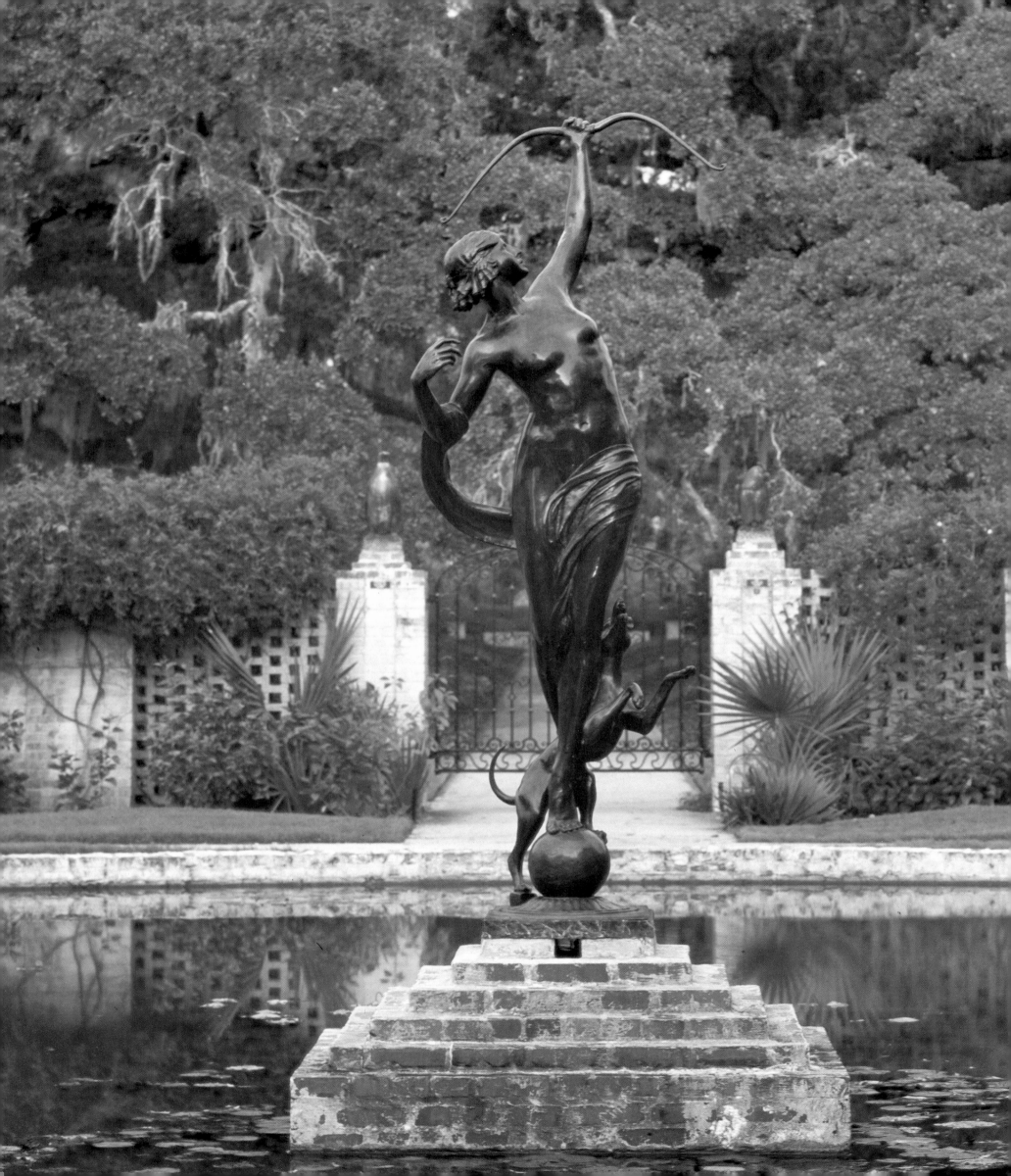

A CENTURY OF

American Sculpture

TREASURES FROM BROOKGREEN GARDENS

INTRODUCTION BY

A. Hyatt Mayor

Curator Emeritus, The Metropolitan Museum of Art

WITH CONTRIBUTIONS BY

Joseph Veach Noble, Beatrice Gilman Proske, Gurdon L. Tarbox, Jr., and Robin R. Salmon

ABBEVILLE PRESS • PUBLISHERS • NEW YORK

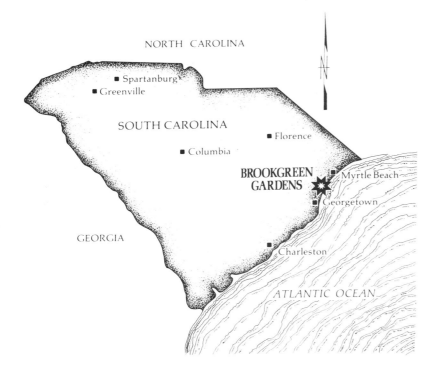

A Century of American Sculpture is published in cooperation with
Brookgreen Gardens, Murrells Inlet, South Carolina, 29576

Editor: Walton Rawls
Designer: Howard Morris
Color photography: Gurdon L. Tarbox, Jr.,
 Salem A. VanEvery III, H. Neil Gillespie

Library of Congress Catalog Card Number: 80-69787
80-22762
ISBN 0-89659-185-9 CLOTH
ISBN 0-89659-150-6 PAPER

Contents

List of Artists and Works Illustrated

Herbert Adams, 1858-1945
 Pages 52, 53. *Sea Scape*, 1935

Edmond Amateis, 1897-
 Page 87. *Pastoral*, 1924

Bryant Baker, 1881-1970
 Page 72. *L'Après-midi d'un Faune*, 1934

George Grey Barnard, 1863-1938
 Page 57. *Maidenhood*, 1896

Chester Beach, 1881-1956
 Page 71. *Sylvan*, c. 1932

Gutzon Borglum, 1867-1941
 Page 58. *Mares of Diomedes*, 1904

A. Stirling Calder, 1870-1945
 Page 60. *Nature's Dance*, 1938

Nathaniel Choate, 1899-1965
 Page 92. *Alligator Bender*, 1937

Henry Clews, Junior, 1876-1937
 Page 64. *The Thinker*, c. 1914

Jo Davidson, 1883-1952
 Page 77. *My Niece*, 1930

Donald DeLue, 1897-
 Page 88. *Icarus*, 1945

Gleb W. Derujinsky, 1888-1975
 Page 82. *Ecstasy*, 1954
 Pages 2-3, *Samson and the Lion*, 1949

Frank Eliscu, 1912-
 Page 94. *Shark Diver*, c. 1955

Rudulph Evans, 1878-1960
 Page 75. *Boy and Panther*, c. 1919

Avard Tennyson Fairbanks, 1897-
 Page 91. *Rain*, 1933

Beatrice Fenton, 1887-
 Page 81. *Seaweed Fountain*, 1920

James Earle Fraser, 1876-1953
 Page 63. *The End of the Trail*, 1915

Laura Gardin Fraser, 1889-1966
 Page 80. *Pegasus*, 1946-1951

Marshall M. Fredericks, 1908-
 Pages 15, 96. *Gazelle*, 1973

Daniel Chester French, 1850-1931
 Page 51. *Benediction*, c. 1922

John Gregory, 1879-1958
 Page 76. *Orpheus*, 1941

Karl H. Gruppe, 1893-
 Page 85. *Joy*, 1948

Trygve Hammer, 1878-1947
 Page 66. *Hawk*, 1920

Walker Hancock, 1901-
 Pages 4-5. *Boy and Squirrel*, 1928

Malvina Hoffman, 1885-1966
 Page 79. *Bali Dancer*, 1932

George Frederick Holschuh, 1902-
 Page 93. *The Whip*, c. 1936

Anna Hyatt Huntington, 1876-1973
 Page 77. *Diana of the Chase*, 1922
 Page 84. *Fighting Stallions*, 1950
 Page 62. *Youth Taming the Wild*, 1933

C. Paul Jennewein, 1890-1978
 Page 83. *Indian and Eagle*, 1929

Joseph Kiselewski, 1901-
 Page 90. *Sea Horse*, 1937

Mario Korbel, 1882-1954
 Page 73. *Night*, 1933

Gaston Lachaise, 1882-1935
 Page 69. *Swans*, 1931

Leo Lentelli, 1879-1961
 Page 67. *Faun*, 1931

Edward McCartan, 1879-1947
 Page 68. *Dionysus*, 1936

Frederick William MacMonnies, 1863-1937
 Page 56. *Venus and Adonis*, c. 1898

Hermon Atkins MacNeil, 1866-1947
 Page 58. *Into the Unknown*, 1912

Paul Manship, 1885-1966
 Page 1. *Black-Necked Stork*, 1932
 Page 31. *Cycle of Life*, 1924
 Page 78. *Diana*, 1924
 Page 1. *Flamingo*, 1932

Elie Nadelman, 1882-1946
 Page 66. *Resting Stag*, c. 1916

Roland Hinton Perry, 1870-1941
 Page 58. *Primitive Man and Serpent*, 1899

Albin Polášek, 1879-1965
 Page 70. *Man Carving his Own Destiny*, 1961

Alexander Phimister Proctor, 1862-1950
 Page 55. *Trumpeting Elephant*, 1908

Frederic Remington, 1861-1909
 Page 54. *The Bronco Buster*, 1895

Lorado Taft, 1860-1936
 Page 52. *Daughter of Pyrrha*, 1934

Gertrude Vanderbilt Whitney, 1877-1942
 Page 65. *Caryatid*, 1913

Augustus Saint-Gaudens, 1848-1907
 Page 50. *The Puritan*, 1899

John Quincy Adams Ward, 1830-1910
 Page 49. *The Indian Hunter*, 1860

Wheeler Williams, 1897-1972
 Page 86. *Black Panther*, 1933

Janet Scudder, 1873-1940
 Page 61. *Tortoise Fountain*, c. 1908

Albert W. Wein, 1915-
 Page 95. *Phryne Before the Judges*, 1952

Mahonri Young, 1877-1957
 Page 74. *The Driller*, c. 1922

Erwin Springweiler, 1896-1968
 Page 89. *Great Anteater*, c. 1938

Adolph Alexander Weinman, 1870-1952
 Page 59. *Riders of the Dawn*, 1946

Foreword

Whén asked about Brookgreen Gardens, I always say that it is the most beautiful sculpture garden in America. Archer Huntington, the Gardens' founder, described it as "A quiet joining of hands between science and art."

Brookgreen Gardens was incorporated in 1931, a nonprofit institution under the laws of South Carolina, as "a society for southeastern flora and fauna," and the year 1981 is its fiftieth anniversary. A half century seems an appropriate period for summing up accomplishments, and it is through this book that we document Brookgreen's past and present.

There are many important sides to a cultural phenomenon of this magnitude, and, accordingly, this book examines several aspects in separate sections. Certainly the book's selection of color plates presents a visual feast, with sculpture beautifully sited among flowering shrubs and ancient trees, on broad lawns, and reflected in still ponds. So conditioned are we to looking at sculpture in museum environments that we forget that originally most sculpture was created to be seen in the sunlight among natural surroundings. Fortunately, the gentle climate of South Carolina and infinite care by Brookgreen's staff make it possible for everyone to experience the joy of viewing a magnificent survey of representational sculpture in a breathtaking out-of-doors setting. In concentrating on American sculptors, Brookgreen Gardens has assembled an unparalleled collection of nineteenth and twentieth century works.

In 1923 Archer Milton Huntington married Anna Hyatt, an outstanding sculptor, and the stage was set for the building of an important collection. Mr. Huntington was already an avid collector, and his wife's work, together with that of some of her peers, enlarged the nucleus of his acquisitions. The story of the growth of this collection, the sculpture and the sculptors, is told in the section written by Beatrice Gilman Proske. Her knowledge of the sculpture and the Huntingtons is firsthand, because she was a member of the staff of The Hispanic Society of America, another institution Archer Huntington founded, at the time he assigned her the task of documenting the collection.

When Mr. Huntington, in 1930, bought four colonial estates on the Waccamaw River in South Carolina, neither he nor anyone else envisioned the ultimate development of Brookgreen Gardens. However, by the following year, the idea had crystallized that an institution should be created by the Huntingtons to exhibit the work of American sculptors, as well as preserve the flora and fauna indigenous to lowcountry South Carolina.

This farsighted concept embodied aesthetic appreciation and ecological preservation long before sculpture was popular, or ecology became a catchword. However, between the dream and reality, years of hard work by the Huntingtons and their associates were needed to develop Brookgreen Gardens. This is the story told by Gurdon L. Tarbox, Jr., the Director.

The land on which Brookgreen Gardens stands has an interesting history all its own. Before the United States achieved independence, English settlers had become landed gentry by acquiring vast tracts in colonial South Carolina from the British Crown. Four historic plantations, The Oaks, Brockgreen, Springfield, and Laurel Hill, comprise the area that Brookgreen Gardens occupies today. Over two hundred years of recorded history had elapsed before the Huntingtons arrived, and this is a story of several families, their friends and enemies, two terrible wars, and a changing economy locked into agriculture. Historic personalities such as Aaron Burr and Washington Allston dot the story like stars in the firmament. To present the record of this area and to separate history from legend has been the task of Robin R. Salmon, historian on the Brookgreen staff, who has written the section on the original Waccamaw plantations before 1930.

A fiftieth-anniversary overview of Brookgreen Gardens calls for a bird's-eye perspective, and fortunately the book's introduction by A. Hyatt Mayor (who, sadly, died before the book's publication) gives just that. With the background of art historian and Curator Emeritus of the Print Department of The Metropolitan Museum of Art, Mr. Mayor charmingly presents the story of this stretch of lowcountry South Carolina from its primeval buildup from sands deposited by the Gulf Stream to the introduction and settling of its first Indian inhabitants, to European intrusions and colonization, to the peopling of its sandy islands by the ancestors of today's residents. Beyond this, we are most fortunate that Hyatt Mayor was the nephew of Mr. and Mrs. Huntington, a close relationship that permitted him to give us an unparalleled insight into the complex lives of these two extraordinary people.

When I first saw Brookgreen Gardens many years ago, I was enthralled by its beauty, fascinated by the primeval woodlands and waterways, and beguiled by its timeless sense of serenity. This book documents much of the Brookgreen Gardens story, but the gardens themselves are there to be experienced directly and to be enjoyed. Come see for yourself; beauty awaits you.

Joseph Veach Noble
President, Brookgreen Gardens

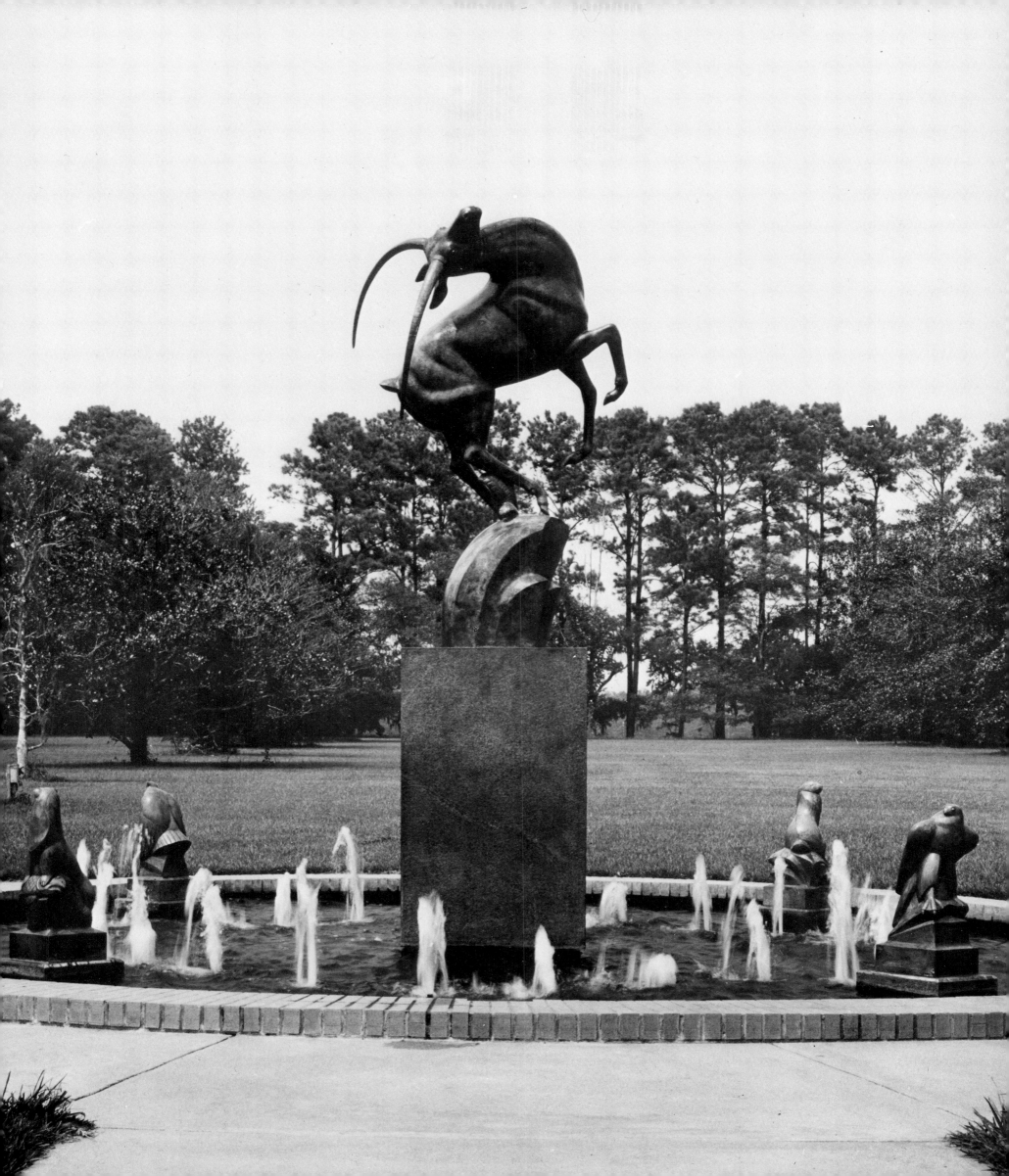

Introduction: Brookgreen Gardens

By A. Hyatt Mayor

The Land SOUTH CAROLINIANS call their coast the lowcountry to distinguish it from the upcountry of the Piedmont in the foothills of the Appalachians, which was the early colonists' western frontier. The coastal plain extends into the sea through dunes and marshes at a gradient almost as near the flat as Holland's. This was laid down through the geologic ages as the Gulf Stream, swirling and curling northward, returns a southward counter-current along the coast forever nudging grain after grain of sand toward their terminal accumulation in the Florida Keys. The smooth and steady labor of stream and counter-stream is upset every few decades by autumn hurricanes that redesign the shore in hours. Then the waves scatter the grassy dunes and churn the rushes in the marshes. The winds even tumble the live oaks, cedars, pines, hollies, and palmettos of the higher inland ground, in spite of the haphazard basketry of pepper vine, greenbriar, and supplejack that laces everything together. The hurricane of October, 1893, was described by a lady who somehow escaped the drowning that swept away thirteen members of her family: "The rumble of the earthquake was heard all day at sea on Friday & before day on Saturday morning we went on the sand hills to watch the waves which were mountain high & the sand crumbled & melted under our feet leaving a precipice. . . . Before afternoon we heard of the dreadful Magnolia disaster, how the tidal wave had been highest there & swept away all before it, leaving no one to tell the fate."

Beyond the reach of wreckage by sea, the ground climbs to more stable stands of hickory, ash, magnolia, sweet gum, and wax myrtle. The Brookgreen land rises still a bit more in the middle to dry sandy soil covered with open forest of longleaf pine and turkey oak. On each side the river swamps are shadowed by tupelo, bald cypress, swamp black gum, red maple, and sycamore. Among these trees and shrubs grow the vast varieties of plants that the last ice age pushed southward as it crawled between our north-south mountain ranges. (In Europe, where mountains range east and west, the ice backed many plants against the heights and killed them.) Brookgreen's seeds

and berries nourish some four hundred species of resident and migratory birds.

Indians SUCH WAS THE LAND that the Indians found when they spread southward after their probable entry from Siberia across the narrow Bering Sea. The early European discoverers encountered many small villages of warring tribes. Where the soil was rich, the Carolina Indians grew corn, beans, pumpkins, squash, and melons. The women mashed peaches together to dry into tough cakes for winter storage. They planted their gardens after wild berries had sated the greedy birds, but they still had to watch day and night to guard their crops from all manner of animals. On the poorer farming land that is now Brookgreen, the more nomadic Indians lived together rather by hunting and fishing.

These Indians built dome-shaped wigwams of bark laid on branches. Each village assembled for councils or just sociability in a ''town house'' like a monumental wigwam, which an early traveler described as being ''raised with wood and covered over with earth and has all the appearance of a small mountain at a little distance. It is built in the form of a sugar loaf and large enough to contain 500 persons, but extremely dark, having, besides the door, which is so narrow that but one at a time can enter, and that after much winding and turning, but one small aperture to let the smoke out, which is so ill contrived, that most of it settles in the roof of the house. Within it has the appearance of an ancient amphitheater, the seats being raised one above another, leaving an area in the middle, in the center of which stands the fire; the seats of the head warriors are nearest to it.''

The Europeans found that they could run faster than the Indians for short bursts, but had nothing like their endurance in the long haul. However, the Indians' desultory gardening had not fitted them for the methodical drudgery of European agriculture. The South Carolina settlers solved the problem of their presence by capturing Indians and selling them into slavery in the West Indies, where they could not escape and soon died. This systematic deportation and the intertribal scrapping so disorganized Indian life that the tribes had lost their identity by 1720 and had practically vanished by 1755. The Indians' thousands of years of occupancy have left no trace today beyond occasional arrowheads and sherds of rough earthenware like that potted by the Savannah Indians. Some ancient tribal names still sound in Winyah Bay and the Waccamaw, Sampit, Santee, Seewee, PeeDee, and Weenee rivers.

Settlers THE LONG WACCAMAW RIVER, the PeeDee, and Winyah Bay form the water boundaries of Waccamaw Neck. Part sand, part swamp, this land was settled later than the more rewarding river bottoms around Jamestown. What is now

Brookgreen Gardens was divided into four plantations—Brookgreen, Springfield, Laurel Hill, and The Oaks—all corridor strips that assured each planter a landing on the navigable waterways that so long provided the only communication. In the 1730s some 6,500 acres in the neighborhood were granted to the brothers John and William Allston, whose nine sons and seven daughters founded the family that dominated locally for the next century. They were all descended from a John Allston who was born in the year of the Great Fire of London, 1666, and landed in Charleston when he was sixteen. He came from Hammersmith, where there is still a Brook Green, which his family much later commemorated in one of their plantations. At Brookgreen Plantation the Allstons (some of them shortened their name to Alston) used their outstanding wealth to build what must have been a splendid house, but it burned in 1901. There Washington Allston, the painter of heroic and Biblical tableaux, had been born in 1779. He financed his European art studies by selling the adjoining Springfield Plantation.

Washington Allston's cousin Joseph Alston, born in 1778, brought the family's fortunes to their peak when he inherited well-planted lands from his grandfather and became the state governor during the War of 1812—all this in a life of less than thirty-eight years. In his mid-twenties he broke into Northern society in Albany, where he married Aaron Burr's only child Theodosia in February, 1801, just when Burr was hoping that the presidency might be voted to him rather than to Jefferson. Burr pushed the match to extend his influence into the South and to tap the Alston fortune for his political expenses. Southern and Northern manners often misunderstand each other, for at the moment of the marriage a New York lady wrote that the bridegroom "is rich, but a great dasher, dissipated, ill-tempered, vain and silly." The young couple settled at The Oaks, where a son, Aaron Burr Alston, was born a year later. Then things began to go wrong. Aaron Burr damaged his political eminence by shooting Alexander Hamilton in 1804 and further wrecked it by his play for power in the West. Although he was acquitted in his trial for treason, he fled to Europe for five years. He returned to New York under an assumed name in 1812 only to find that his ten-year-old grandson had just died of malaria. Then at year's end, on December 30, his daughter sailed from Georgetown to join him in New York on a ship that vanished without a trace in a terrible midwinter storm.

Rice THE ALSTONS' profitable crop had been indigo until India started to undersell the Carolinas. Then about 1800 the Ward family bought Brookgreen to cultivate rice. Between 1840 and 1860 the Georgetown district produced from one-third to nearly one-half of all the North American rice. In 1859 the Wards of Brookgreen grew 4,410,000 pounds, which they sold for some-

thing like $140,000. In 1838 a valuable strain of large-grain rice was propagated from part of a freak ear that the Brookgreen overseer picked up on the threshing floor. The rice fields were swamps cleared and leveled for controlled flooding from the tidal rivers. In spite of an average four-foot rise and fall, the upper reaches of the rivers remained fresh except during droughts, when the sea water seeped inland, but, being heavy with salt, it clung to the river bottoms. The fresh surface waters flowed from the rivers onto the diked fields through long wooden troughs with gates at each end. In April, after the fields had been plowed and harrowed, the seed was coated with clay to keep it from floating away on the first flooding. This first sprout flow had to be exactly timed for three to six days, just until the seed pipped, but before a leaf formed to float it to the surface. After a drying until the plants grew about six inches tall, another short flow of three to six days was followed by a second drying for hoeing. Then began the long flow of twelve to twenty-three days, at first very deep to wash away trash, drown insects, and protect the plants from birds flying north in May. After another drying for weeding and hoeing, the quite deep harvest flow lasted seven or eight weeks until early September, when the crop was cut with sickles, sun-cured on the stubble, tied into sheaves, and taken to the threshing floors. Everything except the winter plowing and harrowing had to be done by many hands exactly coordinated. The planter sent the threshed grain to his factor, usually in Charleston, who sold it to best advantage as the prices fluctuated from day to day, or sometimes shipped it out by Yankee coastwise schooners. The factor also served as the planter's banker, his city purchasing agent, who often took charge of the planter's son by clothing him on his way to boarding school. The intricate balance of this interdependence took generations to nurture, but in brief months it was destroyed under the impact of the Civil War. As the historic disaster absorbed the energies of whites and blacks, weeds invaded the rice fields until they now resemble the aboriginal swamps. Brookgreen settled down into a quiet period perhaps as sleepy as in Indian times—perhaps sleepier, for the inhabitants of the plantations did not scalp each other.

The Huntingtons WHEN THE DEPRESSION STRUCK in 1929, Brookgreen Plantation was put on sale through an advertisement that caught the eye of two remarkable people, Archer Milton Huntington and his wife Anna Hyatt Huntington, who was my mother's younger sister. Since their interest transformed the locality, a word must be said about them.

Archer Huntington's father, Collis Potter Huntington, was born in 1821 on a Connecticut farm as the sixth of nine children. When he was a young man selling hardware from a cart in the New England states, he met an innkeeper

who agreed to buy from him if he would use his huge strength to fight off a gang of hoodlums who threatened to break up a dance at the inn. Huntington sat in the narrow entrance of the inn, pretending to be asleep. When the gang arrived he sprang at them so suddenly and so fiercely that he knocked out the first three or four, then seized the last one, doubled him up, and threw him through the window sash onto the snow. Another time, when his cart horse jumped, Huntington broke his arm in the spokes of a wheel. He tied himself up and went about selling hardware until he could find a doctor. By that time his arm had set, but crookedly. The doctor told him to have it re-broken in a hospital under ether. Huntington simply held out his arm and said, ''Break it.''

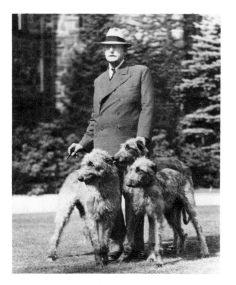

Archer Milton Huntington, co-founder of Brookgreen Gardens, shown with his Scottish deerhounds in the 1930s.

In the spring of 1849 he joined the Gold Rush in a five-month trek to California, where he soon saw that the gold fields were not for him. In Sacramento he and Mark Hopkins started a hardware store that became one of the leading firms supplying equipment to the railroads. In 1861 when the Central Pacific Railroad was incorporated, Huntington, as one of the chief organizers, moved to New York to push the transcontinental venture. When the construction was complete, he took over management of the Central Pacific, adding more lines until in 1886 he could ride his own rails from California to his new shipyard in Newport News. While acquiring railroads in the South in 1868-70 he seems to have stayed in a Richmond boarding house run by Mrs. Richard Milton Yarrington, whose remarkable daughter joined the Huntington household in New York to take care of Collis's invalid wife Elizabeth, whom he had married in 1844, and who died of cancer in 1883. Collis discovered in Arabella a woman who matched him in intelligence, in ambition, and in the capacity to develop. They could not help falling in love. When Arabella was twenty she bore him a son on March 10, 1870. To gloss over the situation she took the name of a Richmond gambling-house proprietor, John Archer Worsham, who was already married and who lived until 1878. She combined Worsham's name with her father's to christen her son Archer Milton Worsham.

In 1877 ''Mrs. Worsham'' and her son moved into a big house at 4 West 54th Street, which she enlarged and had decorated with a modish lavishness so impersonal that it sums up the whole of the current fashion, but which differs completely from the rooms she later was to shape for herself after she had grown into her own individual taste for French court furniture and old master paintings.

Little Archer was sent to the very proper Columbia Grammar School, and his mother kept him in little-boy clothes long after his playmates had discarded them. She praised his goodness to her friends until he felt driven to prove that he was just as bad as other boys by throwing a stone through a

church window. He had to pay for the repairs out of his allowance and, worse than that, had to apologize to the minister. He soon grew bold enough to risk a desperate dare with a school friend. They had to walk along Fifth Avenue past the houses of their families' friends, one openly carrying a brown paper parcel, and the other absolutely bareheaded. It was a test of mettle, but they went through it like men.

His mother gave him his heroic thirst for knowledge by sharing with him the histories and biographies that she was studying for her own self-education. She took him to European museums while she scrutinized them to guide her in collecting works of art. In hotel suites the lonely little boy assembled shoe boxes and furnished them with tiny objects to compose his own museum with a collection to parallel hers. He was later to follow her example by avoiding formal schooling in order to be tutored in Arabic and Spanish, until he was able to publish a scholarly translation of the epic of *El Cid*, between 1897 and 1903, that remains standard to this day.

When Uncle Archer was fourteen, his father was freed by the death of his first wife to marry Arabella Yarrington and to adopt their son. To mark the start of her new life, Arabella and her son moved into Collis's house at 65 Park Avenue. Taking nothing but their clothes out of the 54th Street house, they sold it completely furnished to John D. Rockefeller, who had the good sense to preserve many of the rooms through changes of taste. In 1938 the Rockefeller family gave Arabella Yarrington's bedroom and dressing room to The Museum of the City of New York, and in 1946 her Turkish smoking room to the Brooklyn Museum. The site of the house became the garden of The Museum of Modern Art. When Uncle Archer went to The Museum of the City of New York to see the new Rockefeller gift, he had no idea that he would blunder into his own boyhood. The shock rattled him for days.

In 1892-93 the Collis Huntingtons built a moated gray-granite castle on the corner of Fifth Avenue and 57th Street now occupied by Tiffany's. There, in September, 1923, I lunched with Mrs. Huntington in an elaborate, small square room decorated by Elihu Vedder, later given to Yale. She presided at her table massively upholstered in black, displaying black onyx necklaces, with a black hat tied under her left ear in a giant black satin bow. She spoke with the deliberation of a *donna romana*. Her deep gray gaze, like Uncle Archer's, imposed and alarmed. But she saw nothing, for glaucoma had blinded her before there were remedies. After lunch we drank coffee among ormolu furniture in the drawing room, where Rembrandt's *Aristotle Contemplating the Bust of Homer* hung rather too high for comfort. She then took me to her picture gallery. I remember her saying "This Vermeer was in a Paris collection. I tried to buy it separately, but when they refused to sell, I bought the entire collection and auctioned off everything else. When I settled my

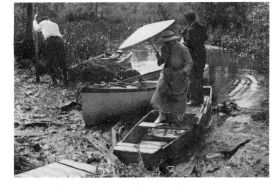

Archer Huntington and Anna Hyatt Huntington traveling to Sandy Island by boat, the usual transportation at Brookgreen in the early 1930s.

accounts, I had my Vermeer for a thousand dollars.'' We were standing, I remember very well, in front of a Reynolds. The Vermeer had been moved after she lost her sight.

The interest in Spain, which his mother had started, received a spur when Uncle Archer as a young man accompanied his father on a railroad planning trip to Mexico. On the evening of their arrival in Mexico City, President Porfirio Diaz had arranged a state banquet in the Chapultepec Palace. After all the guests had assembled, the doors into the dining room rolled apart, and each gentleman took a lady on his arm in to dinner. At just that ceremonial pause, poor Uncle Archer sprawled to the floor, all six foot five of him. He never drank, but the altitude had overcome him. The Mexicans lightened his embarrassment by telling him that this happened to everybody, that they would have been surprised if he had *not* collapsed, that he must think nothing of so routine an episode. He then and there fell in love with the deftness of Hispanic tact and gave the rest of his life to the study of Spain and Portugal and their empires. He always struck the precisely right note in these languages. During his years of exploring Spain on donkey back (poor donkeys!) he spent a night at a lonely farmhouse. After supper by candlelight, he was shown upstairs to the only good bed. When he came down in the morning, the farmer handed him his wallet, which Uncle Archer pocketed with thanks. ''Aren't you going to count your money?'' ''Sir,'' answered Uncle Archer, ''I am in Spain.'' He knew all the dialects in Spain and spoke Castilian, not just correctly but with wit, with eloquence. In Spanish as in English the ringing silver of his voice responded with exquisite alacrity to every prompting of his interlocutor, for he belonged to that long-vanished generation of men who could count on being invited to dinner every night of a season if they conversed well. His talk was summer lightning.

Not that his early life was especially happy. The reticence imposed by his illegitimacy scarred him with a compulsion for secrecy that kept him from confiding the whole of any major project to any one person. At his belt hung a two-foot steel chain with a poundage of keys that would have daunted a jailer. And when he sat down to meals as an old man, he pulled out of his pocket a worn wallet stuffed to splitting with papers, and banged it down beside his plate with a look that said, ''Ask me if you dare.'' Nobody dared. Distrust turned to misery when his first wife, whom he had married when he was twenty-five, pinned a note on his dressing table to say that she had gone away with the British theatrical producer Harley Granville Barker. In a torment of mortified rejection, he threw himself into gluttony and kept awake for work around the clock with black coffee and cigars. One of his frantic throng of projects was to have a medal struck for William Dean Howells, for which he asked my aunt, Anna Hyatt, to design the sketch. She saw him as a

wounded animal that has retreated into the thickets to die. His instant perception understood her simple wish to help, and he asked her to marry him. Though she found herself, in her mid-forties, in love for the first time, she hesitated. Should she give up a way of life that supported her as water does a fish? Could she manage a chauffeur, a butler, and a corps of maids? Would she want to divert so much thought to dressing and so much time to formal functions? Thus divided by doubts and loyalties, she went as usual for the summer of 1922 to Annisquam, Massachusetts. There one night at three or four in the morning, she woke my mother and said, "Harriet, Archer is dying. I know it. I must go to him." And she was gone before breakfast. She found him in a hospital, bloated to some 400 pounds. He simply said, "I want to die. Overeating is more gentlemanly than shooting myself or jumping out of a window." When he once again begged her to marry him, she said yes. He lost over 100 pounds, and they were married in her studio at 49 West 12th Street in 1923, on March 10, which was the birthday of both. After they were safely on the train going south, I was to announce their marriage to the *Times*. When I telephoned Uncle Archer's name to the reporter, he startled me by gasping, "What? That rich man?" This was my first inkling that any unusual amount of money might be involved, so reticent and old-fashioned had all our family discussions been.

Aunt Anna was in so many ways Uncle Archer's exact opposite that she supplied him with essentials that he had never enjoyed before. He could trust her to repeat nothing that he ever said, for her nickname since girlhood had been The Clam. After a glut of elaborate houses he wanted the simplicity in which she had grown up and always lived. She admired the glancing brilliance of his conversation, and he admired her selfless concentration on her modeling. She gave him the support of a total trust.

Aunt Anna was born in Cambridge, Massachusetts, in 1876, six years to the day after Uncle Archer. Her father, Alpheus Hyatt, was a paleontologist as fascinated by fossil animals as she was by living ones. As soon as she could crawl she inspected horses' hoofs, and before she could swim she peered so intently at minnows that she toppled off our dock in Annisquam into the running tide, and pulled herself back with the painter of a boat. Of course she told nobody. She shared a zest for rebellion with her older sister Harriet. Aunt Anna would run away from home on the back axles of buggies, and my mother, the only girl on a baseball nine, used to take the dolls that her grandmother brought her from Paris, pin them to a clothesline, and shoot them with her air rifle to watch the sawdust run out. My mother, who was eight years older than Aunt Anna, took lessons in sculpture from Henry Hudson Kitson, and was exhibiting figures and portraits in her mid-twenties. She was more sensitive to human beings than Aunt Anna, but she did not

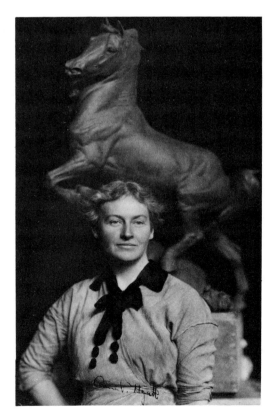

Anna Hyatt Huntington, co-founder of Brookgreen Gardens, shown before a model of her favorite animal.

have such a knack for animals. So when my mother modeled a standing nude boy, she got Aunt Anna to try her hand at modeling their Great Dane Malack, putting his paws on the boy's shoulders. The sisters worked together for several years in a studio rigged up in my grandfather's house on Francis Avenue in Cambridge. After 1900, when my mother married my father, her sculpture became an avocation desperately snatched at between the chores of running a household on a biologist's pay and the stresses of bringing up four children. But whatever her lot might have been, my mother—intuitive, many-sided, frustrated, restless—would have found it hard to settle down to one single pursuit, the way Aunt Anna did with her peaceful determination.

We children learned order and concentration by watching Aunt Anna as she changed into her work clothes as soon as she came home from errands, went straight to her modeling stand, and, instantly, without error shaped the beasts that she had been revising in her mind's eye while outwardly busy with other things. Evenings gathered us around the yellow circle of the oil lamp where my grandmother read aloud while Aunt Anna, heating a spatula over a blue alcohol flame, modeled little animals in pungent wax for direct casting in bronze. What with my mother's making heads of us when she found the time, the production of sculpture was as much a household routine as my grandmother's preparation of the bean pot for baking in the wood stove over Saturday night. We children commented as freely on the sculpture as on the beans.

Aunt Anna studied animal skeletons for years until she completely understood the undulations of the active beast. Some summers in Annisquam she boarded an ancient but noble horse so that she could sit on the grass while it pastured to observe how the leg bones readjusted when the horse settled its weight on them. In time she developed such a flashgun memory that she modeled two large jaguars descending from trees by working from an instant's glimpse each morning when the Bronx Zoo keeper would shout at his jaguar to stop it for a second as it climbed down from its branch to its breakfast meat. The lithe and lively individuality of her animals appealed to people everywhere. To reach as wide a public as possible, she had her bronzes cast in large editions for small prices.

It was at the confident height of this career that the commission for the Howells medal brought her close to Uncle Archer, and he asked her to marry him. They had met here and there for years, but she now discovered his misery. His suicidal work and gluttony had so undermined the strength he had inherited from Collis Huntington that he fell ill with pneumonia, long before the days of antibiotics. One evening, just before some friends came to dine in her studio, the hospital told Aunt Anna that Mr. Huntington's crisis was about to come, and that if he did not rally during the night he would die.

During dinner the telephone rang. There was a change for the better. She returned to her guests without a flicker to betray what she saw ahead. They were married in her studio with my grandmother and me as witnesses. He was still so weak that he would have collapsed while crossing Grand Central Station if he had not clutched Aunt Anna and the porter. He regained his strength in the Caribbean on a yacht that he called *Rocinante*—the name of Don Quixote's horse. Aunt Anna modeled in the saloon under a skylight where the sail made trouble by alternating sunlight and shadow.

Brookgreen Plantation
Becomes Brookgreen Gardens

SEVEN YEARS LATER they were again on the *Rocinante* sailing south, this time for Aunt Anna to recuperate from a long bout with tuberculosis that had kept her inactive in Switzerland. Before leaving New York they had come across an advertisement for the sale of Brookgreen Plantation, which they filed away for something to break the journey through the Inland Waterway. They found themselves enchanted by the romantic remains of the boxwood garden and above all by the shadowy vault of live oaks. Here was a Sleeping Beauty tangle waiting to be brought back to life. Uncle Archer's first reaction was always to start another museum, for he used to say that one sprang up wherever he set down his big foot. Aunt Anna had not yet got back into the swing of modeling after the long confinement in the sanatorium. And the year was 1930, when the Depression had stranded American artists without commissions, and people were destitute everywhere. Under these great trees, and safe from splitting frosts, sculpture could look its best. So Uncle Archer bought Brookgreen and the three adjoining plantations, later adding more land until he had some 10,000 acres of forest, swamp, sand beach, and formal garden. He had ready cash for the purchase in spite of the recent Wall Street crash because, when he returned from Switzerland in the summer of 1929, he found his investments so overpriced that he dismayed his financial advisers by selling all his common stock. Although he had refused to take on his father's financial empire, he inherited his father's business shrewdness.

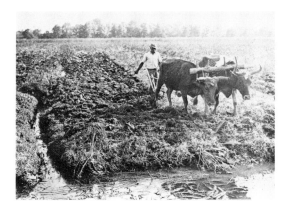

To perpetuate Brookgreen Gardens and to plant it firmly in the life of South Carolina, he set up a board of trustees that enlisted the help of artists and of important people in the vicinity. Certain sculptors have always helped particularly, among them Robert A. Baillie, who copied many plasters in stone, Adolph A. Weinman, Carl Paul Jennewein, Marshall Fredericks, and Donald DeLue. An engineer at the Newport News Shipyards, Mayo M. FitzHugh, laid out the basic services and solved the varied problems created by consolidating so many properties. While Uncle Archer wanted the sculpture in the garden to be intimately accessible, his museum experience had taught him to beware of vandal hands. For a simple, unobtrusive guardianship, he built a reservoir on the site of the great house, out of which water

flows, as in Moorish gardens, through rustling channels into reflecting moats that isolate the statues. He admired the inventiveness of another self-taught planner and architect, Thomas Jefferson, when he economized materials by building garden walls one brick thick that stay upright by undulating like a snake rail fence. As the Brookgreen walls wind in and out, they flow into simple, almost natural niches for statues. Here and there spaced-out bricks open lattices that invite exploration with glimpses through walls, and also break the wind better than solid barriers. A spray of concrete grays all construction to the overhead tone of the Spanish moss.

If two people could be considered indispensable to the construction of the Gardens, they are Frank Green Tarbox, Jr., and his nephew Gurdon L. Tarbox, Jr., for it is they who have transformed an abandoned tangle into the present well-groomed forest and the harmonious sculpture garden. Frank Tarbox was an agronomist trained at Clemson University in South Carolina with a wide experience of working locally and in Florida. He faced a seemingly impossible task, further complicated by the lack of supplies during the Second World War and the absence of visitors because of the gasoline rationing. But by the early 1950s he had managed to shape the formal gardens more or less as they are today, following sketches from the Huntingtons. He traveled widely in the state to collect rare native plants until Brookgreen now has over seven hundred varieties, about which he published excellent monographs. But these labors brought on a series of heart attacks, from which he eventually died in 1968. Long before that he had needed help; so when his nephew Gurdon L. Tarbox, Jr., graduated from Purdue University with a degree in forestry, he came to the Gardens, where he has presided ever since. Gurdon Tarbox has brought the woodlands under control and has carried out a comprehensive reorganization that the landscape architects Clarke & Rapuano began to project in 1974. The first stage of this all-over plan included the laying of new access roads with a modern parking lot, and the construction of a Visitors Center to meet the new problem of crowds. Already in 1955 some 350,000 people came each year. So many used the Gardens as a picnic place to scatter their beer cans and sandwich papers that in 1968 it was reluctantly decided to charge admission. In the second stage of the master plan, Gurdon Tarbox then transformed the cramped animal cages into a wildlife park, where visitors almost walk among animals the Indians knew, which roam at large behind discreet barriers of dry ditches or streams. Clarke & Rapuano's daring invention in the new park is the aviary of net thrown over part of the cypress swamp. The net floats high above the treetops on a central mast ninety feet high, stretching out to eight circling masts seventy feet high. Each mast is fixed to a concrete foundation pushed down seventy feet into the swamp mud. Visitors explore inside the net on a board-

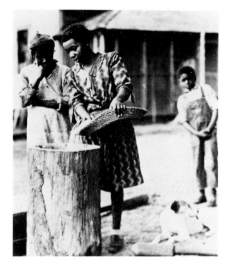

Rice culture near Brookgreen Gardens in the 1930s:
Opposite page: (above) farmer plowing rice field with ox team; (below) stacks of harvested rice. *This page:* (above) man and woman flailing rice to separate grains; (below) woman pouring rice into mortar, with pestle at her feet.

walk right among the ducks, ibis, egrets, storks, bitterns, and many kinds of herons. In spite of its technical difficulties, this new kind of aviary will certainly be copied elsewhere.

This recent emphasis on plants and animals of the Southeast developed out of the interests of both Huntingtons. Uncle Archer, as he walked under the great trees, felt his heart jump with the black flying squirrels as they launched themselves over deeps of air. Aunt Anna always surrounded herself with animals, who never bit or kicked her. In Bethel, Connecticut, she bred Scottish deerhounds, and in her eighties she exercised them in long walks, laughing as she tossed tidbits into the air to make them leap higher than her head. So the animals in the wildlife park represent as personal a taste as the scuptured horses, elephants, eagles, dogs, panthers, deer, goats, and swans that greet one everywhere in the Gardens.

Atalaya

SHORTLY AFTER BROOKGREEN WAS SOLD, a prominent New York lawyer, S. Mortimer Ward, Jr, who was descended from the great Brookgreen rice planters, wanted to show his ancestral domain to his friend Bernard Baruch. The two men pushed their way through scrub growth and strangled gardens without finding anyone to request permission for their trespassing. At last they heard the crack of logs being split, and came upon a giant in bluejeans swinging an ax. They asked him if he thought the new owner would object to their intrusion. Uncle Archer had to admit that he was the new owner, showed them all around, and charmed them with his hopes and dreams.

Both Huntingtons wanted to be on hand for the day-to-day decisions at the beginning of work on the Gardens, so they moved into a large two-story gun club house on the beach just opposite the entrance to Brookgreen. They so enjoyed living on the dunes among the sea birds that they decided to build a house there in 1931-32, using the local labor force by fits and starts whenever it was not needed at the Gardens. Uncle Archer loved to build, for he suffered from the "stone sickness" of the Renaissance popes. His projects did not always please others, for when he built his own house at Bethel, the architect who helped him finally said, "Mr. Huntington, I have only one request. When you speak of this house, please never mention my name." And when the place was ultimately sold, the new owner at once swung the steel ball to flatten it all. But his beach house at Brookgreen allured with strangeness. He thought that the most stable form to place on sand would be his broad-brimmed hat, so he had William Thompson, the Brookgreen contractor, surround the gun club house on three sides with a U-shaped concrete platform, 200 feet long on each outer side. Then he told the bricklayers to lay a wall from here to there, allowing for a window there, and another over yonder. After days of such hints, William Thompson said, "Mr. Huntington,

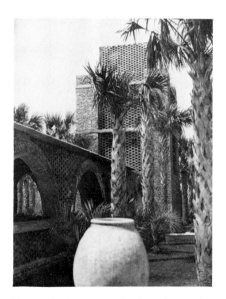

Tower and courtyard of Atalaya, the beach residence of the Archer Huntingtons.

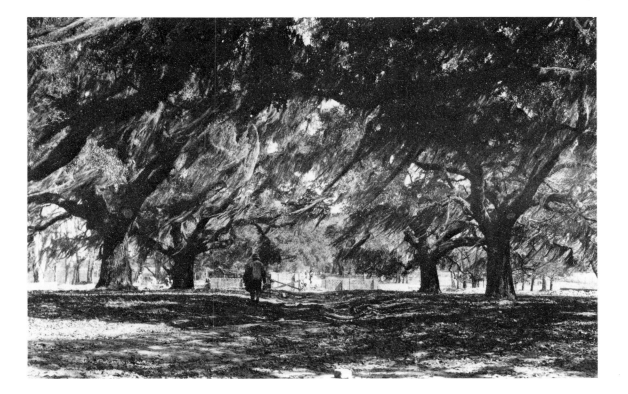

Live oak avenue of the original Brookgreen Plantation in 1930.

if you tell me much more, I'll find out what you're building.'' As the work progressed, the gun club house was cut apart and moved away to make other houses, leaving an awkward interval in which the Huntingtons camped out in a one-room tar-paper shack among the pines. But at last they moved into a house of some thirty rooms, all looking on the dunes or the sea, connected by an inner corridor around three sides of the courtyard. In the middle rose a forty-foot water tower of Moorish patterned brickwork, situated like the towers—*atalayas*—built on the Spanish coast to watch for enemy ships. The push of the sea wind steadily rustled the tops of the vines and palmettos in the courtyard. At night travelers on the highway looked down a quarter-mile of straight drive through the open gate of the courtyard, through the tunnel under the water tower, through the open house door at a fire sparkling in the faraway hearth. Atalaya had magic.

Uncle Archer and Aunt Anna wintered at Atalaya until 1942, when the Army Air Corps moved in to patrol the beach during the war. The Huntingtons lived there for the last time in 1946 and 1947. The house was then used by the Georgetown County Girl Scouts in 1957, and in 1960 was leased to the South Carolina Forestry Commission as part of the state park that was made out of the beach property. But Atalaya was too individual to adapt, and was doomed to die with Uncle Archer. All this was long ago, during our heroic peak of energy, inventiveness, and daring, when some Americans loomed larger than life. Uncle Archer died in 1955, Aunt Anna in 1973, but what they started as a private reverie now allures thousands of motorists from their speeding on the great highway to turn aside and wander among sculpture set in the splendor of flowers and sunshine.

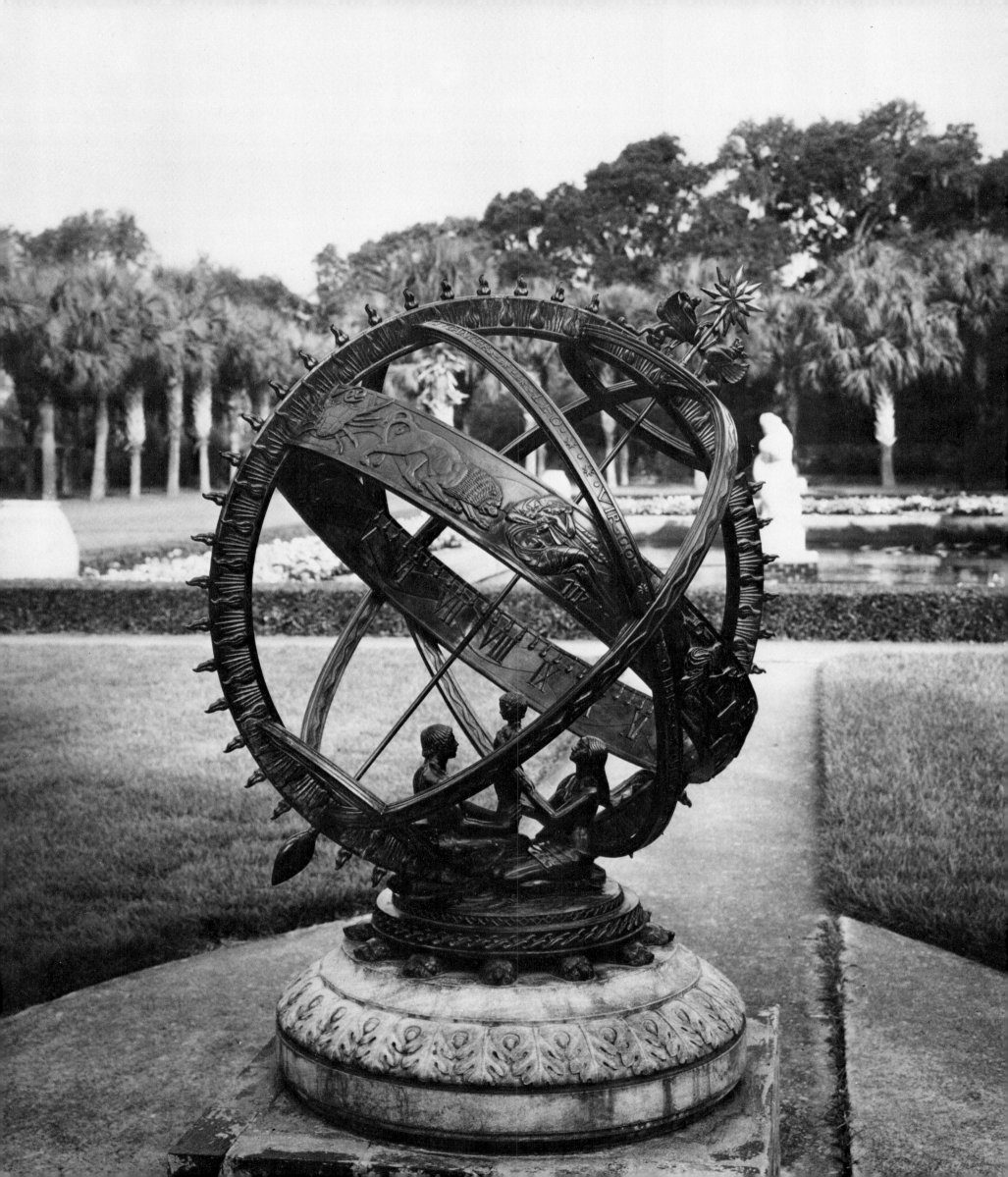

The Development of the Sculpture Collection

By Beatrice Gilman Proske

THE FOUNDATION AND DEVELOPMENT of Brookgreen Gardens, quite aside from private use as a favorable climate in which Anna Hyatt Huntington could recover from illness, had two larger purposes, both inspired by major interests of the founders. As revealed in his poem "A Flight of Birds," Archer Huntington was a naturalist and appalled by the wanton destruction of wildlife.

> Terrified creatures in bitter entanglements,
> Painted and passionate things that we kill.

He already had begun a campaign for the preservation of natural beauty when he gave "Camp Arbutus," his Adirondacks retreat surrounded by acres of woodland, to Syracuse University for a wildlife preserve. Brookgreen became the southernmost in a chain of such refuges. There, among forests and swamps that were the natural habitat of many varieties of animals and birds, a cultivated area that was approached through a magnificent avenue of ancient live oaks immediately suggested the creation of a garden on a grand scale. Such a garden, in turn, would provide splendid settings for sculpture, and it was quite natural that some of Mrs. Huntington's works should be placed in it. At the same time, she insisted that sculpture by other American artists be included, so that her colleagues could benefit from this opportunity.

The Huntingtons had few precedents for such an ambitious plan, since garden sculpture had but a short history in the United States. Our early settlers were too busy with practical matters to pay much attention to beautifying their surroundings in this fashion, and the Puritans of New England thought decorative sculpture too pagan and frivolous. Only the urbane Thomas Jefferson, when he was planning Monticello in 1767, wanted Roman statues in the garden. At the end of the eighteenth century, *Water Nymph and Bittern*, carved in wood by William Rush, one of the earliest native American sculptors, was placed in a fountain in front of the Water Works at Philadelphia, but it rotted away and had to be replaced by a bronze cast.

Later, occasional wealthy American travelers, on the grand tour of Europe, brought back examples of classical sculpture that were placed in the garden, as Horatio Greenough's father had done with a marble copy of *Phocion*. Greenough and other serious early-nineteenth-century sculptors rarely descended from a lofty plane of noble ideals to divert themselves with what they considered trivialities, and works such as Thomas Crawford's *Chanting Cherubs* or Harriet Hosmer's *Puck* were more likely to find a place in parlors than outdoors. Hosmer also designed fountains executed in marble, although none was destined for her native country, but Hiram Powers, at work in Italy, sent a fountain to the Preston family of Columbia, South Carolina.

By the second half of the nineteenth century, highly esteemed works by the Italian sculptor Antonio Canova were being imported, and a pair of his nymphs might well be found in someone's garden. A few native sculptors ventured into the open air, and New York's Central Park became the site of Emma Stebbins' early *Angel of the Waters* fountain and later John Quincy Adams Ward's *Indian Hunter*. A replica cast from an example in the collection of the American Academy of Arts and Letters was obtained for Brookgreen. Dated 1860, it is the earliest work in the Gardens.

The prosperous years at the end of the nineteenth century that led to the amassing of large fortunes encouraged rich men to buy country estates and develop extensive gardens. For these gardens, Janet Scudder, inspired by Italian artists of the Renaissance, created a whole series of sculptured children very much at home playing with water in fountain pools. A small version of the first of the series, *Frog Baby* (inspired by the gay antics of a child model), was placed in the Small Sculpture Gallery, and sites for larger pieces were found in the Gardens later. Stanford White and other architects after him often seized on motifs created by Miss Scudder as just the thing to enhance the palaces they were building for their clients. Seeing that garden sculpture was in demand, many sculptors soon followed Janet Scudder's example and gradually introduced new themes and different styles of sculptural expression.

Fountains not only ornamented gardens, but monumental examples that imitated European prototypes began to embellish city squares and public buildings. One of the earliest, erected in the 1890s, was R. Hinton Perry's *Fountain of Neptune* in front of the Library of Congress in Washington, D.C. New York's Botanical Garden later erected Charles E. Tefft's fountain in the form of cascades down a flight of steps. Then Lorado Taft had ambitious ideas about a series of fountains in a chain of Chicago parks, beginning with the *Fountain of the Great Lakes*. A small sketch model for a detail of his *Fountain of Time, Daughter of Pyrrha*, is at Brookgreen. The sculptor Stirling Calder had a special talent for original, spirited creations, as seen in

fountains at Indianapolis and Philadelphia, and his work eventually found a place at Brookgreen. Gertrude Vanderbilt Whitney developed fresh designs, such as the Aztec Fountain for the Pan American Union in Washington, D.C., and a study for one of her caryatids that supported the basin of a fountain intended for a hotel in the capital is at Brookgreen. The only life-size replica of Carl Paul Jennewein's *Nymph and Fawn* done for the Darlington Memorial Fountain, also in Washington, is in the Gardens.

Long before he married Anna Hyatt, Archer Huntington had long been interested in sculpture. One of his earliest associations with American sculptors was with George Grey Barnard, when Archer took care of the arrangements for a bust of Collis Huntington ordered by Arabella after her husband's death in 1900. Barnard's respect for Archer Huntington's artistic judgment is echoed in lines he wrote to accompany a program for the dedication ceremonies of his sculpture at the Capitol in Harrisburg, Pennsylvania:

Do you remember—a night
When the contract came
And we sat up till morning light,
Giving the *"vision"* a name?

Huntington's familiarity with Europe fostered admiration for its artists, including sculptors. In 1911 he had arranged to show the work of Paul Troubetzkoy in the Hispanic Society building, under the sponsorship of the American Numismatic Society. The success of this exhibition encouraged the Russian sculptor to spend a number of years in the United States. A small bronze of a Troubetzkoy elephant that Mr. Huntington had owned is in the Small Sculpture Gallery at Brookgreen.

When Archer Huntington began to build the museum and library of The Hispanic Society of America in New York and to help erect buildings for the institutions around Audubon Terrace, he thought of adding sculpture as a way to ensure that the buildings would be preserved as works of art themselves. One of his first projects was a group of figures for the court just off Broadway. Gutzon and Solon Borglum, Chester Beach, and Charles R. Harley were asked to carry out this idea. Unfortunately, World War I intervened, and although some sketches were prepared the work was never completed. Three of these sculptors are represented at Brookgreen: Beach by the marble statue *Sylvan*, Solon Borglum by two small bronzes, and Gutzon Borglum by a study for a section of the *Mares of Diomedes*, the original of which stood for many years at the foot of the main staircase in The Metropolitan Museum of Art in New York.

In 1922 Archer Huntington had a chance to work closely with the National Sculpture Society when he offered them Audubon Terrace for their first open-air exhibition as well as the Hispanic Society and American Academy

of Arts and Letters buildings to display sculpture unsuited for outdoors. Among the sculptors he came to know well was A. A. Weinman, chairman of the exhibition committee. One of the members was Anna Hyatt, who became his wife before the exhibition actually opened in April, 1923. He financed not only this exhibition but one in Lincoln Park, San Francisco, six years later. Through his active collaboration with the National Sculpture Society, he was well prepared to choose the best in American sculpture when he began the collection at Brookgreen. In buying he was guided by his own very definite tastes, with which his sculptor wife fully agreed. He once said, "My wife and I are classicists," thereby affirming his preference for permanent sculptural values over innovation for its own sake. A favorite quotation of his was "Art is craftsmanship concealed by its own superiority." Implicit in the above statements are the guiding principles in Huntington's choice of sculpture: a high level of creative imagination and an equal emphasis on skill in execution. Fortunately at this time (which one author has dubbed the "Golden Age" of American sculpture) he could draw on a large number of fine sculptors.

Mrs. Huntington not only appreciated the accomplishments of her fellow sculptors but also sympathized with their financial difficulties. The Depression of the 1930s made it hard for artists to get commissions, and with the full cooperation of her husband she was determined to help them. One way was to establish with the National Sculpture Society a loan fund for relief of deserving sculptors temporarily in need of assistance. Another was to buy suitable pieces for Brookgreen Gardens, sometimes from dealers and many times from the sculptors themselves.

It is not hard to imagine with what eagerness Archer and Anna Huntington started to embellish their garden with the sculptured beauty of living forms, human and animal. After the topographical layout had been planned (in the shape of a butterfly), their first concern had been to set boundaries and wall-in the central area of the gardens, with entrance gates and paths laid out within. Gates demanded gateposts, which in turn were good pedestals for sculpture, and pieces by Anna Huntington at hand were chosen. A pair of *Great Danes* ordered for the Hammond Estate at Gloucester, Massachusetts, had been damaged in transit and replaced; the repaired originals were then installed on the gateposts beyond Youth Circle at the beginning of a long avenue of live oaks. Iron gates, some of them with medallions of birds and animals, were designed by Mrs. Huntington and wrought by Tito and Roger in Miami.

At the approach to the walled garden, a large circular pool was built; in 1931, *Diana of the Chase*, one of Mrs. Huntington's most important sculptures, was placed in the center of it. Taken from a niche in the dining room of

Archer Huntington's New York town house at 1083 Fifth Avenue, Diana now draws her bow surrounded by water with its everchanging reflections, aiming her arrow into the sky as her eager hound leaps up beside her. Soon after the first casting of this statue in 1922, it won an important award at the National Academy of Design in New York. Immediately *Diana of the Chase* became so much in demand that more than a dozen full-size replicas were cast, dotting the United States from New York to Texas and traveling as far away as Cuba and Tokyo.

The top of the steps leading to the Diana Pool was an appropriate spot for two bronze lions formerly at the main entrance to The Hispanic Society of America in New York, the first of Archer Huntington's foundations. These had been replaced by others carved in limestone. The Brookgreen lions later were changed to a site near the Visitors Pavilion when the steps were removed.

The founders thought that stone and marble were particularly suitable for a garden and sought out good examples wherever they could be found. The first of works carved especially for the Gardens was Mrs. Huntington's *Youth Taming the Wild*, which shows a young man subduing a rearing horse. It was cut in limestone by Robert A. Baillie in his studio at Closter, New Jersey. For the setting, a large pool was built at the end of the approach from the entrance gate through an avenue of longleaf pines, on an axis with the Live Oak Allée central to the walled garden. The powerful mass and forceful action hold the attention and prepare the visitor for what is ahead.

Bringing this massive stone from New Jersey and putting it in place involved many difficulties. Together Mr. Baillie and Mr. M. M. FitzHugh, an engineer from the Newport News Shipyards, worked out the solution. Mr. Baillie told how this was accomplished:

Anna Hyatt Huntington's *Youth Taming the Wild*, being finished at R. A. Baillie's studio in Closter, New Jersey, about 1932.

> When the huge stone arrived in Closter, New Jersey, it weighed 57 tons. It had weighed 100 tons when quarried. It was on a special flat car, and no trucking concern would accept the task of taking it from the car to my studio because of road conditions and a bridge; so I rented space by the Erie railroad siding, and for the next four months six men and myself cut away 30 more tons. Now at 27 tons I could get permission and truckmen agreed to take it to my studio, where we spent the next 14 months carving it.
>
> . . . I made plans for shipping the finished group to Brookgreen. When the group on a flat car arrived in Georgetown, S.C., a crowd came to watch the unloading. Mr. M. M. FitzHugh of Newport News, Va., arranged for a barge to convey the stone group up the Waccamaw River to the dock which had been made for the purpose. We had to wait for the tide to lift the barge up to the pier level, and at a given signal we all worked furiously to take advantage of the tide to roll the stone group from the barge to the roadway already prepared. . . . The men were eager to make the mighty stone arrive safely and they sang as they pulled, ''Come on, Horse, Come on, Horse, we got a stable all fixed for you.'' When it was placed on its base in the pool they sang again that the good Lord had made the stone horse come to its stable.

With the carving of *Youth Taming the Wild* there began for Robert Baillie a close association with the Gardens that lasted until his death. When the sculpture began to need care, he came to Brookgreen once a month to look after it. In 1941 he was appointed curator of sculpture. As the collection increased, Baillie was often called upon to enlarge small works and carve them in stone or marble. His studio at Closter had long been well-known to sculptors, since he had worked with Gutzon Borglum for many years and also for Mrs. Huntington after he met her in Borglum's studio. Mr. Baillie's mother and, after her, his older sister Mary had made their farmhouse a center of cordial Scottish hospitality. Any sculptor for whom Baillie was working was welcome to stay there, and on Sundays the long table that filled the dining room from end to end was crowded with the family and guests. Brenda Putnam, who shared a studio with Mrs. Huntington for a time, has left a record of her affection for the Baillie family in the statuette called *Communion*, a study of Mr. Baillie's mother tenderly holding a pet chicken.

Within three years after the founding of the Gardens, the brick wall around the central area had been completed (as well as the Small Sculpture Gallery built to house works unsuitable for placement outside), and niches along the walls and pools under the live oaks became showcases for sculpture. First to be installed were two of Mrs. Huntington's bronze jaguars near the entrance of the walled garden. Small sketches for these magnificent creatures had been among her early works, which were modeled at the Bronx Zoo from a ferocious beast native to Paraguay named Señor López. She had enlarged and improved her sketches in 1907, when working in France at Auvers-sur-Oise in a studio that once had belonged to the painter Daubigny, and she herself carved the finish on a pair in stone that were placed in the Musée du Luxembourg, Paris. Two pairs were cast in bronze in 1926; one was given to The Metropolitan Museum of Art, New York, and the other eventually went to Brookgreen Gardens.

In the butterfly-shaped plan drawn by Mrs. Huntington, the focal point of the Gardens was the oval where the creature's body would be, continuing the axis of the Live Oak Allée. This vital spot required an impressive sculpture. The first piece installed there was Chester Beach's idyllic marble, *Sylvan*, a youth whose smiling face and careless ease suggested sunny woodland glades; it had been ordered originally for a niche in the dining room of Mr. Huntington's New York home. Within a few years it was supplanted by Edward McCartan's gleaming *Dionysus* of gilded bronze, setting a livelier mood in a classic harmony of rhythmic curves. This work was enlarged and remodeled from a previous design especially for Brookgreen. The heart-shaped space at the head of the Live Oak Allée has in its center Walker Hancock's *Boy and Squirrel*, perpetuating a happy moment on a summer afternoon. Mrs. Hunt-

ington had seen the bronze version and asked the sculptor to carve it in marble for Brookgreen. When Beach's *Sylvan* was moved to the boxwood garden that had belonged to the original house, it was joined by Hilda Lascari's *Autumn Leaves* and Mario Korbel's *Sonata*; these snowy marbles strike three clear notes in the midst of dark foliage. Korbel's tranquil reclining figure *Night* lightens another shadowy area.

The wall at the back of the garden, topping a steep bank above the marshes, offered an advantageous site for works that would benefit from being outlined against the sky. First of three over-life-size bronzes placed there was Albin Polášek's *Forest Idyl*, a graceful design of a girl holding a fawn, with a doe standing beside her. The intricate silhouettes of Paul Manship's *Diana and Actaeon*, with their balance of flowing line and open space, make striking patterns. Since Manship was one of the most important figures in American sculpture of the first half of the twentieth century, his work is well represented. Scattered throughout the Gardens are replicas of his birds that were created for a gate in the New York Zoological Park. *Evening* is a study model for the *Moods of Time* made for the New York World's Fair of 1939-40, and there are other smaller bronzes.

Dominating the western part of the Gardens is the large fountain pool on the site of the original plantation house, built as a reservoir for water irrigating all parts of the Garden. The first of the sculptures with appropriate aquatic motifs to be set around the rim of the pool was *Little Lady of the Sea* by Ernest Bruce Haswell of Cincinnati, Ohio. A companion piece showing a girl riding a seahorse, *Sea Scape*, was ordered carved in limestone from Herbert Adams, who with his wife Adeline were old friends of the Huntingtons and trustees of the Hispanic Society. He already had carried out other commissions for Archer Huntington, such as bronze doors for the Mariners' Museum at Newport News, Virginia. A pair of children astride dolphins that Milton Horn carved in limestone joined the other groups on the rim of the pool, and, finally, at the back, dominating the scene with its unique design and strong modeling, was *Alligator Bender*, carved in Italian marble by Nathaniel Choate.

During its first ten years of existence there was a steady stream of sculpture flowing into the Gardens. The Huntingtons often stayed at Atalaya, the beach house, during the winter months and personally chose sites for the new sculpture. In their search for the best works suitable for their purpose, they explored many avenues. Janet Scudder's early and successful innovations in creating fountain figures had been eagerly followed by many sculptors, among them Edith Barretto Parsons, whose cheerful *Frog Baby* enlivens the pool in the Small Sculpture Gallery. Several fountains in the parks of Philadelphia are animated by lively studies of girls' forms created by Beatrice Fenton; a

Mario Korbel's *Night*, nearly crushed by fallen tree during Hurricane Hazel in 1954.

replica of one of these, *Seaweed Fountain*, was procured for Brookgreen. Harriet Frishmuth developed a special breed of vibrant, lyrical figures, exemplified by *Call of the Sea*.

Some fine works already in existence satisfied the Huntingtons' preference for marble. One of these was George Grey Barnard's *Maidenhood*, a life-size reclining figure of which the sculptor wrote, "I finished that marble in a way I finished no other flesh." To supplement what was available, the founders began to ask sculptors to enlarge small works they liked. The fragile limbs and intricate detail of Bryant Baker's small bronze *L'Après-midi d'un Faune* made it a tour de force when the sculptor recreated it in marble. The simpler forms of the closely knit composition of Edmond Amateis' *Pastoral*, with clear outlines and low-relief ornamental passages, were more readily transferred to marble. This work, cast in plaster, fulfilled the final requirement of the artist's years at the American Academy in Rome. After being exhibited in New York, it was brought to the attention of Mrs. Huntington, who commissioned the artist to carve it in marble for Brookgreen. At her suggestion he had the carving done by Robert Baillie.

For hard-to-find works by older masters, studies for or reduced replicas of well-known monuments were often the answer. Saint-Gaudens is represented by a reduction of *The Puritan*, a memorial to Samuel Chapin at Springfield, Massachusetts, and R. Tait McKenzie by a model for *The Young Franklin* at the University of Pennsylvania. A softly draped angel with spread wings entitled *Benediction*, a study for a war memorial never erected, is characteristic of Daniel Chester French. Small versions of the magnificent *Rearing Horses* at one entrance to Prospect Park, Brooklyn, by Frederick MacMonnies were later complemented by another facet of his art when his widow presented the impudent *Venus and Adonis*, carved in Numidian marble, that had scandalized the American public when first shown.

Sculptors who had studied or worked with Saint-Gaudens were still active in the 1920s and 1930s and are well represented. A. A. Weinman's *Narcissus*, originally in bronze but later replaced by a marble version, and Elsie Ward Hering's *Boy and Frog* are each reflected in the water of two rectangular pools at the beginning of the Live Oak Allée. Henry Hering, Elsie's husband, modeled two infant wood nymphs playing panpipes that were cast in aluminum. Charles Keck's *Fauns at Play* is the only replica of a fountain created for an estate at Centreville, Maryland. Frances Grimes' *Girl by a Pool* was enlarged from a small bronze and carved in marble.

Because of her profession Anna Hyatt Huntington knew many sculptors well. Two lively figures by her older sister, Harriet Hyatt Mayor, who had introduced her to sculpture, are in the Gardens, as well as a bust done of Anna when she was a girl. Her teacher at the Art Students' League, Hermon

MacNeil, is represented by one of his most popular works, *The Sun Vow*, depicting a tribal ceremony in which an elderly Indian encourages a boy to shoot an arrow at the sun. When American sculptors began to look for native subjects, the West and the Indian were magnets for their imagination. Two of the most famous results of this attraction are in the Gardens: Frederic Remington's extraordinary action study *The Bronco Buster*, which ran into an edition of over 300 bronzes, and James Earle Fraser's pathetic *End of the Trail*, which symbolized the passing of the Indian's way of life.

When the young Anna Hyatt first came to New York she shared a studio with Abastenia St. Leger Eberle, and the two collaborated on a few groups, Miss Eberle doing the human figures and Anna the animals. Archer Huntington also knew Miss Eberle at this time and asked her to design sculpture for the main door of the Hispanic Society. She made a sketch for a relief, but the architect objected and the idea was abandoned. One of Miss Eberle's small bronzes, *The Windy Doorstep*, was acquired for Brookgreen.

Many years later, just before her marriage, the future Mrs. Huntington joined Brenda Putnam in a studio on Twelfth Street in New York. This sculptor created for the Gardens a charming bronze sundial surmounted by a boy playing with a young goat that became the keynote of a section called the "Baby Garden," a series of studies of children grouped at the entrance to the Small Sculpture Gallery.

Anna Hyatt Huntington never had any formal students nor even assistants, but she did allow aspiring young women sculptors to observe and work in her studio. Katharine Lane Weems as a girl in Boston had this privilege and went on independently to become a distinguished sculptor of animals. Several of her bronzes are in the Small Sculpture Gallery, and a larger work, *Greyhound Lying Down*, that Mrs. Huntington kept in her own house during her lifetime is now in the Live Oak Garden. Sylvia Shaw Judson spent a summer at Gloucester when she first became interested in sculpture and did some early work in Mrs. Huntington's Annisquam studio. Her *Girl with a Squirrel*, a replica of a work designed as a memorial in a Milwaukee park, was acquired for Brookgreen and placed between the two sections of the Small Sculpture Gallery. Opposite is *Rain* by Avard Fairbanks, whom Mrs. Huntington had met when he was a boy in knee pants modeling animals beside her at the Bronx Zoo.

The Huntingtons did not rely exclusively on well-known artists. When news of their acquisition policy circulated, more and more sculptors sent photographs of their work, from which many were chosen. When Mr. Huntington saw (in Baillie's studio where Abram Belskie was working) a statue of the Christ Child that Belskie was modeling in his spare time, he said immediately, "I want that," and ordered it carved in marble. It was the first

of the sculptor's works to be publicly exhibited. One young sculptor, Albert Wein, had sent the Huntingtons a photograph of a sketch called *Phryne Before the Judges*, based on a legend that had caught his fancy when he was traveling in Greece. The sketch pleased them, and they ordered it enlarged and carved in limestone for Brookgreen.

Being an animal sculptor herself made Mrs. Huntington especially responsive to interpretations by other artists. Several years after her own *Jaguars* had been installed, two *Black Panthers* by Wheeler Williams came to join them just outside the gate to the Live Oak Garden. They are more sleekly stylized than Mrs. Huntington's cats; their glossy black surfaces are the result of oxidized silver-plating on the bronze, and their green lacquer eyes, against palmetto foliage, give them the menacing look of creatures stalking out of the jungle.

Bird and animal themes are appropriate subjects for sculpture in a wildlife sanctuary, and variations range from the accurately observed work of men trained to mount specimens for natural history museums, like James L. Clark, Robert H. Rockwell, and Louis Paul Jonas, through the elegantly feathered *Great White Heron* of Gertrude K. Lathrop and the suavely fringed hair of Erwin Springweiler's *Great Anteater* to the simplified planes of Gaston Lachaise's *Swans* and Trygve Hammer's *Hawk*. Among the sculpture acquired at an early date was *Turning Turtle* by Albert Laessle of Philadelphia, as realistic as the one done in his student days that he was accused of casting from life. Later, the Huntingtons acquired his sprightly *Dancing Goat* and *Two Penguins* that preside over their own pool. Another group of birds and animals is by one of Laessle's students, Ralph Hamilton Humes, who brings a special empathy to his studies, such as *Performing Goat*, of which only the one casting was made. Bruce Moore delighted in the funny ways of the creatures he modeled and added his own decorative treatment of varying textures of skin and feathers. His gleeful pelican catching a fish, cast in aluminum, animates an area of South Carolina Terrace; it is the only replica of a memorial fountain in Pratt, Kansas.

In the 1930s many pieces were bought from the Arden Gallery in New York, which specialized in contemporary American sculpture and had as its fundamental purpose "to expand and to awaken the consciousness of art in daily life." The gallery sent out letters to sculptors informing them that Brookgreen was buying sculpture and suggesting that they submit photographs of their work. Joseph Kiselewski received several of these letters, and assuming that they were advertisements threw them in the wastebasket unopened. It was only at his wife's urging that he read one of the letters and decided to send a photograph of *Sea Horse*, the piece he was then modeling. It was chosen for Brookgreen and eventually launched in its own lotus pool.

Milton Horn's two children on dolphins also were ordered carved in stone, based on photographs of a pair of bronzes that he submitted to the gallery. In the spring of 1938 Arden Gallery had a special exhibition of garden sculpture, including many photographs of Brookgreen Gardens that showed how well sculpture appeared in that setting. In 1940 the gallery carried out its aim to bring native sculpture into American gardens by inaugurating its "Limited Editions of American Masterpieces of Garden Sculpture" with Wheeler Williams' *Childhood of the Gods*. A set of four of these lead statues was acquired by the Huntingtons, as sponsors of the scheme, and sent to Brookgreen.

As was his custom with all institutions he founded, Mr. Huntington began to publish information about Brookgreen's sculpture as soon as there was a sizable collection. Although he kept each of his foundations quite separate, he did not hesitate to use the resources of one to benefit another. First he brought down members of the Hispanic Society's photographic staff, chiefly Frances Spalding and Della Catuna, to photograph the Gardens, although some photographs already had been taken by Mrs. Bayard Wooten of Chapel Hill, North Carolina. At the same time he asked me, as curator of sculpture at the Hispanic Society, to catalogue the collection. A brief description of works by fifty-two sculptors was printed in 1936, and as new sculpture was added the catalogue was revised to keep pace.

The increasing number of small bronzes acquired made it necessary to add to the Small Sculpture Gallery in 1937. Three years later work was begun on a new area adjacent to the walled garden at the northwest corner, which was planted with dogwood trees whose white blossoms make it a fairyland in spring. For the central pool A. A. Weinman was commissioned to execute a heroic group of galloping horses ridden by jubilant young men blowing trumpets, which he called *Riders of the Dawn*. As in the main garden, the low boundary wall along the marshes received sculpture with interesting silhouettes: A. Stirling Calder's *Nature's Dance*, carved in limestone, and John Gregory's *Orpheus*, playing his lute to entertain two panther cubs. Four pools around the central group received sculpture to reflect in their surfaces: Joseph Nicolosi's *Dream*, Walter Rotan's *Reclining Woman with Gazelle*, Joseph Renier's *Pomona*, and Berthold Nebel's *Nereid*. Nebel already had been employed by Mr. Huntington to design nine panels symbolizing the civilizations that had flourished in Spain; they were cut in limestone and incorporated into the smooth façade of the main building of the Hispanic Society. During World War II, from 1942 to 1946, no new works were added to the Gardens, but some pieces previously ordered were completed.

There still was room in the main garden for a few more pieces when purchasing was resumed. Karl Gruppe enlarged a small marble carving entitled *Joy* that had won a prize at the National Academy of Design and carved

it for Brookgreen. The dreamlike mood of the crouching girl is appropriate for a sunlit spot. Frank Eliscu's bronze *Shark Diver* carries out a rare underwater theme, exemplifying the sculptor's belief that, "Only within the suspension of water can the human form be released to its ultimate flow of grace and action."

The next area to be developed after the Dogwood Garden in 1949 was the Palmetto Garden to the southeast of the Live Oak Allée. For the central pool Gleb Derujinsky's *Samson and the Lion* was ordered carved in stone, dominating the scene with its rhythmic masses and vigorous action. Standing at each end of the pool are Albino Manca's bronze *Gazelle and Cactus* and Paul Manship's armillary sphere sundial *Cycle of Life*. In one corner is Derujinsky's *Ecstasy*, a bronze group showing a different facet of his art, with emphasis on impassioned movement combined with open spaces. Donald DeLue's bronze *Icarus*, graphically shown as if falling from the sky, and Vincent Glinsky's expressive *Awakening*, enlarged from a smaller version and carved in marble by the sculptor himself, are also here.

The corner opposite the Palmetto Garden, on the north side of the Live Oak Allée was not enclosed but was developed with pools in open spaces to become the setting for important sculpture. The most remarkable of these works is *The Thinker* by Henry Clews, an old friend of Archer Huntington and a self-taught sculptor. This life-size aluminum statue represents the wasted figure of an old man seizing a fleeting idea, and the bronze base is richly decorated with symbolic figures that embody the sculptor's critical conception of life and the forces that shape it. The mold of the statue had been presented by the sculptor's widow for casting; it had been done at La Napoule, the château on the Riviera that Clews had rebuilt and peopled with his own fantastic creations.

For the open space to the southwest of the walled garden, Laura Gardin Fraser was asked to supply a large sculpture. The subject she chose was *Pegasus*, the winged horse, lifting a human form on his back. The group symbolizes the person gifted with creative imagination, "floating along with Pegasus, symbol of inspiration, through the clouds and over the heights"; and, indeed, placed as it is on a rise of ground under a wide expanse of sky, *Pegasus* seems in spite of its heavy stone to be taking flight. Its great blocks of granite were roughed out at a quarry in North Carolina before being brought to Brookgreen in 1953, where E. H. Ratti finished the carving in place. Laura Fraser and her husband, James Earle Fraser, had a studio in Westport, Connecticut, not far from where the Huntingtons lived and were their good friends.

Mrs. Huntington continued to add her sculpture to the Gardens. Around a circle at the entrance to the Wildlife Park are four groups of animals and birds

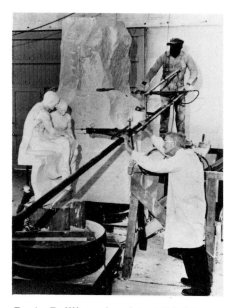

R. A. Baillie and assistant Ed Alston using Brookgreen pointing machine to enlarge Anna Hyatt Huntington's *The Visionaries*, about 1955.

cast in aluminum from the same models that had been used for those carved in marble on the terrace of the Hispanic Society. Don Quixote had captured Mrs. Huntington's imagination when she used him as the theme of a large relief on a wall of the same terrace. In her studio at Atalaya on the beach at Brookgreen she undertook to model a very different interpretation of that renowned knight errant. Because she conceived of him as a tragic figure, she looked for a dejected horse to share his sadness. When word got around that she needed a decrepit horse to model, offers poured in. The specimen finally chosen was so weak that it could not stand and had to be supported by a sling when the work began. The horse's health so mended as work progressed that it lived to an honorable old age. Two of the preliminary sketches for *Rocinante* are now at Brookgreen. The model was enlarged to more than life-size in the studio at "Rocas," Haverstraw, where the Huntingtons lived for several years, and was cast in aluminum. After it was placed in the Gardens, Paul Jennewein, then president of Brookgreen, reported to Mrs. Huntington that there was public clamor for a Sancho Panza to accompany his master, and would she model one. She replied, "Why don't you do it?" Jennewein accepted the challenge, and his Sancho came to stand behind Don Quixote, the sculptural personalities contrasting as distinctly as those Cervantes had imagined in his book. The main entrance on the Ocean Highway called for a striking object to catch the attention of tourists speeding by on their way to Florida. For this purpose Mrs. Huntington imagined a heroic group of two frenzied stallions battling for supremacy. Cast in aluminum, the sculpture is visible from a long distance and makes the motorist want to stop and look further. The design has been adopted as the special emblem of Brookgreen Gardens.

Mrs. Huntington wanted to prepare a memorial to her husband and herself, as the founders, while they were still alive to enjoy it. Her model, called *The Visionaries*, was so nearly finished that Archer could see and approve it before he died in December, 1955. She imagined herself and her husband as symbolic figures surrounded by books and animals. Carved in limestone, this memorial has a special quiet enclosure near the Visitors Pavilion. On the back of the stone is inscribed a fragment from Archer Huntington's poem, "The Silver Gardens," inspired by Brookgreen. Poetry was his favorite form of literary expression, and, when he was a young man, his most ambitious undertaking had been a translation of the Spanish epic *Poem of the Cid*. He never stopped writing poetry himself, and he interspersed appropriate poems engraved on stone slabs with the sculpture in the Gardens. He selected the verses and Robert Baillie carved them in the stone, showing his skill by using a variety of ornamental lettering.

Mrs. Huntington sent Brookgreen a major work that had been offered to

Washington, D.C., but no appropriate site for it had been found there. A special setting outlined by a semicircle of trees was prepared for *In Memory of the Workhorse*, an open space where this magnificent tribute to the animal Anna Huntington loved most could be seen to advantage from all sides. It was a subject that had been in her mind for many years, beginning with a small group called *L'Orage* (the Storm) that she had modeled in France in 1907 and remodeled later until she arrived at this heroic conception. The monument was unveiled on February 15, 1971. Toward the end of her life, Mrs. Huntington decided to send Brookgreen a number of small bronzes, some from her studio, others from the foundry. They are animal studies, chiefly of horses, some combined with children, and also a few statuettes of ancestors that are evidence of her interest in family history.

For more than ten years after Archer Huntington's death, no sculpture was acquired except such pieces as were presented. Most significant among these was the plaster mold for Albin Polášek's *Man Carving His Own Destiny*, given by the sculptor, who felt that he had expressed not only his own life struggle in his statue but that of the human race. Robert Baillie began carving it in limestone at Brookgreen, and Arthur E. Lorenzani finished it when Baillie died.

After Paul Jennewein was elected president of Brookgreen in 1963, a plan for new purchases was gradually formed to continue the tradition established by the Huntingtons. Their choices had been governed by rigorous standards of excellence. Jennewein, because of his own superiority as a sculptor and his critical judgment, was well fitted to be their successor. The Trustees invited sculptors to submit photographs of their works, and in 1973 four were chosen for purchase. The only artist new to the Gardens was Marshall Fredericks, for whose *Gazelle* a pool was built in the Arboretum to the north of the Visitors Pavilion. The vivid action and fluid lines of this piece make a distinctive accent in this open field; four small animal subjects were added later to complete the fountain.

In 1973 the custom of having a special medal designed and struck annually was instituted, an idea entirely consistent with Mr. Huntington's tastes, since he had been enthusiastic about medallic art and had promoted the commissioning of medals by all the institutions with which he was connected. Those issued by Brookgreen called upon the talents of the finest medalists in the country. So far Gertrude Lathrop, Paul Jennewein, Robert Weinman, Joseph Kiselewski, Marshall Fredericks, Donald DeLue, Michael Lantz, Granville Carter, and Abram Belskie have each commemorated some facet of Brookgreen. Miss Lathrop celebrated the wildlife of the region with her usual exquisite touch, Jennewein portrayed the Huntingtons, and Weinman depicted Theodosia Burr Alston. Kiselewski's medal was a bicentennial tribute to

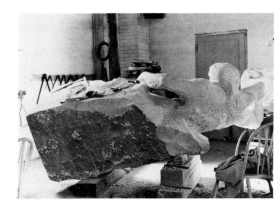

Albin Polášek's *Man Carving His Own Destiny*, being roughed-out by R. A. Baillie at Brookgreen studio in 1961.

George Washington, who did sleep at Brookgreen on his southern tour in 1791. Marshall Fredericks used his own fountain as a theme, and DeLue, at the request of the current president of the Gardens, Joseph Veach Noble, depicted the sculptor's art by having one figure on the medal model and another carve a statue. Lantz chose to depict the cycle of life in the wild with animals from the area, and Carter presented an equestrian figure of Francis Marion, the Revolutionary War hero from South Carolina. The fiftieth anniversary medal was executed by Belskie, showing sculpture on the obverse and the conservation of nature on the reverse.

Continuing the policy that Jennewein inaugurated, new acquisitions are made as funds become available. In 1977 four works by sculptors not previously represented were chosen: Charlotte Dunwiddie, Adlai Hardin, Bruno Mankowski, and Edward Widstrom.

In the Visitors Pavilion, one room was designated the Carl Paul Jennewein Gallery in 1978 after the sculptor's death, when it became the repository of a group of his sculptures bequeathed by him to Brookgreen. The highlight of this collection is a more than life-size *Iris* in shining bronze that Jennewein and his secretary, Mrs. Alice Muzzy, themselves polished by hand.

In the selection of sculpture the Trustees have sedulously observed the principles established by the Huntingtons. Since they believed with Alexander Pope that "The proper study of mankind is man," abstract art did not appeal to them; therefore, Brookgreen Gardens has remained a showplace where the great traditions of sculpture can be kept alive.

John Quincy Adams Ward
The Indian Hunter, 1860

*Ward changed the direction of sculpture in
the United States by choosing specifically
American subjects and treating them
realistically. Turning away from the Greek and
Roman models that had prevailed until then,
he proved that a sculptor could find themes
in this own surroundings and develop a sound
technique without studying in Europe. Ward's
sculpture struck a responsive chord in public
sentiment. When* The Indian Hunter *was shown
in New York it aroused so much enthusiasm
that a group of citizens bought it for Central
Park, the first statue so honored.*

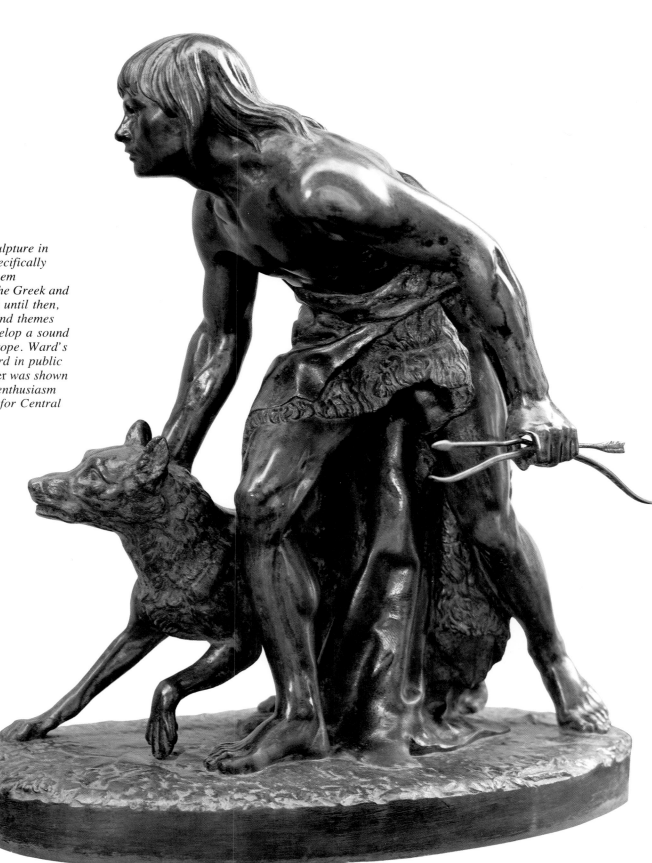

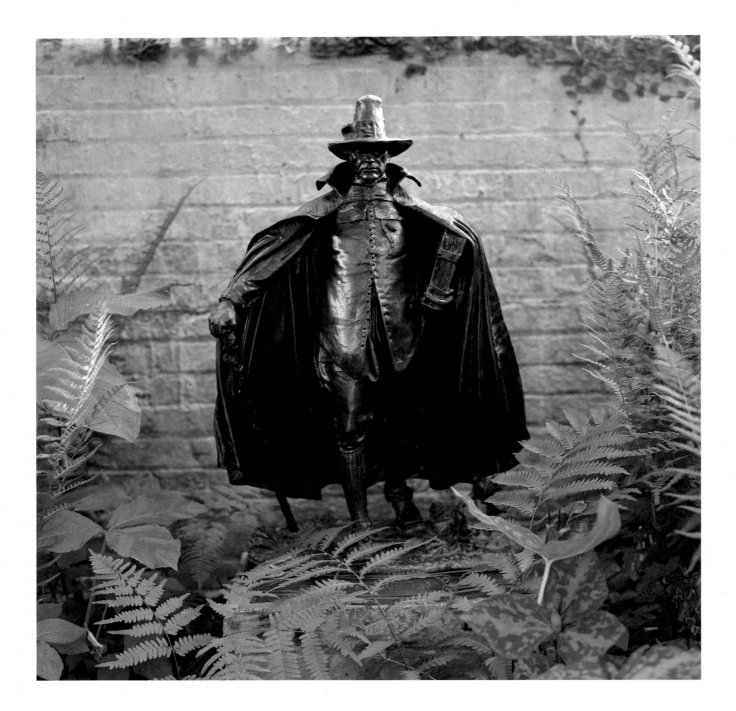

Augustus Saint-Gaudens *The Puritan*, 1899

Another figure who exerted a tremendous influence on sculpture during the last quarter of the nineteenth and well into the twentieth century was Augustus Saint-Gaudens. He set a precedent by studying in Paris rather than in Italy, where the atmosphere strengthened his realistic tendencies. Unlike his neoclassic predecessors, who had observed only classical sculpture, he was impressed by the delicate low relief of Renaissance sculpture and used this style for portrait reliefs and ornamental passages. A strain of idealism led him to introduce symbolic figures with their own gentle dignity enhanced by classical overtones. The Puritan, *a product of his later years, was commissioned as a monument to Deacon Samuel Chapin, one of the founders of Springfield, Massachusetts.*

Daniel Chester French *Benediction*, c. 1919

The classical tradition was carried on by French in his own individual fashion. Brought up in that stronghold of New England idealism, Concord, Massachusetts, he never abandoned those principles. His concept of classicism was, however, entirely distinct from that of his early nineteenth-century predecessors. The rich full modeling of nude figures gave them an impressive monumentality. In addition, his masterly handling of voluminous soft draperies contributed volume and grace to his conceptions. Benediction, *designed as a memorial to the dead of World War I to be erected on the banks of the Meuse River, is a good example of French's style. Unfortunately, it was never completed.*

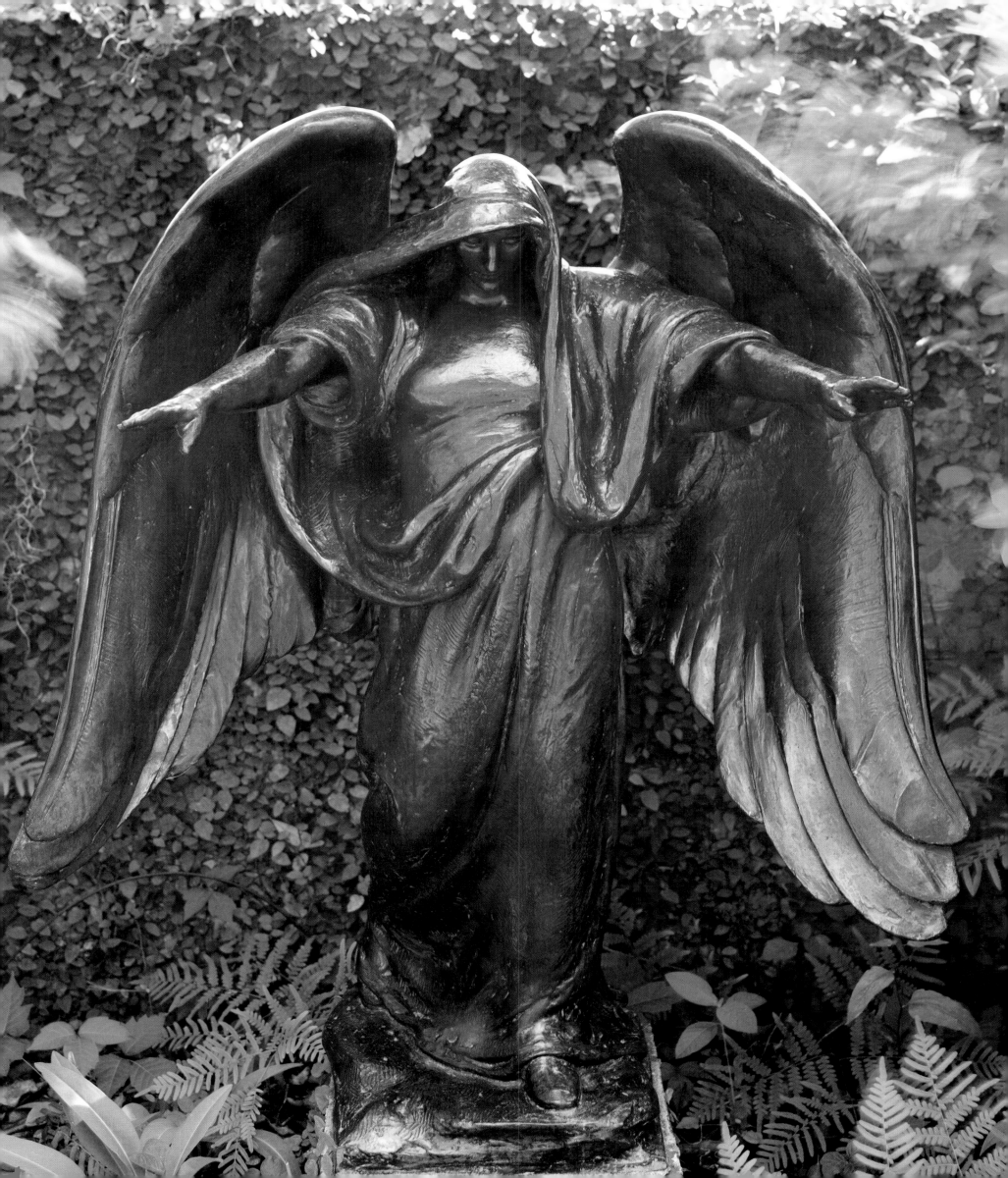

Lorado Taft *Daughter of Pyrrha*, 1910

Born in Illinois, Taft returned to Chicago to make that city a center of sculpture, not only in terms of works themselves but also through teaching and writing. In spite of years of study in Paris he had a strong feeling that America should develop its own style of sculpture and worked all his life to that effect. He had a preference for monumentality implemented by broad surfaces and understated detail.

Among his most ambitious plans was a series of fountains to ornament the public parks of Chicago. One of them was to represent the myth of Deucalion and Pyrrha, as the evolution of man from matter in stones taking human form. The working model was made in 1910 but not cast in bronze until 1934 and never placed on the intended site.

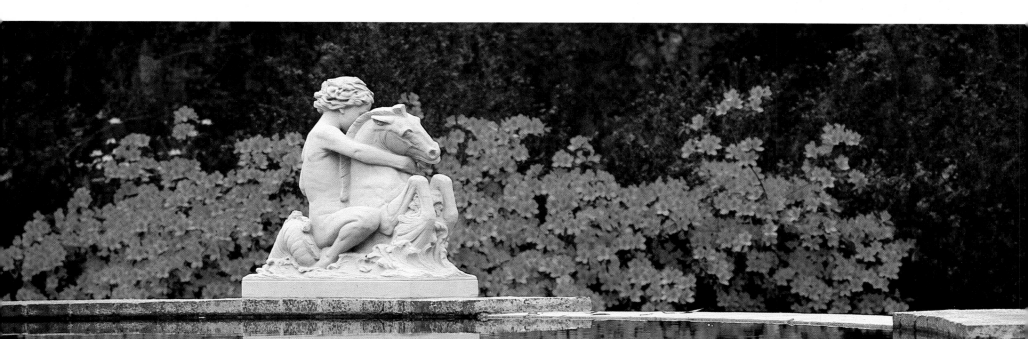

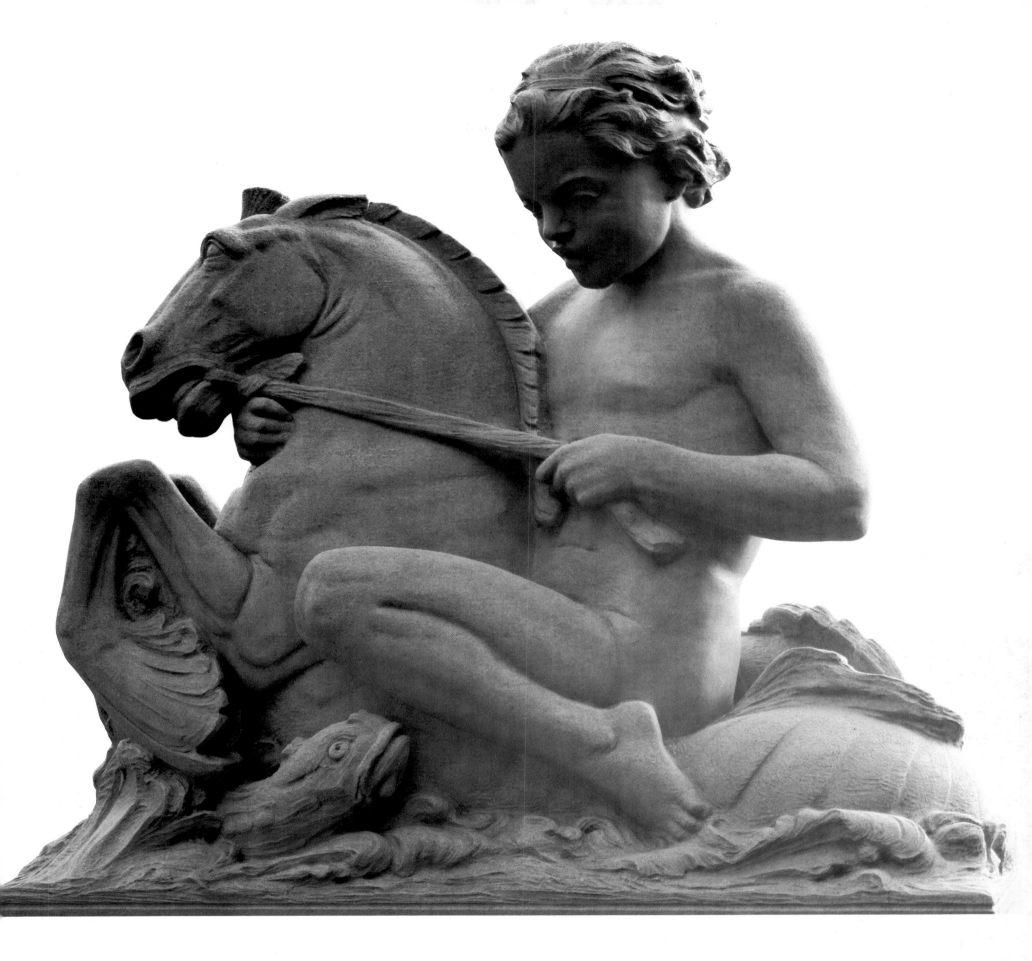

Herbert Adams *Sea Scape*, 1935

*Study in Paris and admiration for the Italian Renaissance
strengthened Adams' natural sensitivity and delicate touch. For a
time women's heads were his favorite subjects. Later, commissions
for bronze doors led him to a similar kind of almost intangible
low relief as had attracted Saint-Gaudens. Fountains gave him
a chance to combine lovely figures with sheer, floating or clinging
drapery. One of the last of these fountains was Sea Scape,
in which fluent surges of water and lightly wind-blown hair
harmonize with the subtle modeling of the girl and the sea horse.*

Frederic Remington
The Bronco Buster, 1895

Although not the first American sculptor to specialize in Western subjects, Remington was certainly the author of the most famous bronze in that genre, The Bronco Buster. *His training was not that of a sculptor but of an illustrator. As a young man he worked on a ranch in Montana and began to sketch the life about him, making a special study of horses. Discouraged by the poor reception his first exhibition of paintings received, he turned to sculpture, and his very first work,* The Bronco Buster, *was a tremendous success. More than 300 copies were cast in two sizes, with minor variations by the author in each new edition.*

54

Alexander Phimister Proctor *Trumpeting Elephant*, 1908

As the westward pioneer movement resulted in more settlements, young people who grew up out west began to take an interest in the arts. Proctor's parents settled in Denver, where hunting and study of wild life in the Rocky Mountains gave him basic material for small bronzes when he began his formal art studies in New York. He also won a scholarship for study in Paris, which helped him to perfect his technique. Proctor had a studio in New York for a time and traveled widely in the Western states, where several of his equestrian monuments were erected. Trumpeting Elephant, copyrighted in 1908, is characteristic of his flair for vivid action combined with accurate anatomical detail.

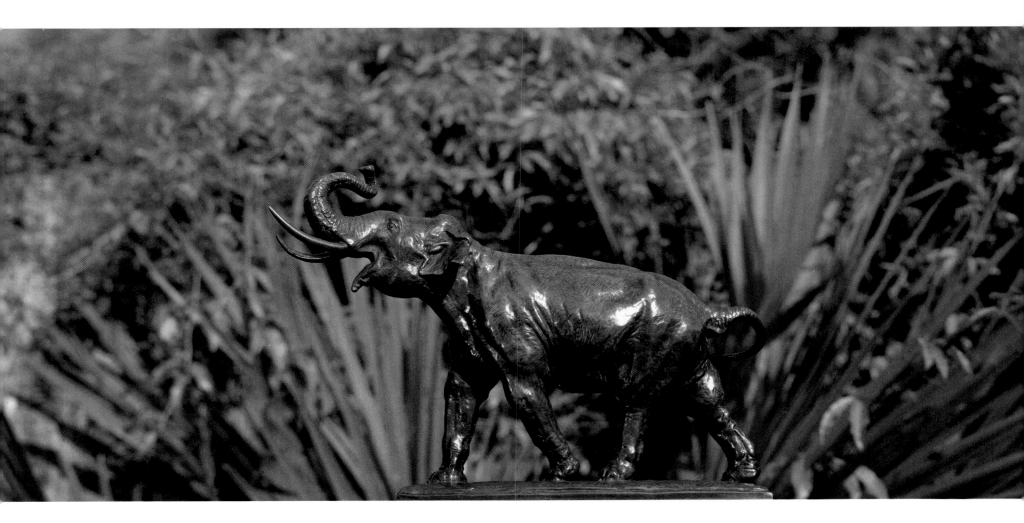

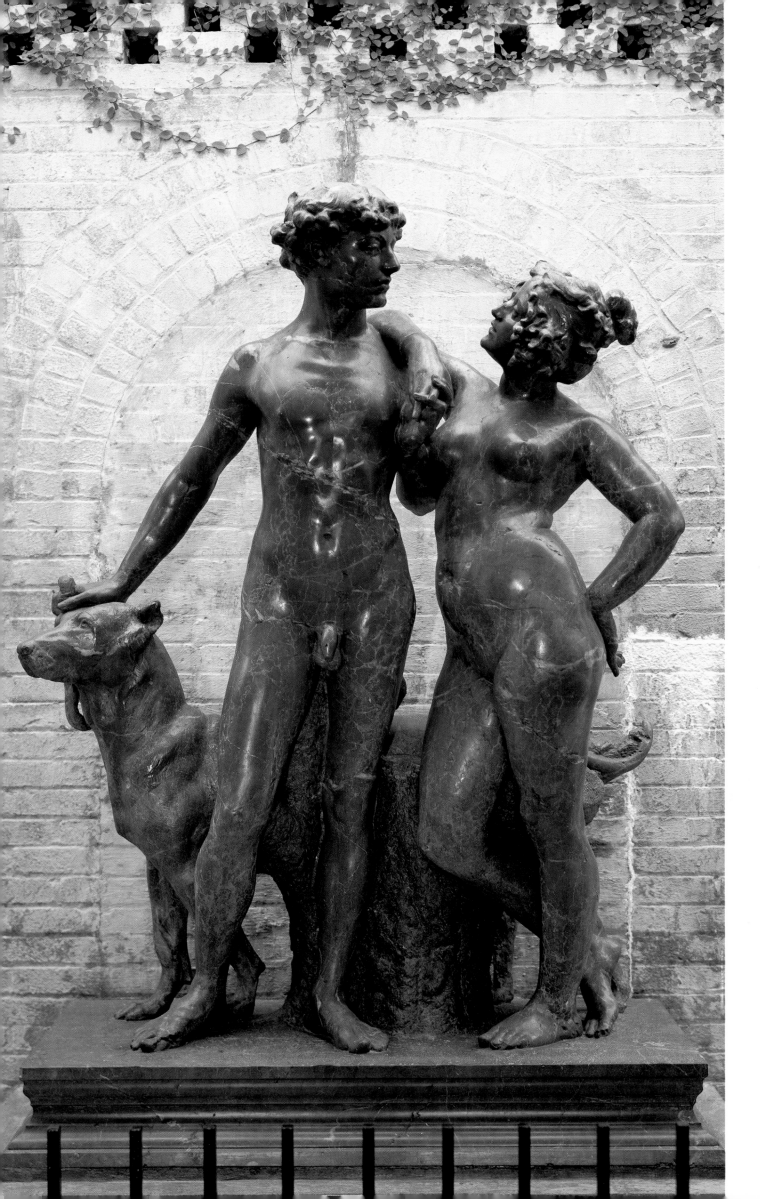

Frederick William MacMonnies
Venus and Adonis, 1895

As the number of professionally trained sculptors increased, greater self-confidence inspired more personal expression. A gay spirit and a light touch were new qualities introduced by Frederick MacMonnies. His style was just right for the many fountain figures that issued from his Paris studio and supplied the great architects of his generation. Occasionally he ran afoul of Victorian prudery, as when his Bacchante was not considered a proper ornament for the Boston Public Library. Of the many monumental works that he produced, two groups of rearing horses at one of the entrances to Prospect Park, Brooklyn, New York, are particularly notable for spontaneity and vigor; small versions are at Brookgreen. Venus and Adonis was exhibited at the Paris Salon in 1898 after it was carved in marble, but its impudent tone was not well received in the United States.

George Grey Barnard *Maidenhood*, 1896

Barnard's originality was in the cosmic ideas that he tried to embody in his powerful sculpture. For a number of years he worked in France quite by himself, at the same time using his trained eye to collect examples of medieval sculpture that eventually became the nucleus of The Cloisters of The Metropolitan Museum of Art in New York. The first works that he showed made a tremendous impression both in Paris and in New York, not only because of their breadth of thought but also the forceful modeling. Groups for the state capitol at Harrisburg, Pennsylvania, gave him a chance to develop universal themes relating to the destiny of man: The Burden Bearers *and* Work and Brotherhood. *He never completed his most ambitious project,* The Rainbow Arch, *a sermon against war, on which he spent the last twenty years of his life.* Maidenhood, *carved in marble in 1896, represents a rare serene moment, the youthful figure admirably observed and exquisitely chiseled.*

Gutzon Borglum *The Mares of Diomedes*, 1904

One of the most active and contentious sculptors of the early twentieth century, Borglum was as facile with his pen as with his modeling tools. He urged American sculptors to develop native talents, although he himself was not untouched by the pervasive influence of Rodin. Architectural ornament and commissions for construction of monuments paved the way to acceptance of a challenge to his skill both in engineering and in carving. One plan was for a memorial to leaders of the Confederacy to be carved on the face of Stone Mountain in Georgia; Borglum stopped work on it after a disagreement with the association in charge. His imagination had, however, been fired by the thought of sculpture of that magnitude, and he undertook to carve gigantic heads of four presidents of the United States on Mount Rushmore in South Dakota, which have become a magnet for tourists. The Mares of Diomedes is a successful attempt to convey the sensation of rapid motion by a group of horses at full gallop. The bronze at Brookgreen is the middle section of the whole group, modeled in Borglum's studio in New York in 1904. It was only later that a title from mythology was bestowed on it.

Hermon Atkins MacNeil *Into the Unknown*, 1912

In the first three decades of the twentieth century there was a tremendous burst of sculptural energy. Public buildings were being erected in Washington and other cities, often in a neoclassic style that called for pediments and sculptured groups. Prominent among the sculptors who produced this kind of work was Hermon A. MacNeil. His early works, done when he had a scholarship to study at Rome, were of American Indian subjects. One of these, The Sun Vow, is in Brookgreen Gardens. When MacNeil returned to the United States, his time was absorbed by the demand for monuments and architectural sculpture. In accordance with prevailing eclectic tastes, he adapted his style to the setting, but even in a neoclassic framework he never failed to introduce sturdy realism and picturesque detail. Into the Unknown, carved in marble, symbolizes the mystery of artistic creation. A design based upon it was chosen as the emblem of the National Sculpture Society.

R. Hinton Perry *Primitive Man and Serpent*, 1899

Both a prolific painter and a sculptor, Perry received his training in Paris. His versatility made it possible for him to undertake such disparate works as the exuberant Neptune Fountain at the Library of Congress, decorations for theaters, and Civil War memorials. Travels in Germany and Norway aroused keen interest in Wagnerian themes as well as in subjects from Norse mythology. One result was Primitive Man and Serpent, which originally was entitled Thor and the Midgard Serpent until it was more generalized to represent male strength overcoming the evil powers in nature.

Adolph Alexander Weinman
Riders of the Dawn, 1945

*Sculptor of monuments, carver of architectural
ornament, and expert in medallic art, Weinman made
use of his special gift for rhythmic movement
and interplay of flowing lines in all these fields.
Although born in Germany he never returned to Europe
to study but developed his skills by working for
sculptors of a slightly older generation, such as
Saint-Gaudens and Daniel Chester French. Many
important buildings were beautified by his additions: in
Washington two pediments, on the National Archives and
Post Office buildings, are his work, and there are
others on the state capitols of Wisconsin and Missouri.
A strong sense of pattern marks the panels and friezes
that were incorporated into other architectural works.
Memorable among the many edifices in New York for
which he designed sculptured ornament are the
Pennsylvania Station and the Morgan Library.*

In the joyous Riders of the Dawn, *the sculptor
combines every element to create the feeling of a great
surge of high spirits and youthful vigor. The powerful
masses, the patterns of muscles on men and horses,
the wind-tossed manes, and the scrolled waves all
contribute to this effect.*

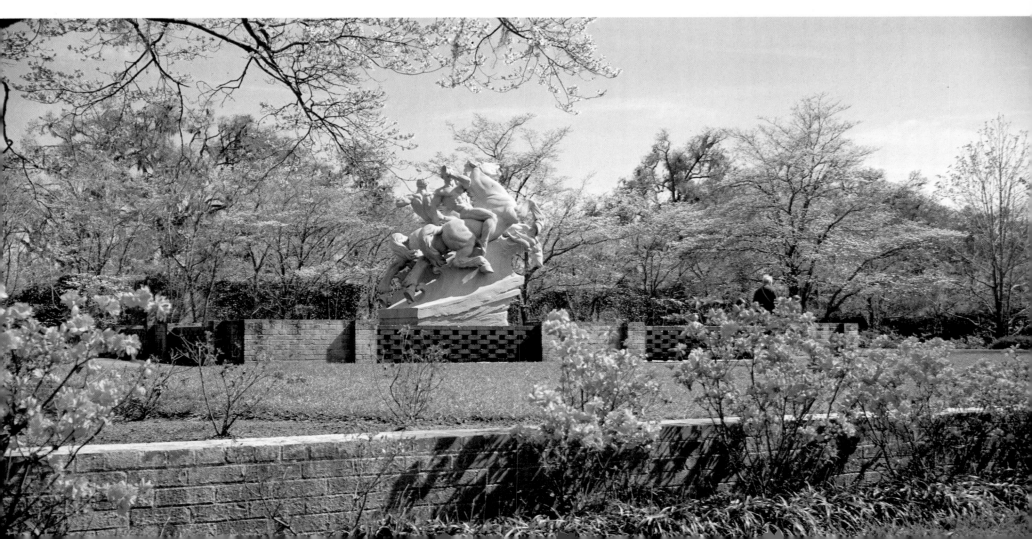

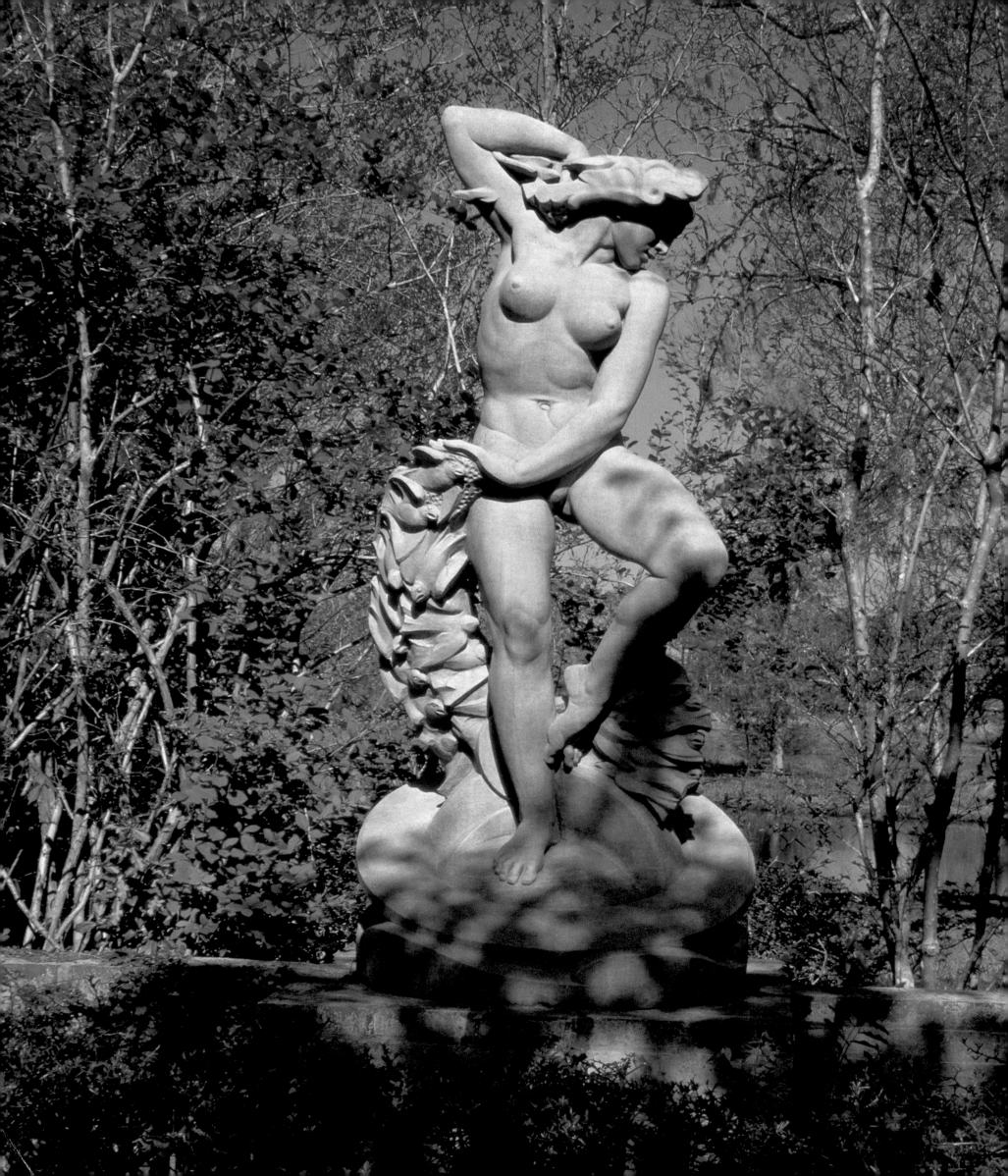

Janet Scudder *Tortoise Fountain*, c. 1908

Working in MacMonnies' Paris studio gave Janet Scudder an introduction to garden sculpture, but it was a trip to Italy and discovery of Donatello's Singing Boys *and Verrocchio's* Boy and Fish *that inspired her to attempt similar themes. After the architect Stanford White bought her first* Frog Fountain, *other Scudder works quickly found places on the estates of wealthy Americans. One of this early group that shows the direct impress of her Italian trip is* Tortoise Fountain. *It is in the merry mood and carried out with the graceful touch and fine detail that are her trademark.*

A. Stirling Calder *Nature's Dance, 1938*

Throughout the early years of the century an increased emphasis on pattern and decoration was apparent. Planes were simplified and forms stylized to achieve beauty of line. Stirling Calder was the middle member of a dynasty, son of a Philadelphia sculptor and father of Alexander Calder. His fertile imagination saw decorative possibilities in natural forms that he accentuated with sharp-edged outlines. A keen dramatic sense gave life to his monuments. Elaborate fountains at Indianapolis and Philadelphia allowed free play to his verve and creative instincts. For the James Deering estate in Miami he shaped a whole island into a boatlike structure, using marine themes. In Nature's Dance *the fluid movements of the woman's body are enhanced by a swinging garland of a flight of birds rising around her feet.*

61

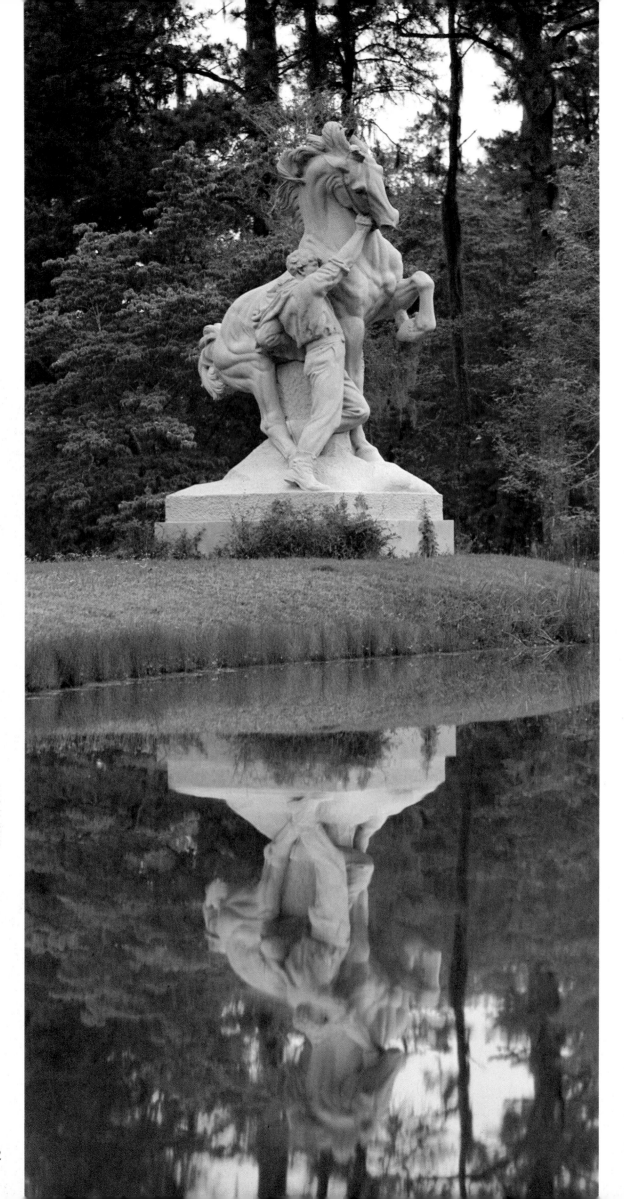

Anna Hyatt Huntington *Youth Taming the Wild*, 1933

Some sculptors began to specialize in animal sculpture toward the end of the nineteenth century, and it soon became a favorite branch of the art. From early childhood, Anna Hyatt was fascinated by horses and came to know their anatomy so well that she could model them from memory. The first sculpture to be carved expressly for Brookgreen was her Youth Taming the Wild. *With the pioneer movement westward still a tangible reality, themes that underscored the conquest of the New World were popular. They usually took the form of a man subduing an animal, as in Mrs. Huntington's group. The same work with a different base was appropriate for a monument to Collis Potter Huntington, near the Newport News Shipyard that he had founded, since he was one of the men who had built the first railroad from the Pacific coast eastward.*

James Earle Fraser *The End of the Trail*, 1915

As an assistant to Saint-Gaudens, Fraser absorbed that sculptor's rare mastery of subtle low relief. In a more robust strain his work was suitable for pediments and massive figures on the new buildings rising in Washington. For portrait statues and monuments, a romantic approach and impressionistic modeling set him apart from the mainstream. His boyhood had been spent in the West, and this background inspired one of the most widely known pieces of American sculpture, The End of the Trail—*''a moving parable of a losing people.'' First conceived as a statuette, it was enlarged and erected in temporary material at the Panama-Pacific Exposition in San Francisco. A large bronze casting was placed in Waupun, Wisconsin, and many reductions were sold.*

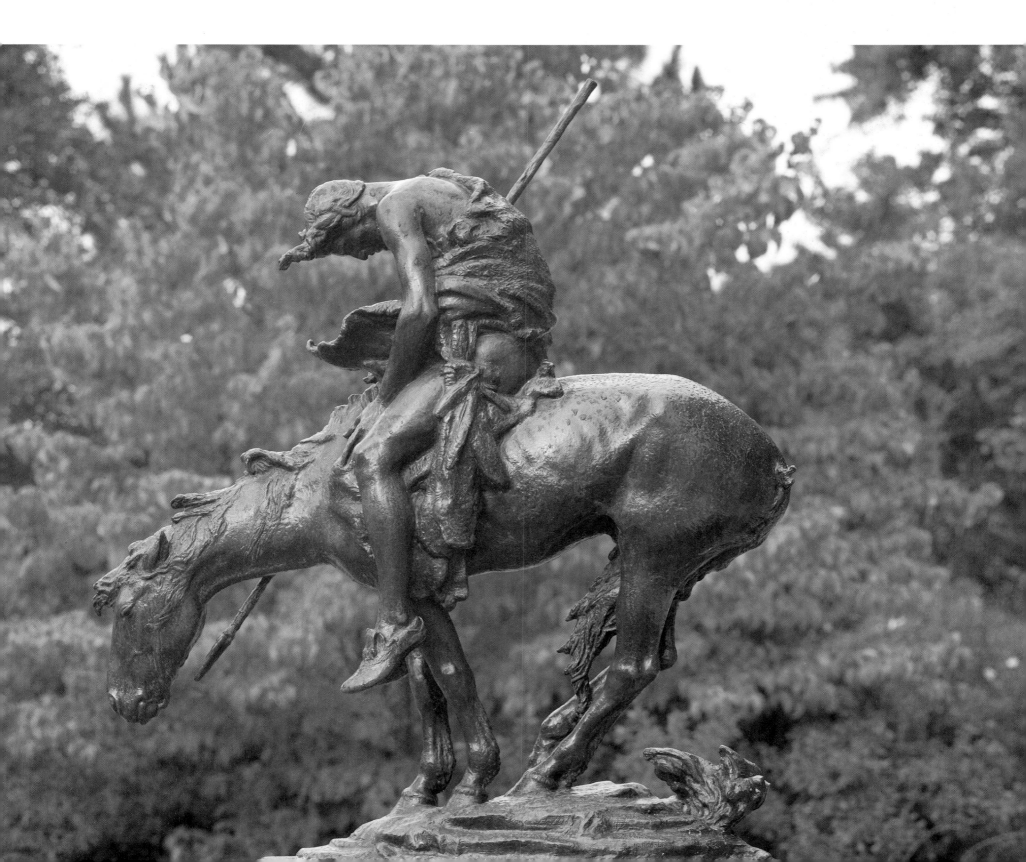

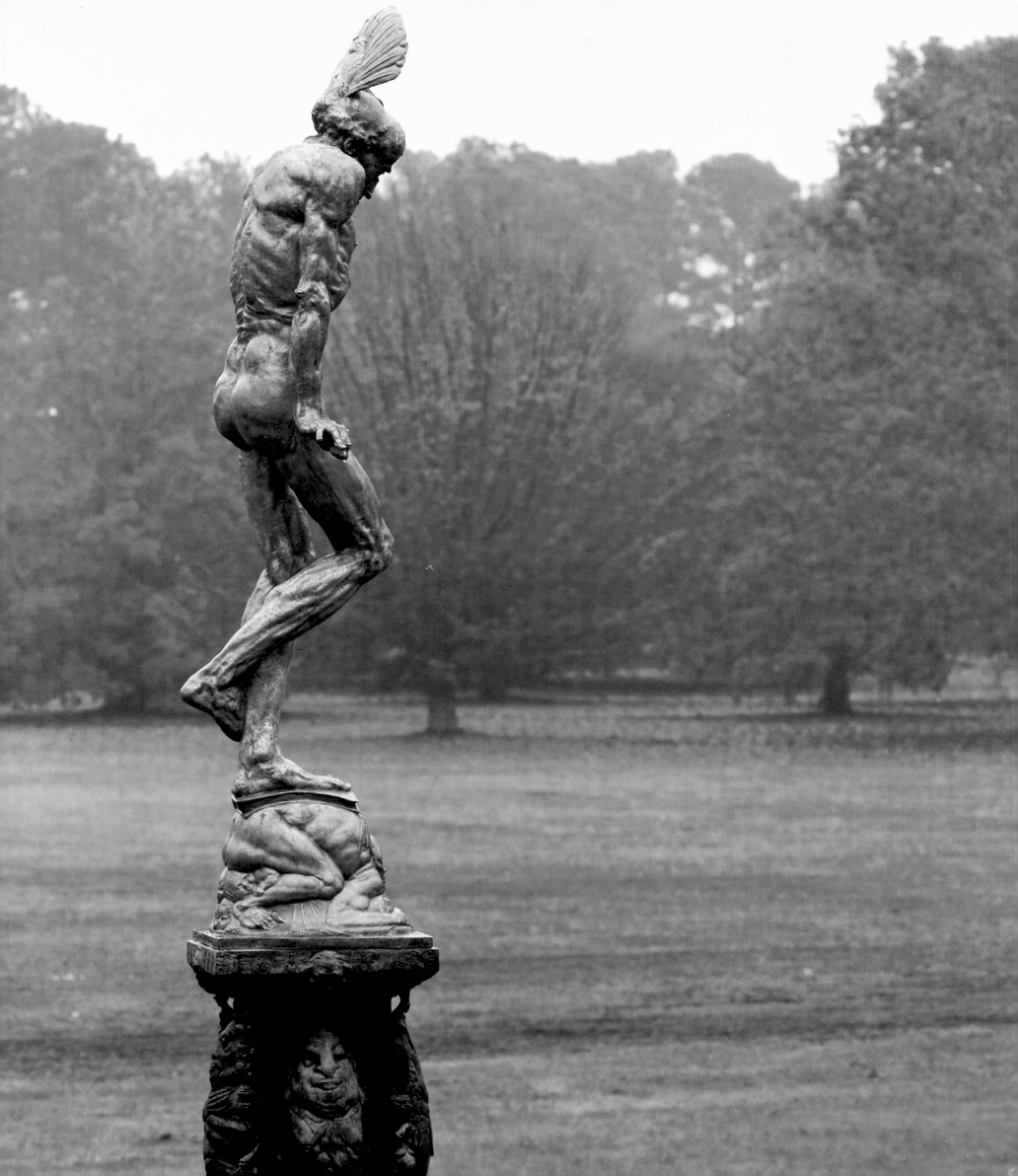

Gertrude Vanderbilt Whitney *Caryatid*, 1913

After her marriage to Harry Payne Whitney, Gertrude Vanderbilt made a serious study of sculptural methods in New York and in Paris. She preferred the Bohemian world of art to that of society leader. Contact with American soldiers during World War I in a hospital that she founded at Juilly, France, supplied a realistic background for a war memorial on Washington Heights, New York. Other monuments and statues came from her New York studio, which became famous as the starting point of a club to encourage young artists and developed into the Whitney Museum of American Art. Caryatid *is a sketch for one of the supports of a fountain originally designed for a hotel in Washington, D.C., but later sent to McGill University, Montreal.*

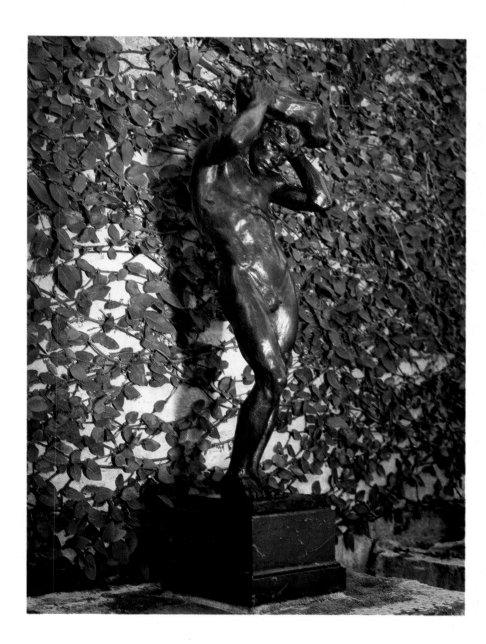

Henry Clews, Jr. *The Thinker*, c. 1914

The son of a wealthy financier, Henry Clews abandoned the business world to devote himself to expressing his very original ideas in art—first painting and then sculpture—in which he was completely self-taught. Both his writings and his art were sharp criticism of the society around him. Disgust with materialism drove him to France, where he felt he could find a more sympathetic atmosphere. In rebuilding a chateau at La Napoule on the Riviera, he carved in the stones strange creatures who satirized all kinds of people. The Thinker *epitomizes his thoughts about humanity, compact with symbolism both in the aluminum statue and on the richly modeled bronze base. Clews' superb modeling has recreated every detail of the wrinkled body and tense muscles of an old man striving to catch an elusive thought. The base is peopled with grotesque creations similar to those at La Napoule depicting the qualities of the civilization that culminated in* The Thinker.

Trygve Hammer *Hawk*, 1920

By the beginning of the twentieth century, a restless search for new ways of understanding and creating sculpture had begun in Europe. It was through European sculptors who settled in the United States that these new ideas infiltrated. Trygve Hammer from Norway was primarily an interior decorator who brought with him a fondness for the intricacies of Norse carving. He preferred wood as a medium but also carved some sculpture in stone. This solid material invited him to adopt Cubist principles and reduce forms to basic geometric shapes. This he did with the Hawk, carved in bluestone but softened by the flowing lines suggesting feathers.

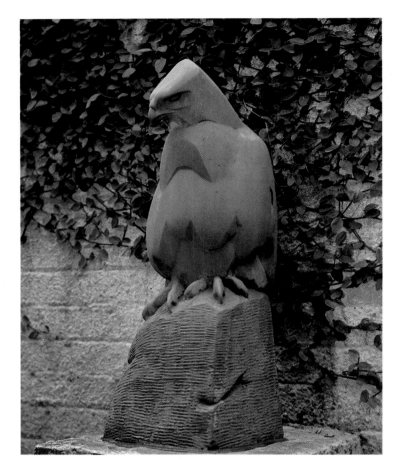

Elie Nadelman *Resting Stag*, c. 1916

Nadelman was drawn from his native Poland to the lively atmosphere of Paris. In the many phases of his own work, he always concentrated on form for form's sake, employing smoothness of contour and elegance of line. Hellenistic art supplied models for a series of marble carvings, and folk art attracted him to such an extent that he made·a collection after he moved to this country. An unexpected sense of humor led him to follow this simplified style for carved wood figurines of contemporary types, from circus performers to society people. Resting Stag is one of a few animal studies in which exquisite subtleties of line may have been learned from Chinese art.

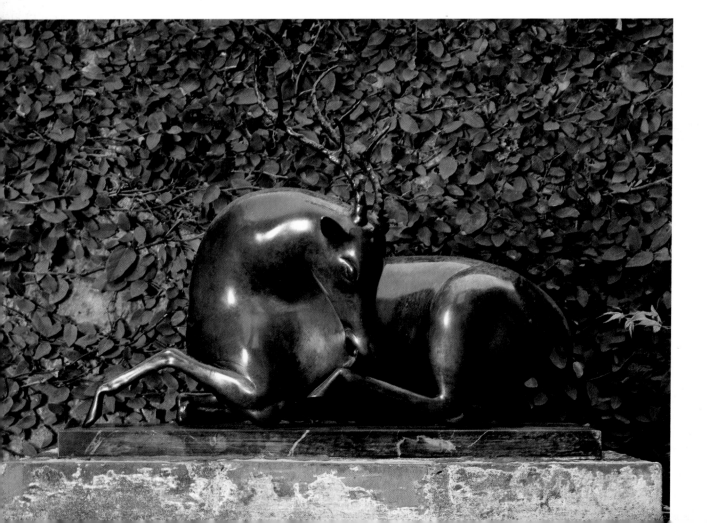

Leo Lentelli *Faun*, 1931 ▷

Lentelli worked in Rome before coming to the United States, and the Panama-Pacific Exposition brought him into the ranks of sculptors employed on architectural and garden ornament. Association with Stirling Calder helped him establish his personal style of long-limbed figures with hair and draperies in loose frills. He stayed for a few years in San Francisco, where he designed the ornament for a theater and two public libraries before returning to New York to continue the same kind of work as well as decorative single figures. In one of these, Faun, copyrighted in 1931, the spontaneity of the pose is maintained by impressionistic modeling. It is one of three examples, the first of which was created for the Boca Raton Club in Florida.

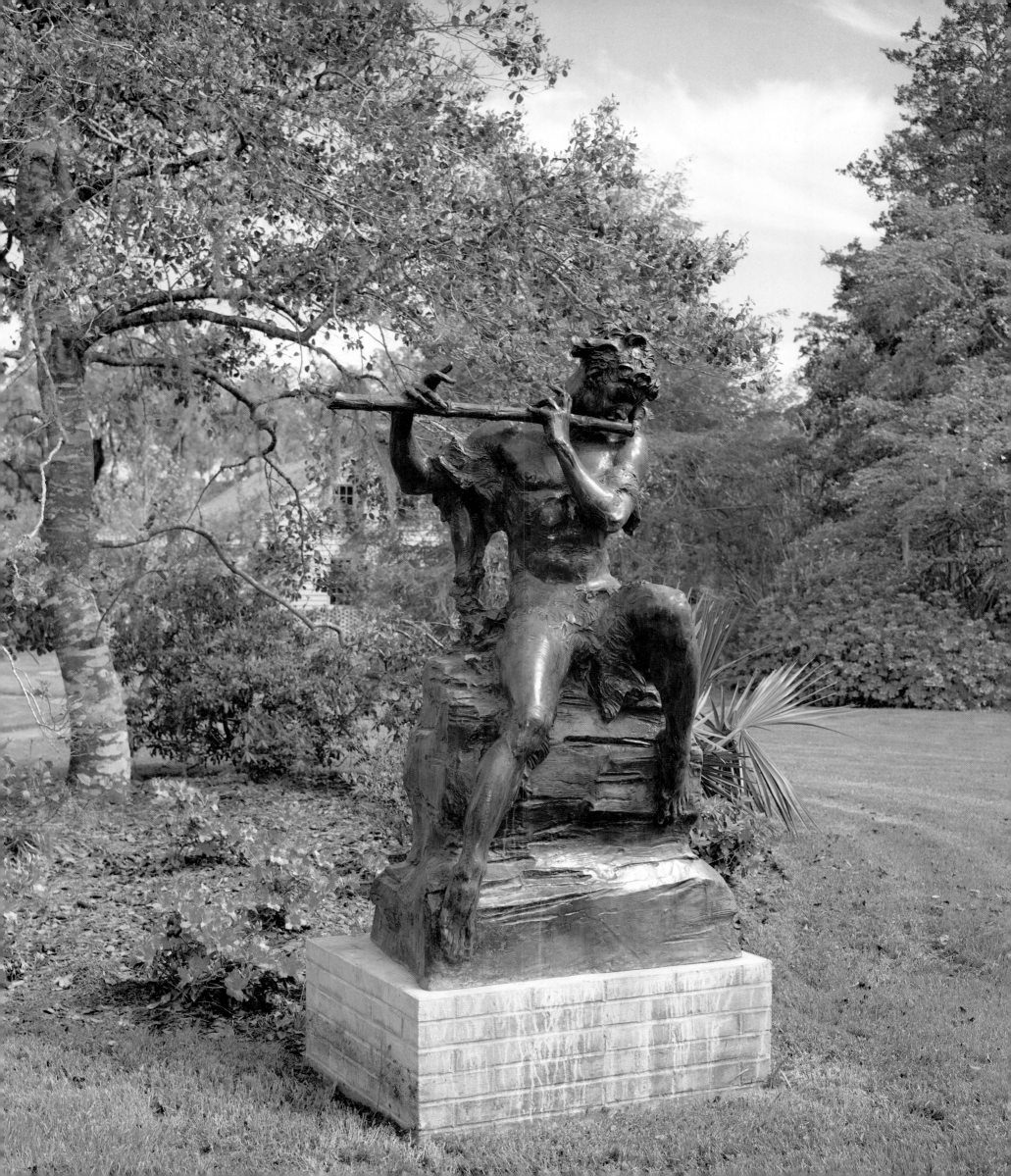

Edward McCartan *Dionysus*, 1936

*The period that McCartan most admired and emulated was an unusual
choice; he felt an affinity with the refined taste of eighteenth-century
France, especially the work of Houdon. A period of study in Paris
familiarized him with the style that he so admired, and back in New
York his interest in perfecting ornamental details brought him commissions
from architects. In his fastidious search for perfection he produced
a limited number of single figures remarkable for their lucid composition
and fluid line. In the gilded bronze Dionysus, classic harmony results
from the fine balance of the pose and the lyric interweaving of curves.
It was enlarged especially for Brookgreen from a small work designed
in 1923.*

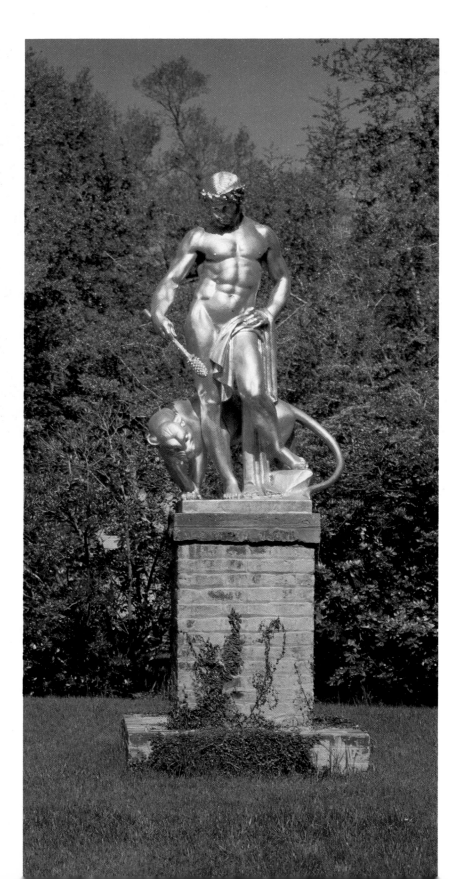 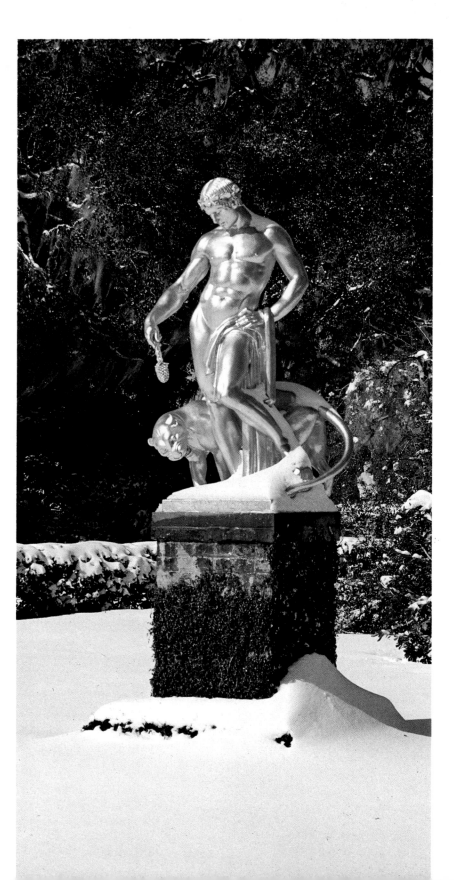

Gaston Lachaise *Swans*, 1931

Early training in craftsmanship supported Lachaise in Paris and when he later came to this country, urged by an American girl who later became his wife. In Boston and then in New York he was employed by other sculptors to execute highly finished ornamental passages. At the same time he was evolving his personal vision of mature beauty: Woman as a cosmic force, a symbol of fertility and power. This unexpected concept of beauty as a female with full torso and large hips buoyantly poised on her toes or actually floating in air only gradually became accepted. Lachaise transferred his skill in decorative sculpture to a few compositions with dolphins and with birds like Brookgreen's Swans, *commissioned for a private garden on Long Island, in which the smooth bodies and curving necks make a graceful pattern.*

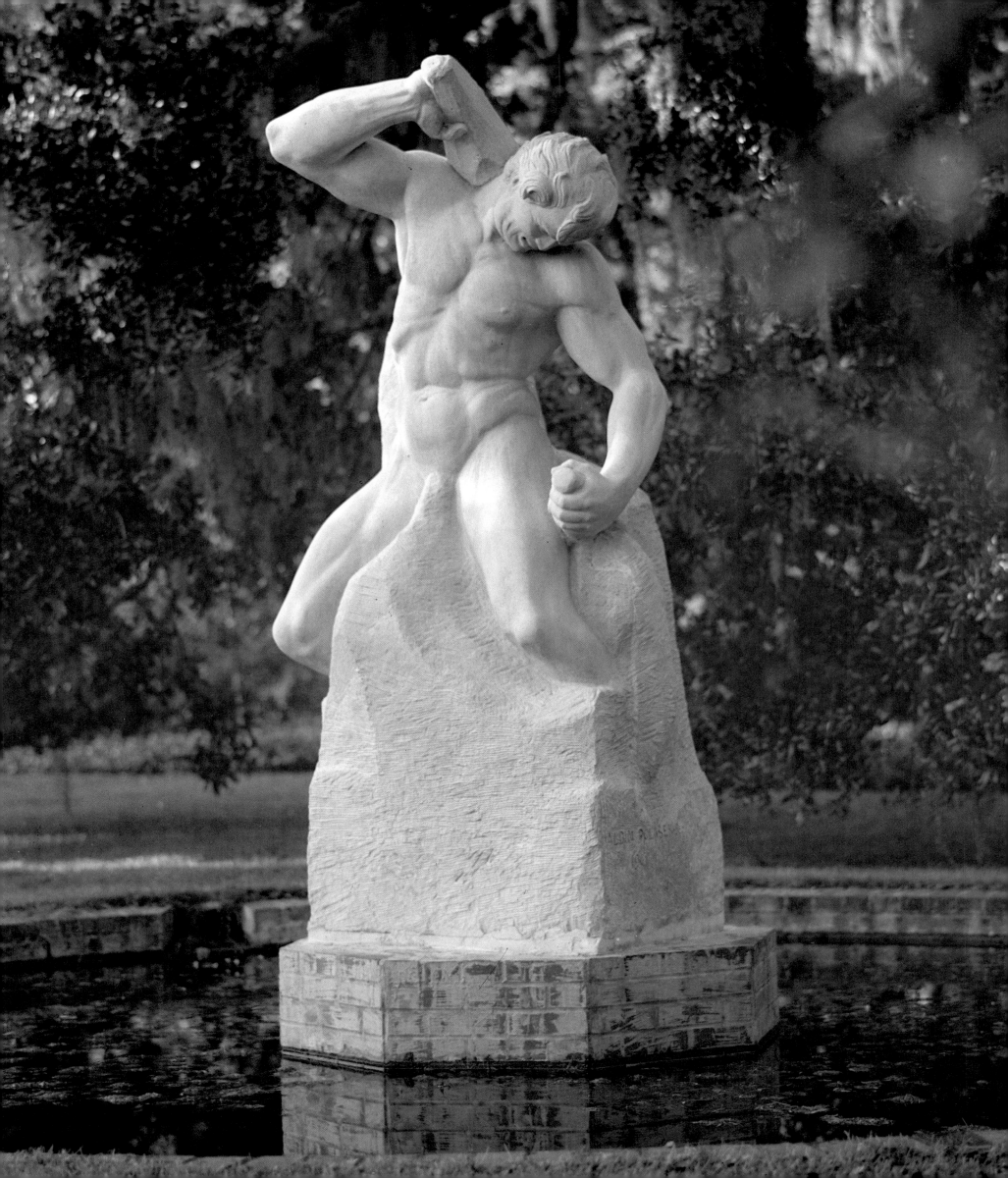

Chester Beach *Sylvan*, 1932

Beach, like many others of his generation, was exposed to the influence of Rodin; however, he was completely individual in his choice of subjects and way of handling them. Beach was born and brought up in San Francisco but he left to study in Paris and returned to settle in New York. Sometimes, he followed Rodin's example in leaving part of the marble unworked to make the sculpture more expressive of vaguely defined sentiments. His impressionistic technique lent itself to impalpable elements such as clouds and water into which he could incorporate vaguely suggested human figures. This style was appropriate for a large Fountain of the Waters *in front of the Cleveland Museum of Art. The carefree mood of* Sylvan *is well conveyed by the play of light over the surface and the sketchily finished accessories.*

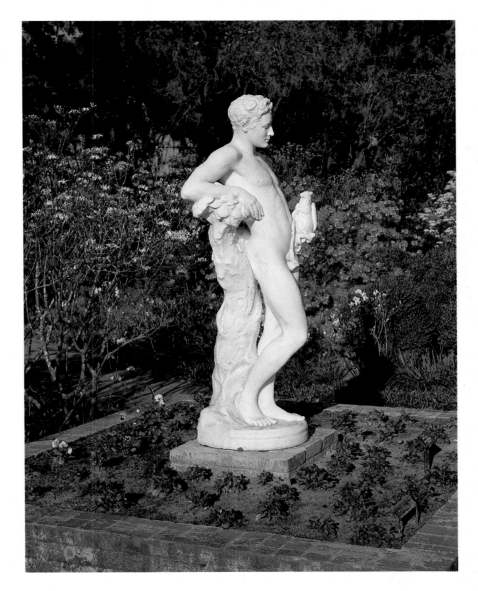

Albin Polášek *Man Carving His Own Destiny*, 1961

Polášek was born in what is now a part of Czechoslovakia and was trained as a woodcarver. When he migrated to the United States his skills were useful to several altar factories in the Midwest before he finally settled in Chicago. Even when he was busy with fanciful statuettes, there was always in the back of his mind an awe for the elemental forces of nature. He never lost touch with his native country and decided to make an image of the Slavonic god of harvest to place on the mountain above his native town. An idea that had haunted him from his student days (typical of his thoughtful approach) was exemplified in Man Carving His Own Destiny, *". . . struggling to hack out his own character, carving his future by the effort of his will." In a later remodeling he made the figure more barbaric. The sculptor presented the plaster model to be carved in limestone for Brookgreen Gardens.*

Bryant Baker *L'Après-Midi d'un Faune*, 1934

Both England and Scotland, because of their stone quarries, nourished families of carvers. Baker was born into such a family and began as an apprentice to his father. Success came with commissions for portrait busts of the royal family. Bryant followed a brother to the United States, where there was an immediate clamor for his facile portraits, always lifelike and dignified and executed with consummate ability. His sculpture has been placed in 40 states and 10 countries. All these commissions left him little time to work out his own creations, but fortunately one of the finest survives. L'Après-Midi d'un Faune was modeled as a small bronze between 1927 and the date it was enlarged and carved in marble by the sculptor himself. Because of the slender proportions and fragile details, the carving was a difficult task.

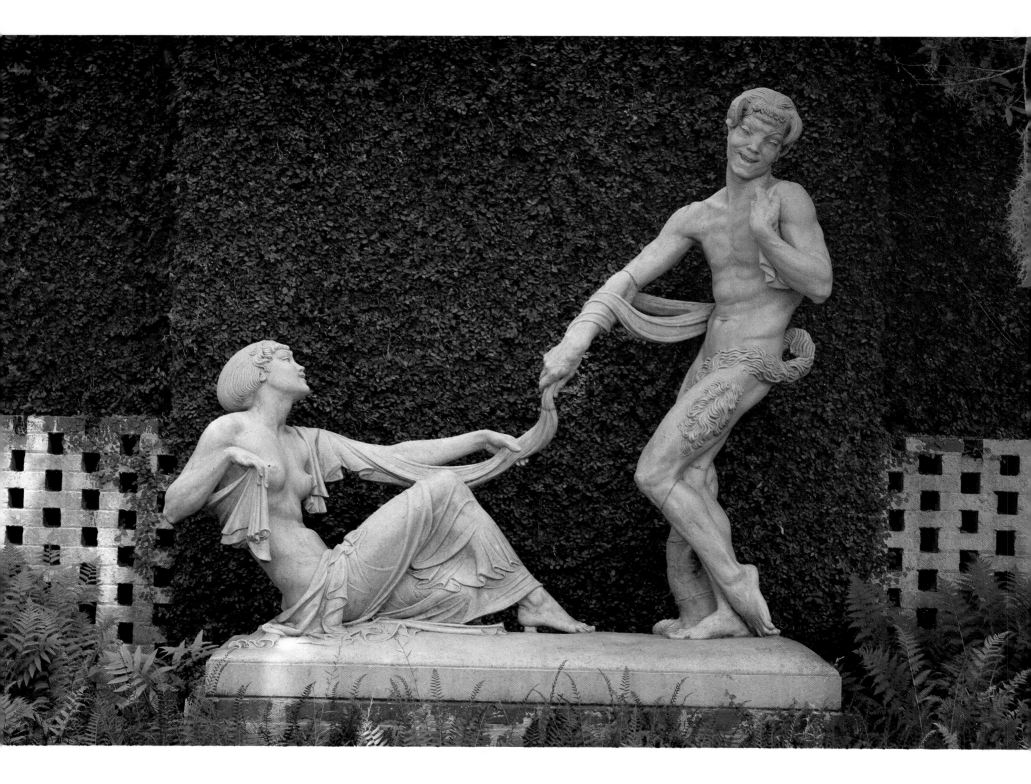

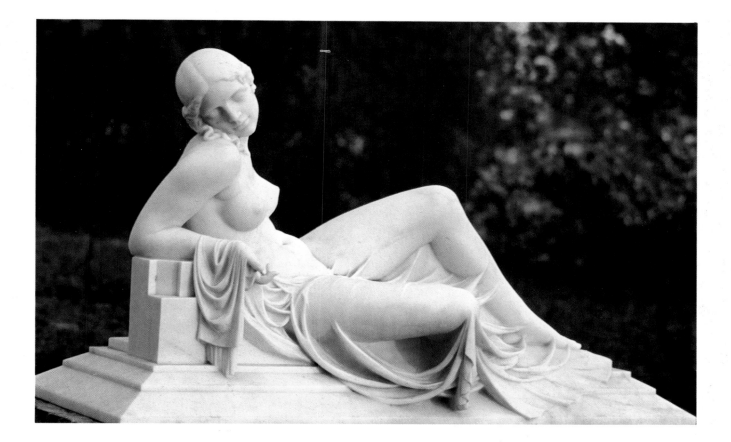

Mario Korbel *Night*, 1933

The neoclassic tradition was carried on in somewhat modified fashion by Mario Korbel. He was born in what is now part of Czechoslovakia, where he began to study sculpture. As his career progressed he alternated residences between the United States and his native country. His figures, popular as garden ornaments, have a quiet presence, and, unlike the hardness of earlier classicizing, their surfaces are softened by slightly veiled outlines, and the modulations of the figures' flesh suggest human warmth. Both this marble version of Night *and another on a Long Island estate were based on a bronze statuette modeled in 1921.*

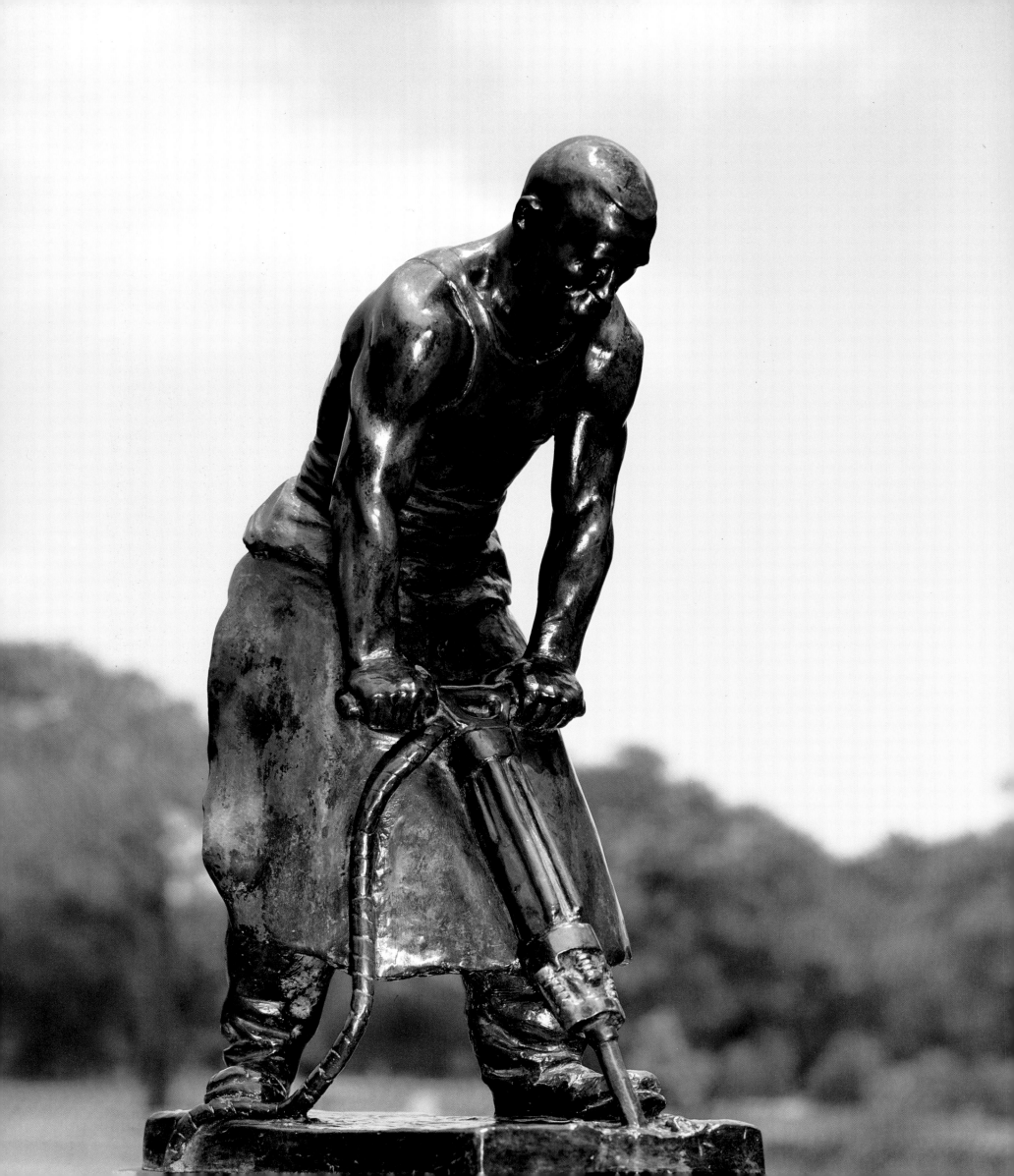

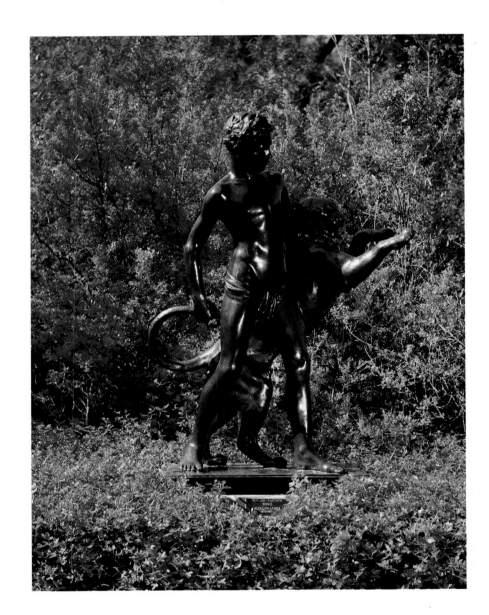

Mahonri Young *The Driller*, c. 1922

Without any inspiration from the surroundings of his Salt Lake City birthplace, Mahonri Young found clay for modeling and showed a talent for drawing. He never limited himself to one medium in his professional life but became equally good in drawing, painting, watercolor, and sculpture. He treasured his memories of the West, revived them by visits later in life, and kept using them as artistic material. All kinds of people interested him—Breton peasants, prizefighters, and workingmen —although he concentrated on the purely sculptural qualities of his subjects. His figures immediately give the essential characteristics of each man and his occupation. The Driller and its companion The Rigger, *modeled in 1922, are both in Brookgreen's Small Sculpture Gallery.*

Rudulph Evans *Boy and Panther*, c. 1919

Although Evans did not leave a large body of work, each piece that he issued, first from his Paris and then from his New York studio, was executed with the greatest care. Dignified portrait busts and statues are idealized representations with little attempt at characterization. The classic norm of moderation was the goal in all his work, of which the most important was a heroic statue for the Thomas Jefferson Memorial in Washington, D.C. His imaginative figures follow the classic tradition of calm poise and serenity. Boy and Panther, *designed for a garden at Scarborough, N. Y., was intended to represent Kipling's "Mowgli." It was awarded a gold medal at the National Academy of Design exhibition in 1919.*

John Gregory *Orpheus*, 1941

Scholarships to the American Academy in Rome were a strong force in maintaining the classic tradition. This background was congenial to Gregory, who absorbed general principles of purity of form without slavish copying. He let the play of his imagination transform even well-known themes from mythology. His architectural projects ranged from scenes from plays for the Folger Shakespeare Library in Washington, D.C., to Oriental figures executed in polychromed terra cotta for a pediment on the Philadelphia Museum of Art. In garden sculpture he demonstrated his striking sense of design and clarity of execution. An earlier version of Orpheus *with only one panther was made in 1918 for the Charles M. Schwab garden at Loretto, Pennsylvania.*

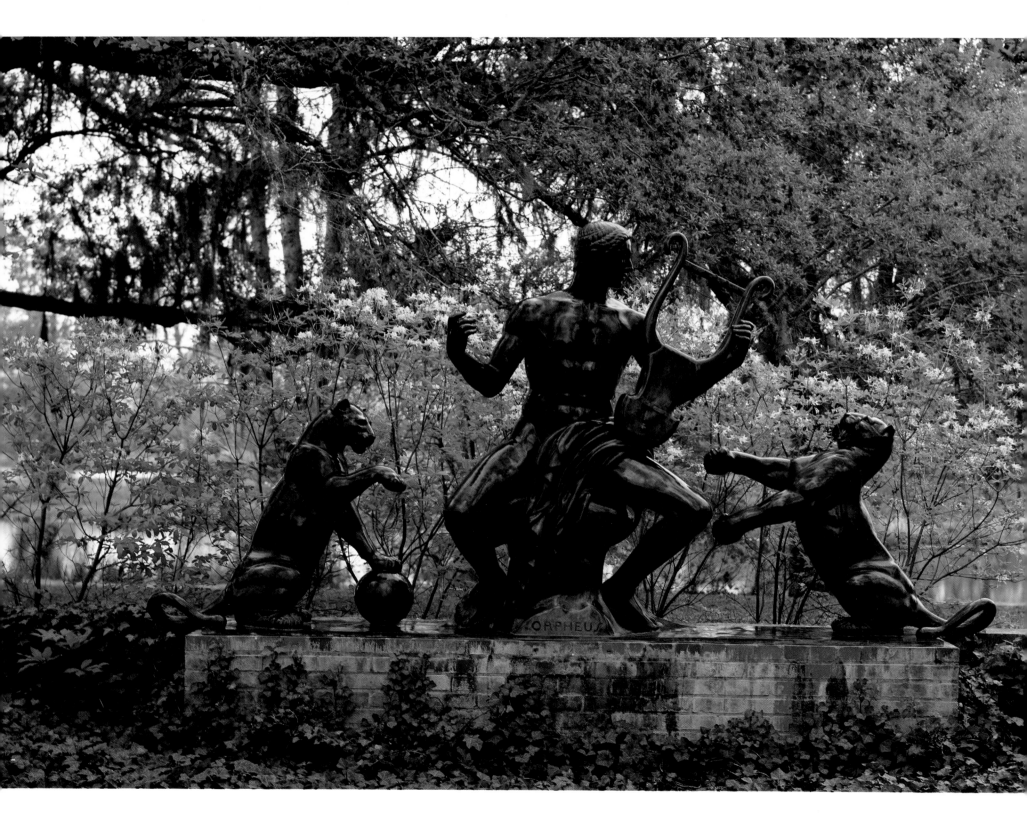

Jo Davidson *My Niece*, 1930

*From a poor neighborhood of New York City, Davidson rose to be
the most famous portrait sculptor of his generation. As a student
in Paris he was attracted to the post-Impressionists but was
brought sharply back to realism by war in 1914. Davidson always
had an instinct for interpreting character, and he thought of
making a sculptural history of World War I by means of a series of
portrait busts. The works were such a success that a list of them
reads like an international ''Who's Who.'' In the midst of constant
travels and sittings by important people he found time to create
a few figure studies fine in their truth and simplicity. One of these
is* My Niece, *also entitled* Aged 10, *made in Paris in 1930.*

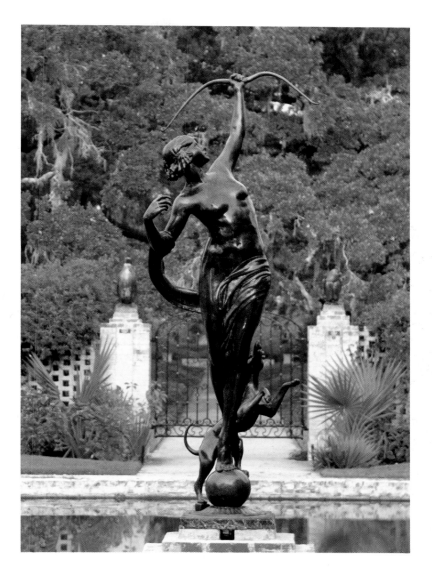

Anna Hyatt Huntington *Diana of the Chase*, 1922

*Although Anna Hyatt never studied in Europe, she rented a studio
at Auvers-sur-Oise to complete some works, including three
different statues of jaguars now at Brookgreen. It was a French
heroine, Joan of Arc, who inspired her first great success, an
equestrian statue erected on Riverside Drive, New York City,
in 1915. The demand for garden sculpture encouraged her to model
a number of such figures. The most famous was* Diana of the Chase,
*which was placed in museums and parks throughout the United
States and also in France, Cuba, and Japan. Immediately after it
was completed, this work received the Saltus Medal for Merit from
the National Academy of Design. After Anna married Archer
Huntington in 1923,* Diana *was placed in one of the niches in the
dining room of their home at 1083 Fifth Avenue, New York City,
in company with Beach's* Sylvan, *before both were moved to
Brookgreen.*

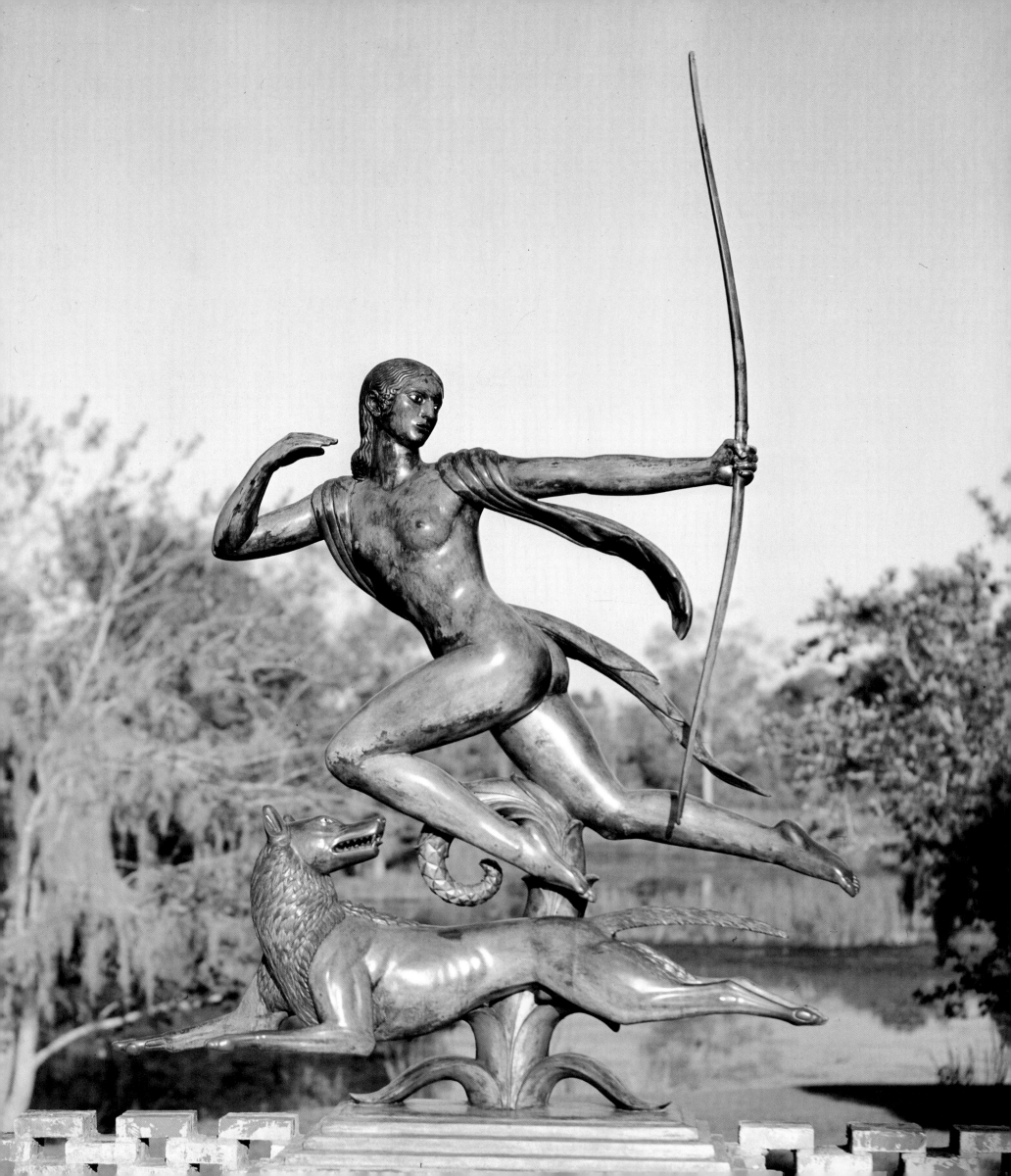

Paul Manship *Diana*, 1924

More than any other artist, Manship determined the character of American sculpture in the second and third decades of the twentieth century. He ventured out on the rising tide of eclecticism, and many of his contemporaries followed. During foreign travels he saw and appreciated archaic Greek and even Far Eastern sculpture, then little known to Americans. He had the ability to extract the essence of other cultures and make them his own, fusing diverse elements by the white heat of his imagination into inventions of freedom and originality. Manship's concept of bodies moving through space, with spare modeling and singing line used in perfect balance and counter-point, make the gilt-bronze Diana *a supreme example of his art. This and its companion* Actaeon *were modeled in heroic size at Rome in 1924.*

Malvina Hoffman *Bali Dancer*, 1932

Malvina Hoffman remained true to the inspiration that came from real life, adding to her sculpture only heightened vitality and emotion from her study with Rodin. Friendship with Pavlova gave her an entrée into the world of dance that resulted in a series of bronzes depicting moments in the Russian ballet. A commission that took five years and required travel in many countries was executed for the Hall of Man in the Field Museum of Natural History, Chicago. There the Races of Man are represented in 105 heads and full-length figures, most of them modeled on the spot from native people. Her fondness for the dance recurred even in this context. Bali Dancer *was done from the dancer Ni Polog in the village of Den Pasar.*

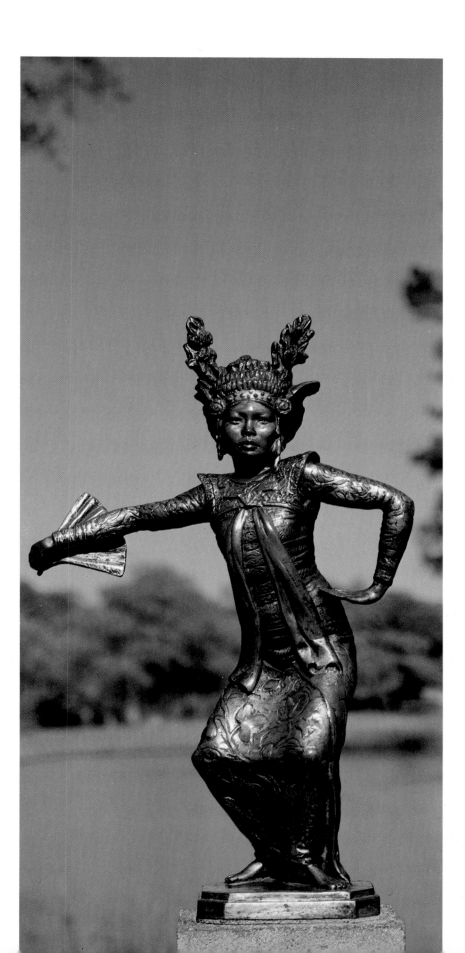

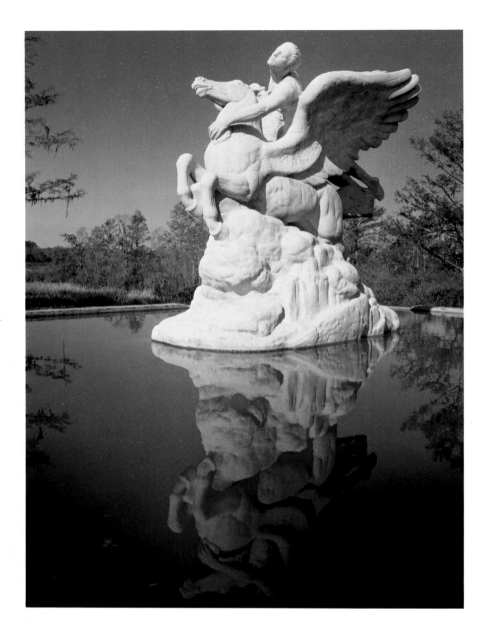

Laura Gardin Fraser *Pegasus*, 1946-1951

A pupil of James Earle Fraser, Laura Gardin married her teacher. Adept in many forms of sculpture she became best known for designing coins and medals, which are notable for fidelity to the subject combined with distinction in composition. She already had sculptured some monuments, such as the equestrian group of Lee and Jackson at Baltimore, when the commission for Pegasus *gave her a chance to execute another major work. She chose a subject symbolic of inspiration and spent five years modeling the huge piece. The granite blocks of which it is composed were set up in the Gardens after they had been roughed out, and the carving was finished in place.*

Beatrice Fenton *Seaweed Fountain*, 1920 ▷

The painter Thomas Eakins encouraged Beatrice Fenton of Philadelphia to become a sculptor, and most of her work has been done for that city. Many of its parks are enlivened by her fountains, in which single realistic figures, anatomically detailed, are softened by touches of sketchily modeled ornament. She delights in the contrast of firm young forms with the delicate intricacy of flower and plant shapes. The original Seaweed Fountain *is in Fairmount Park. Many years later, Fenton's two groups of angel fish swimming through coral reefs were installed in a pool at each side of this fountain.*

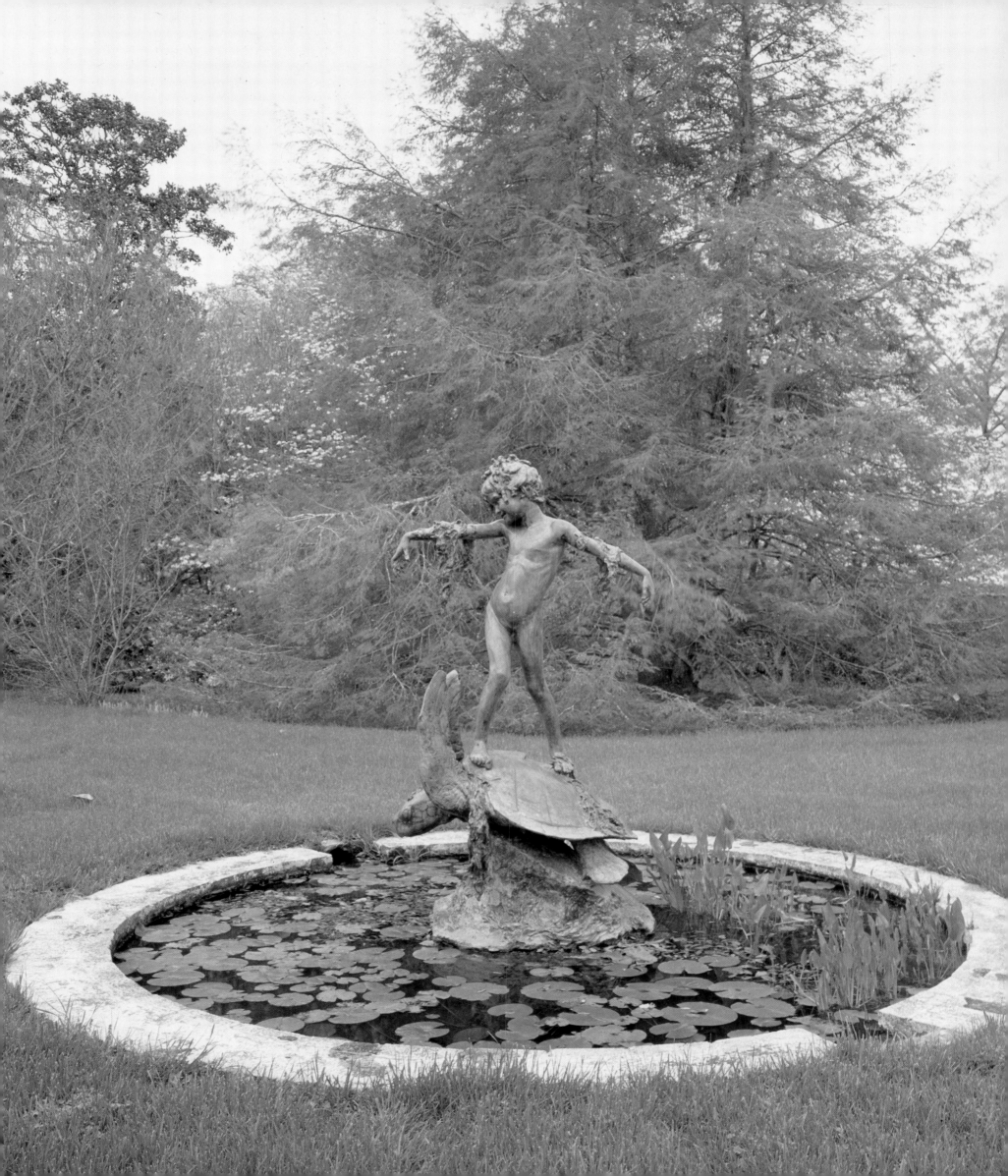

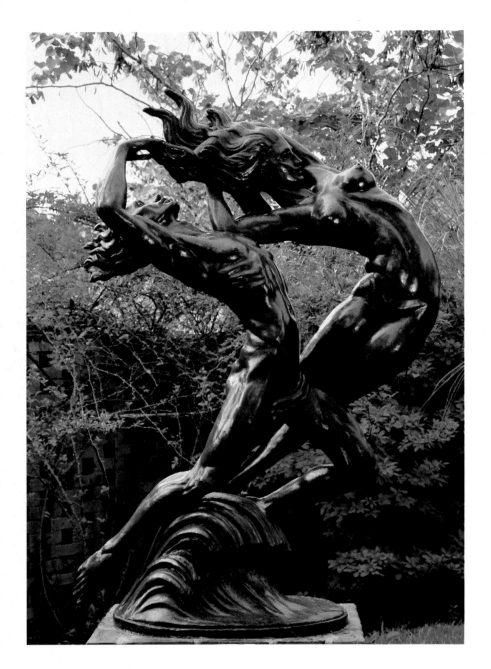

Gleb W. Derujinsky *Ecstasy*, 1954

Derujinsky prepared for his career both in Paris and in his native Russia—from which he had to flee during the Russian Revolution. Eventually he reached New York, where his graceful creations were immediately appreciated. Wood was one of his favorite materials, and it was an excellent vehicle for the religious sculpture he was often asked to do. Derujinsky thought that his love for music and association with musicians might have been somewhat responsible for the rhythmic arrangements and vibrant lines of his sculpture. In late works such as Ecstasy, *his figures became more attenuated, pulled taut by nervous energy. This group was composed with the emphasis on space surrounding figures.*

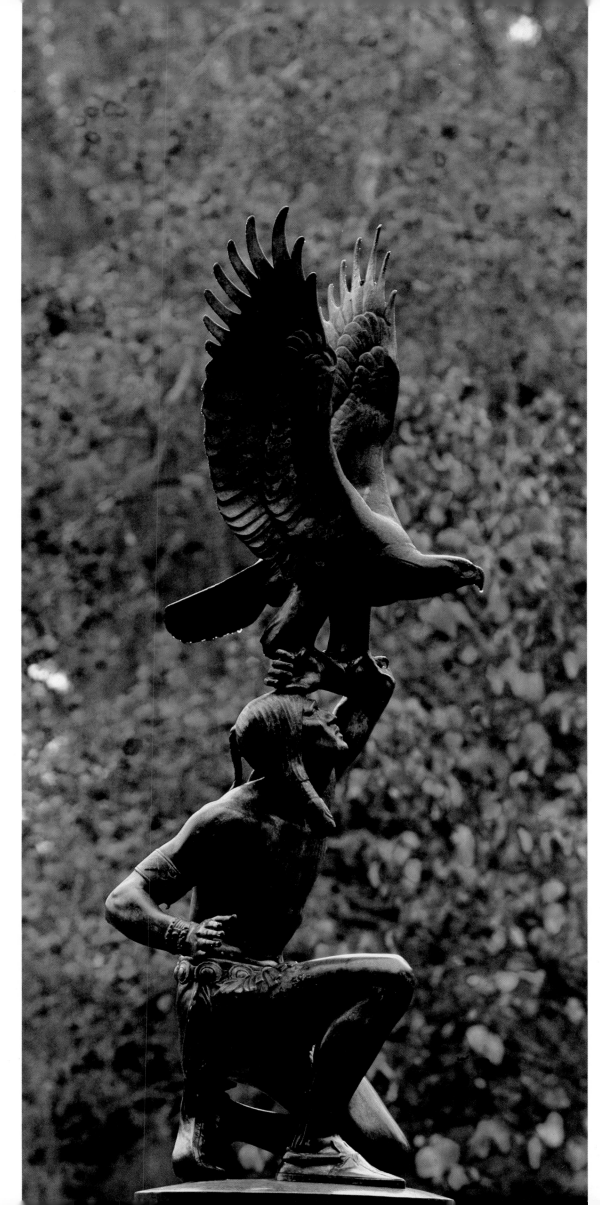

C. Paul Jennewein
Indian and Eagle, 1929

From the time he first came to New York from Germany, Jennewein was steadily employed on architectural carving, to which his pure design and exquisite modeling were well suited. His taste was formed by travel in Europe and study in Rome, where the intimate charm of Hellenistic Greek art fascinated him.
His mind and hands were never idle, creating to delicate perfection the forms that his imagination devised. Many of these delightful statues and statuettes can be seen at Brookgreen. A new departure in architectural sculpture was a pediment for the Philadelphia Museum of Art executed in polychromed terra cotta. Indian and Eagle, erected at Tours, France, was chosen as an appropriate subject for a memorial to American soldiers.

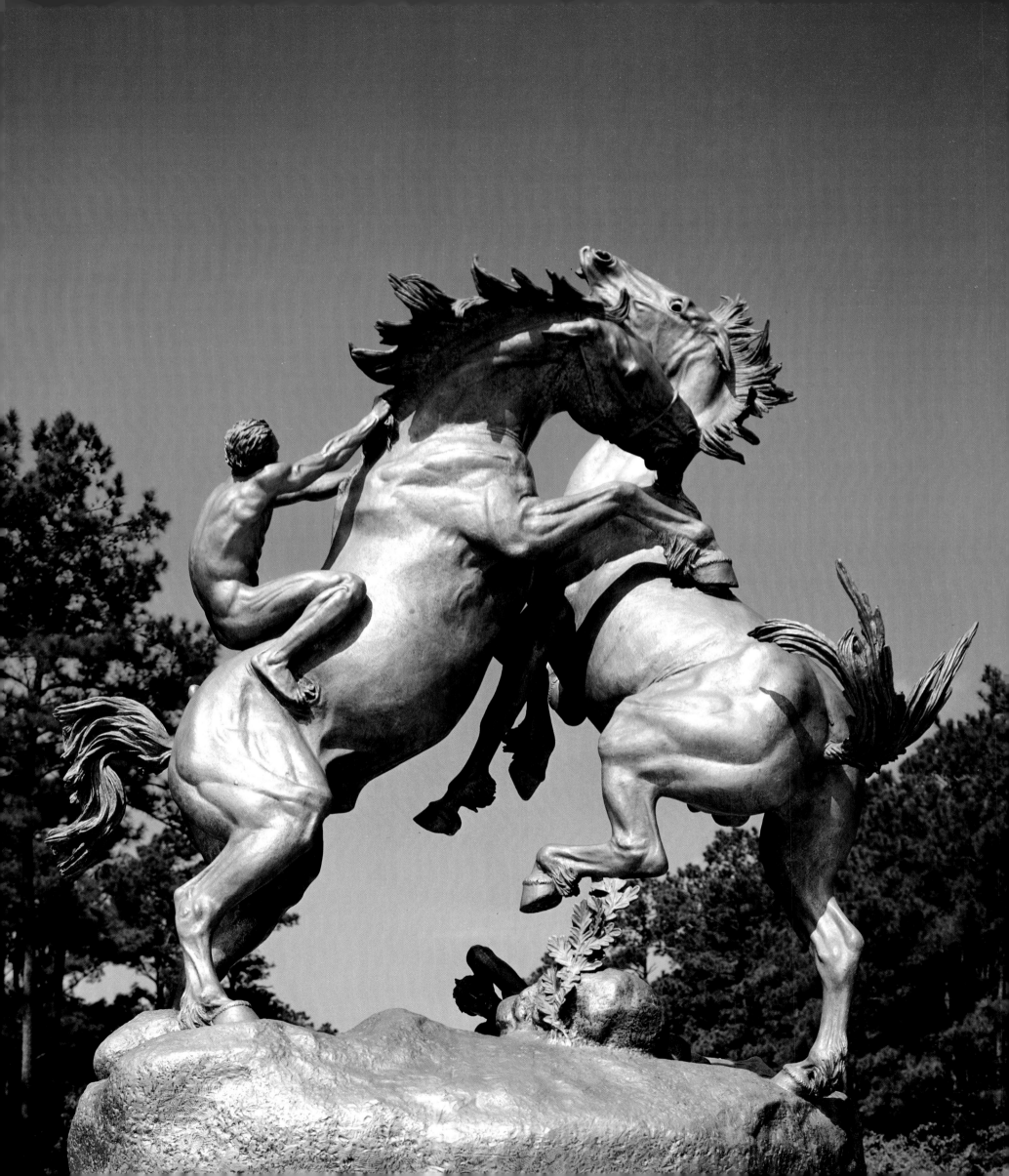

Karl H. Gruppe *Joy*, 1948

*Although he was born in Rochester, New York, Gruppe was brought
up in Holland, where his father, a painter, had settled his
family. When Gruppe was twelve years old, he began his sculpture
studies at the Royal Academy in Antwerp. He gained further
experience as an assistant to other sculptors when the family
returned to the United States. Brought up among older sculptors,
Gruppe had clung to their ideals of fine craftsmanship. Sensitive
to scarcely perceptible variations of surface on the living form,
he has preserved them in refinements of modeling and lightly
suggested texture. This delicate modeling was particularly adaptable
to the tender forms of children and young girls such as* Joy, *first
carved in Serravezza marble at Paris in 1925.*

Anna Hyatt Huntington *Fighting Stallions*, 1950

*During her married years, almost until her death in 1973 at the age of
ninety-seven, Mrs. Huntington was never without a major work
in progress. Because of her love for horses she preferred equestrian
monuments, and often the subject was suggested by her husband's
interests in Spain. The first casting of her heroic equestrian statue of
the medieval warrior El Cid Campeador was presented to Spain
and placed at Sevilla, and* The Torch Bearers *was erected on the
grounds of Madrid University. Much later, an arresting sculpture
was needed at Brookgreen's highway entrance. Mrs. Huntington
created a group featuring her favorite animal, and the lively silhouette
of* Fighting Stallions, *cast in aluminum, is visible from quite a
distance. A design taken from it is the emblem of Brookgreen Gardens.*

Edmond Amateis *Pastoral*, 1924 ▷

Since he was the son of a sculptor, Amateis was born to the profession and could adapt himself to the different styles required of him. As soon as he opened his studio in New York, architectural commissions flooded in, often panels on which he could exercise the low-relief technique studied from the Italian Renaissance. In garden sculpture Amateis kept pace with the times in reducing detail to a minimum, and in later works he preferred to compose in bold masses with strong outlines. Pastoral, *originally called* Mirafiore *and modeled at Rome in 1924, is carved in Tennessee marble with flowing lines and soft modulations of forms.*

Wheeler Williams *Black Panther*, 1933

Williams became familiar with French art of the eighteenth century when he was studying and working in Paris and incorporated something of its fastidious charm into his own sculpture. His ordered compositions and clear-cut outlines were effective in architectural carvings. In fountain and garden pieces the decorative character of his work is quickened to greater warmth by sympathy for human qualities. Williams was attracted by the possibilities of different materials for his highly finished works, and French sculpture influenced his choice of terra cotta for portrait busts. He found white-glazed porcelain suitable for some decorative figures. The pair of panthers at Brookgreen is cast in oxidized silver-plated bronze with green lacquer eyes.

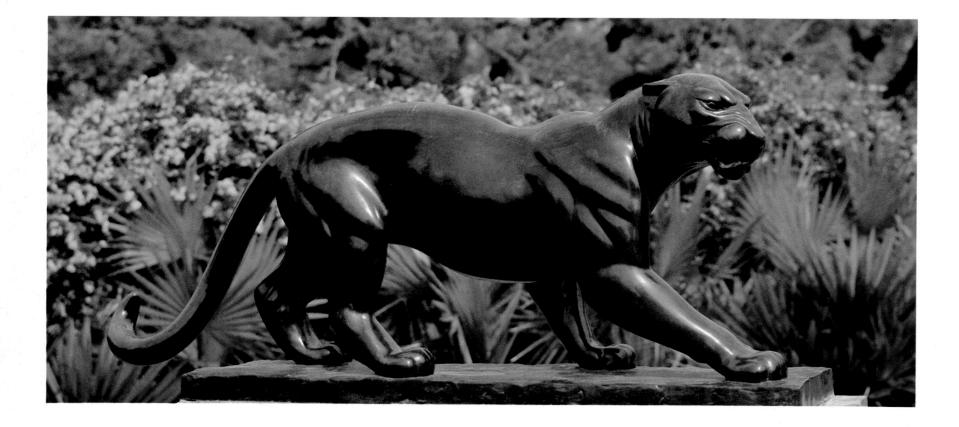

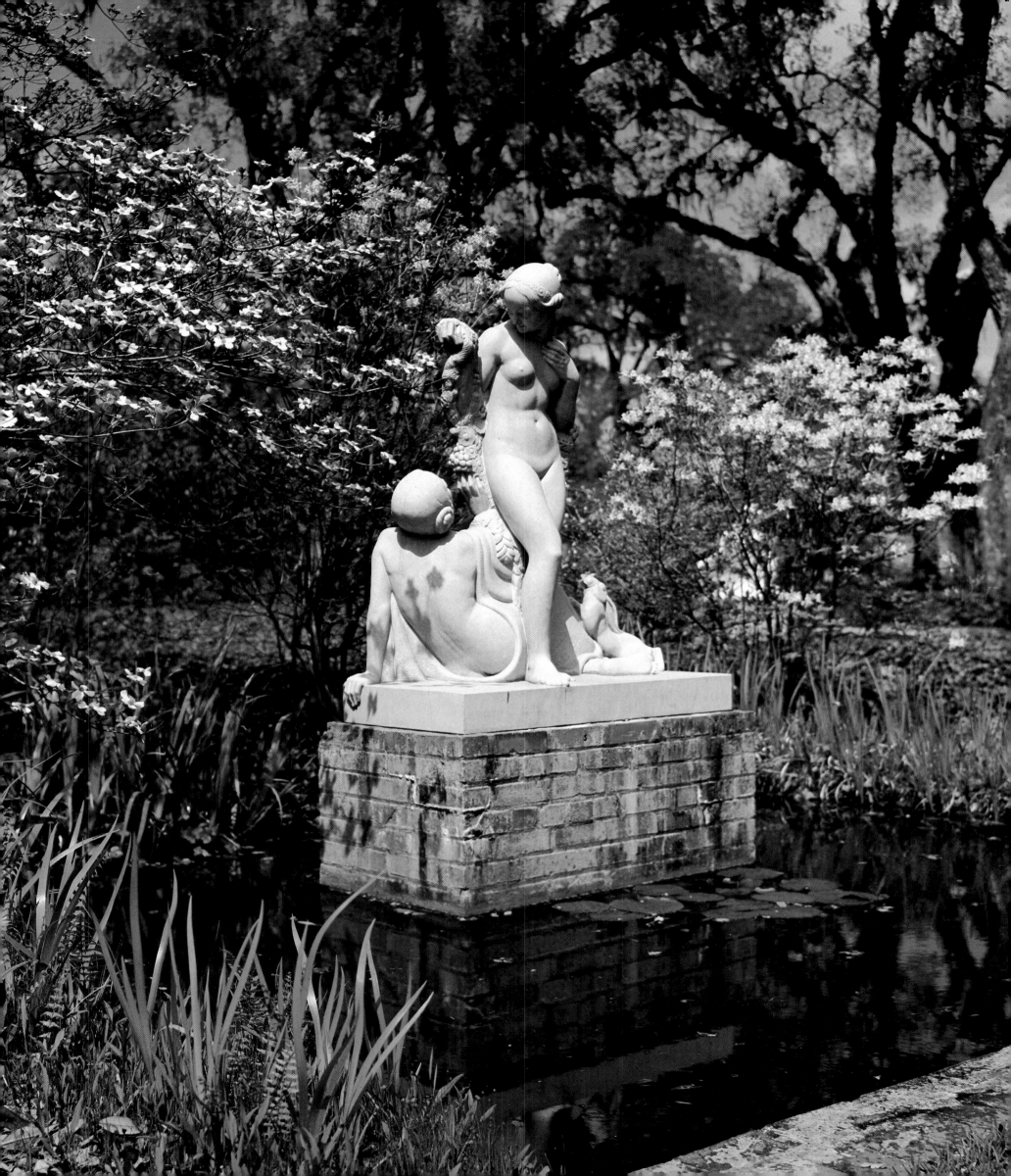

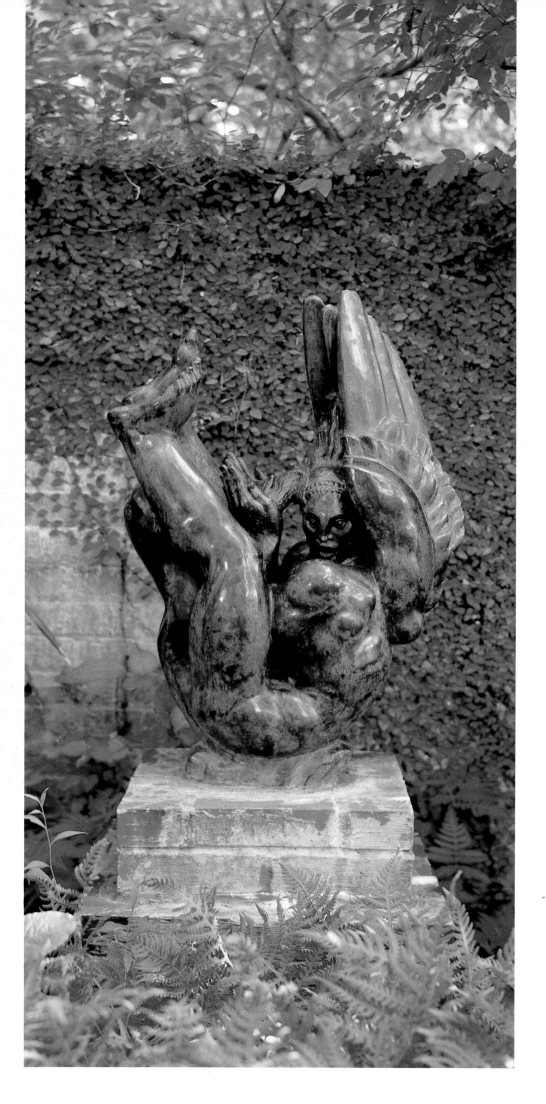

Donald DeLue *Icarus*, 1945

At a time when the demand for monuments and architectural sculpture forced major sculptors to enlarge their studios and hire assistants, many young men learned the sculpture trade that way. DeLue chose this path and worked for sculptors in Boston and Paris. In the evolution of his own idiom he let his style grow naturally within traditional bounds. Strong lines are supplemented by swelling or flowing forms, with an emphasis on musculature that is reminiscent of late Hellenistic sculpture. DeLue strengthened patterns and infused powerful emotions that often seem to propel the figure skyward, as in a war memorial on a Normandy beach. Soon he became a leader among architectural and monumental sculptors, with an extensive list of works to his credit. Icarus demonstrates DeLue's characteristic qualities, used to convey the terror of falling from the sky as well as the pressure of air on a down-rushing body.

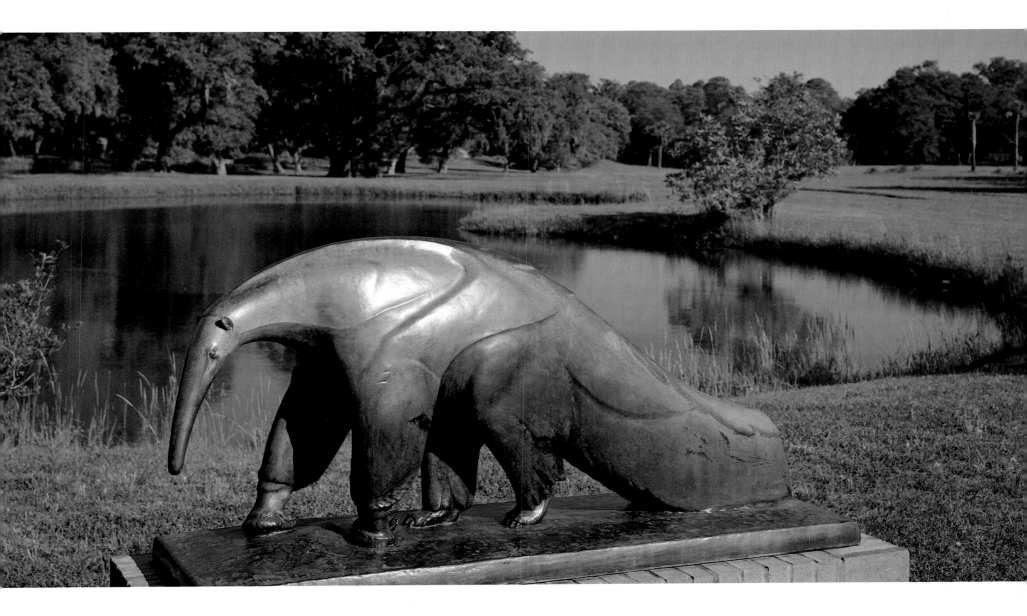

Erwin Springweiler *Great Anteater*, c. 1938

*Born in Germany, the son of a master goldsmith, Springweiler
served an apprenticeship as a worker in metal before turning
to sculpture as a profession. When he came to New York his
ability was put to good use in assisting other sculptors. Animals
seemed to offer him the best possibilities for concentrating on
volume and broad planes, thus reducing detail. A version of
the* Great Anteater *was chosen for placement in front of the
Small Mammal House in the Washington Zoological Gardens
and cast in bronze. Since its exact realism did not please the
sculptor, he later remodeled the figure to utilize its strange
elongated shape and the smooth enveloping coat in an artistic
combination of line and form.*

Joseph Kiselewski *Sea Horse*, 1937

Kiselewski's training under Lee Lawrie made him especially skilled in architectural sculpture and notable for his clear-cut designs and precise detail. This skill was fortified by a few years spent in Paris and in Rome. After he opened a studio in New York he never lacked commissions, many for religious institutions and others for government buildings in Washington, D.C. One of his most deeply felt statues, Peace, the essence of quietness, was done for the American Battle Monument Commission and placed in a cemetery in Holland. Kiselewski was one of the many sculptors who contributed works that beautified the New York World's Fair of 1939. Four copies of the Sea Horse, like the one at Brookgreen, were placed in pools as fountains.

Avard Tennyson Fairbanks *Rain*, 1933

Somewhat like Lorado Taft before him, Fairbanks became an apostle of the art of sculpture in Utah and other Western states. He organized the teaching of sculpture in universities in Oregon and Michigan as well as in his native state. While teaching others he never stopped studying and produced a large number of statues and monuments in the American tradition of noble ideas embodied in realistic human figures. Many themes were drawn from the pioneer movement in which his family had taken part. Rain, one of the decorative figures less common in his works, has a universal idea. In the sculptor's own words, rain "enfolds itself and drops to earth to give growth and beauty to life." Fairbanks' treatment of the figure's headdress, with hair falling like a fringe of raindrops, suggests the interest in pattern that caused the term "Art Deco" to be applied to the artistic style of the second and third decades of this century.

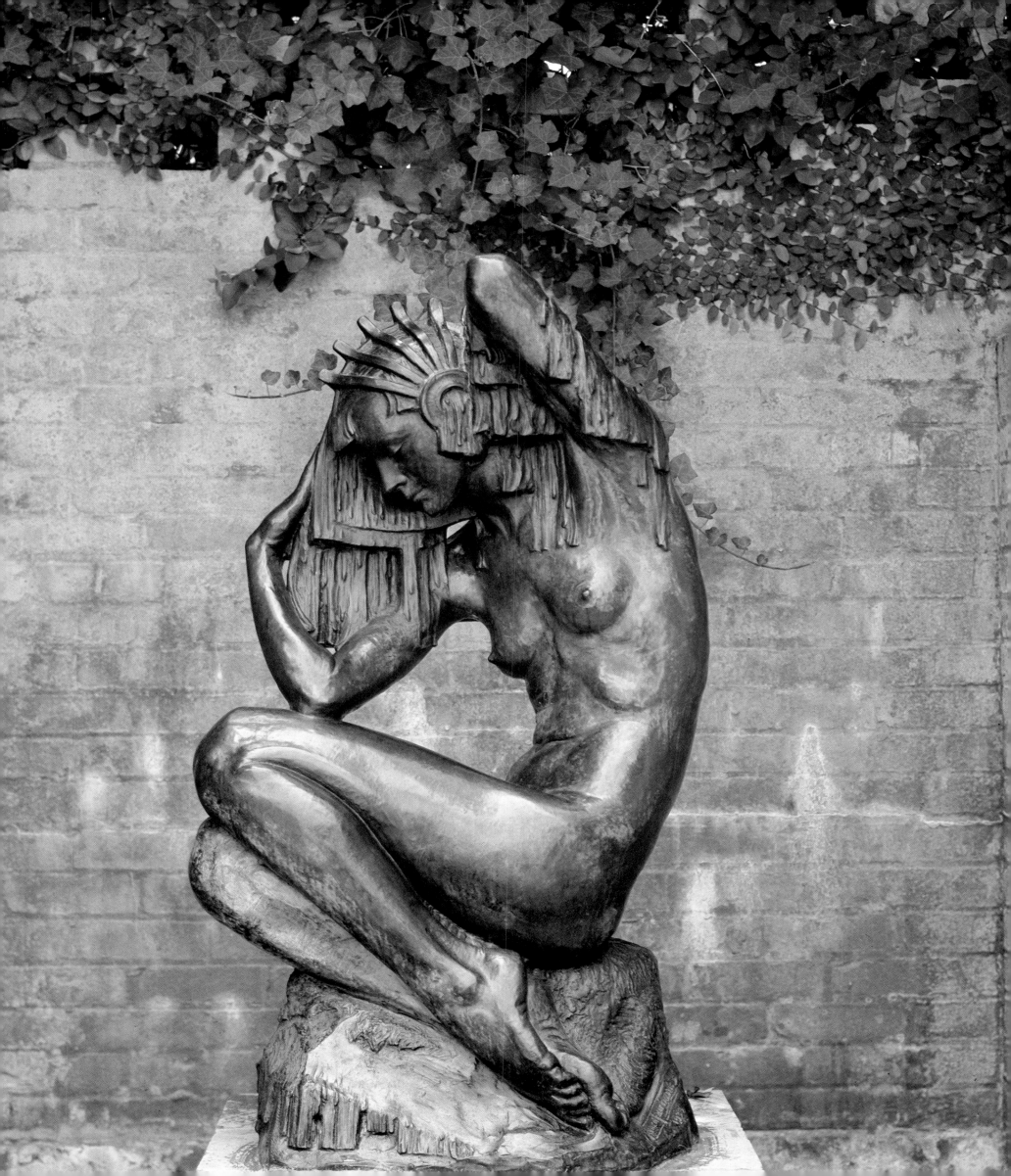

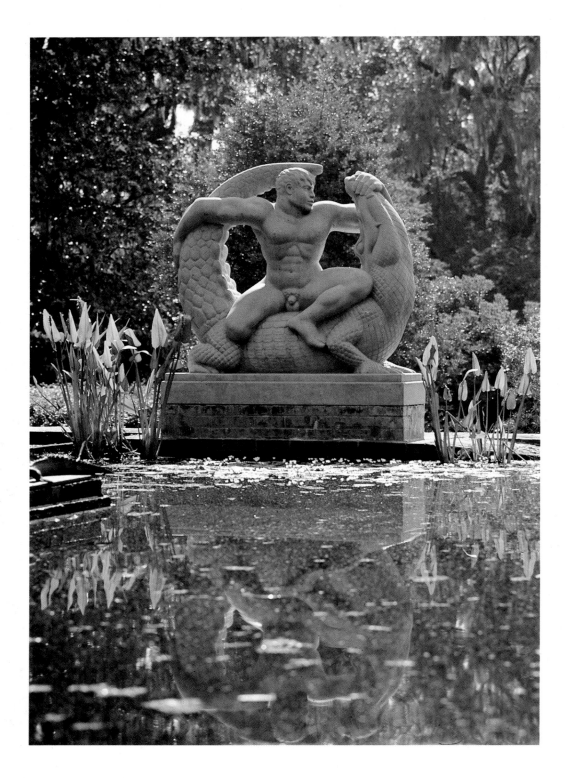

Nathaniel Choate *Alligator Bender, 1937*

*Choate began his art education at Harvard. After trying painting
and mural decoration, he decided that he liked sculpture best.
The first works that he exhibited, chiefly cut in marble and
stone, resulted from a trip to Morocco and the Sudan. Keeping
the surfaces very simple, he depended on the arrangement of
forms and on silhouette for effect. Later, Choate founded the
Aldham Kilns and devoted most of his efforts to designing for
ceramics—until the kilns were destroyed by fire. The muscular
form and strong silhouette of* Alligator Bender *are typical of
Choate's originality of design. He first carved a small group
in mahogany. Then he took the half-size model of a revised
version to Querceta, near Carrara, Italy, and carved it in marble.*

George Frederick Holschuh *The Whip*, 1936

*Holschuh was born in Germany and studied there after he had
completed courses at The Pennsylvania Academy of the Fine Arts.
He has done architectural sculpture for schools in Philadelphia
and for the Finance Building in Harrisburg, Pennsylvania.
Holschuh taught at Cedar Crest College in Allentown,
Pennsylvania, and at Florida State University in Tallahassee.*
The Whip *was exhibited at the National Academy of Design,
New York, in 1937. The arc and thrust of the whip stretched
between extended hands is echoed in the lines of the kneeling figure.*

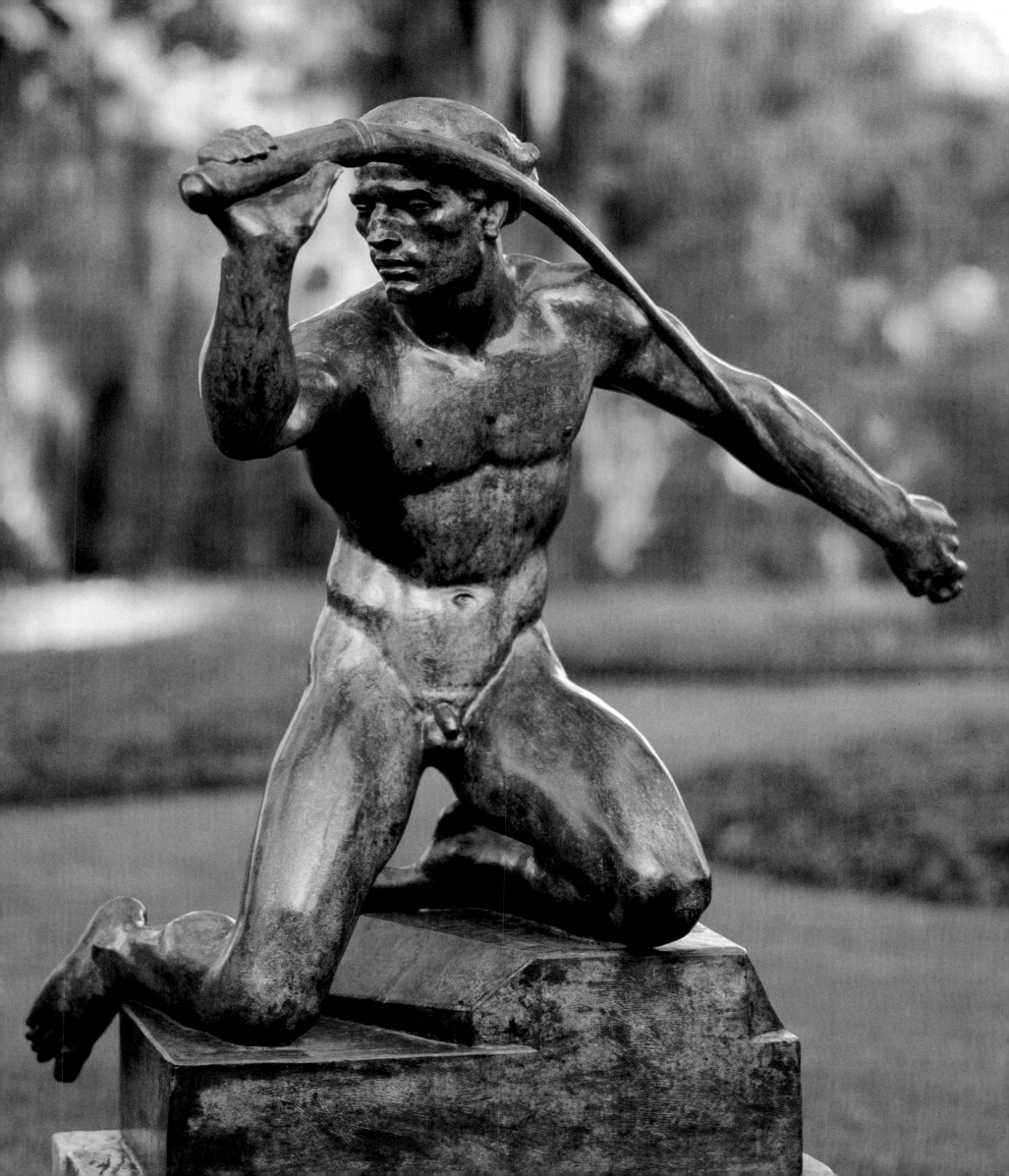

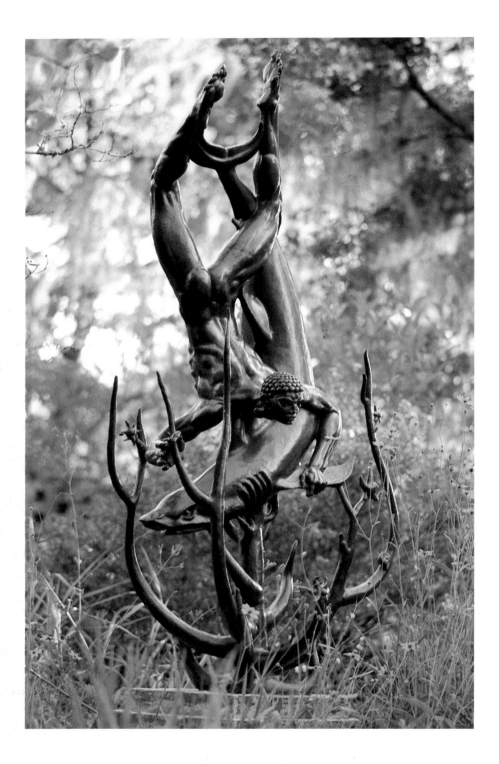

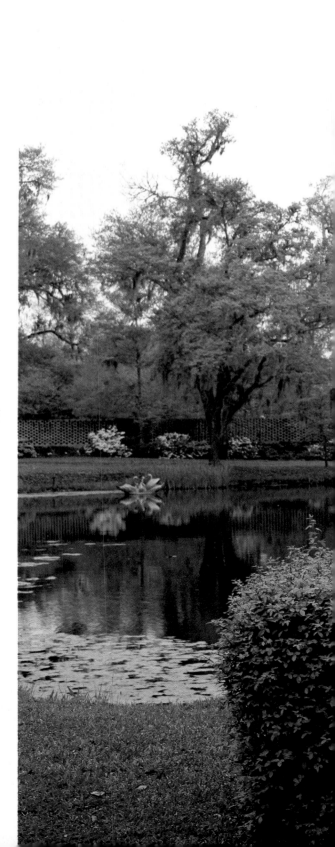

Frank Eliscu *Shark Diver*, c. 1955

In contrast to the solid shapes that stone carvers traditionally prefer, Eliscu has been attracted to the inexhaustible possibilities of lean forms in action. He perfected an improved technique of lost-wax bronze casting that enabled him to launch his figures in air on tenuous supports, creating striking linear patterns. The muscular forms, in spite of their small scale, are solidly constructed. Another technique, which he developed for mural decorations, was low relief carved in gray or deep red tones of slate with incised outlines and shallow modeling. In Shark Diver *the sculptor has captured the freedom and fluidity of living forms suspended in sea water.*

Albert W. Wein *Phryne Before the Judges*, 1952

After Wein's scholarship years at the American Academy in Rome, the impact on him of classical art, especially that of archaic Greek, made itself felt in his sculpture through powerful forms and insistent rhythms. When he began to exhibit in New York, his originality attracted attention. Later he moved to the West Coast, where much of his sculpture was done for synagogues. One of Wein's major productions was the largest granite bas-relief in America, placed on the Treaty Tower of Libby Dam in Montana. The unusual mythological story of Phryne caught his fancy in Greece, and he made a sketch model at Rome in 1948. Wein chose the moment when the courtesan, being brought before the judges for trial, won a favorable verdict through the display of her beautiful form.

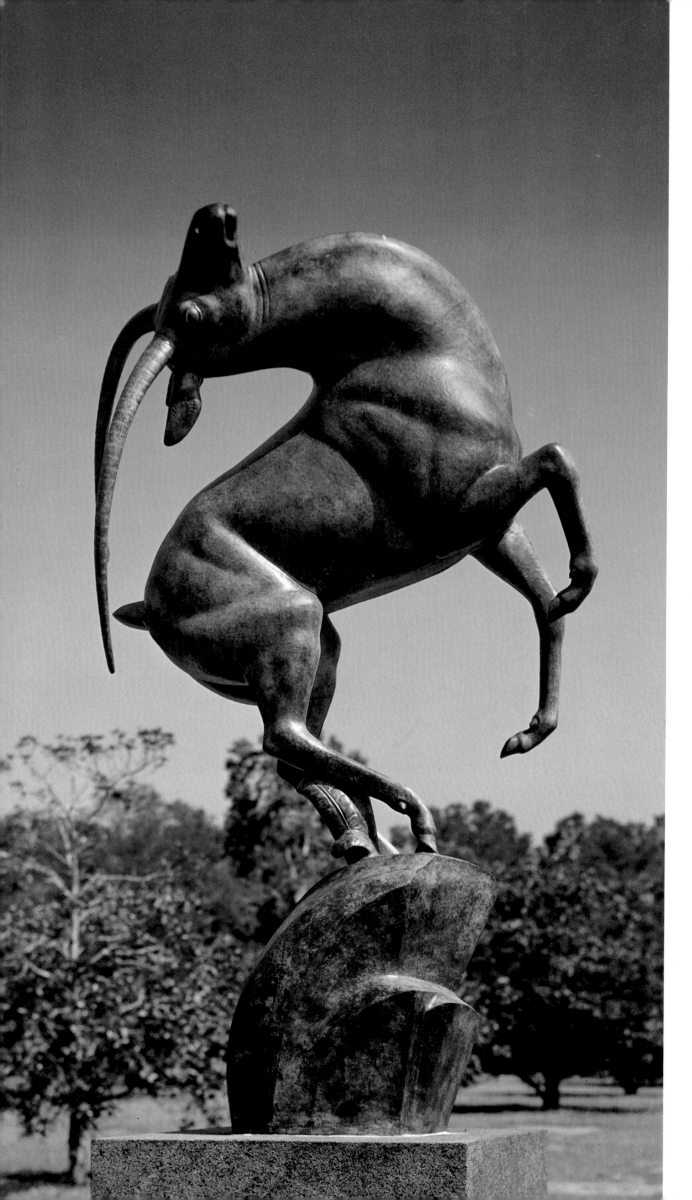

Marshall M. Fredericks *Gazelle*, 1972

Studies at Paris and Munich and with Carl Milles at Stockholm prepared Marshall Fredericks for the leading role that he has played in American sculpture. As early as the Baboon Fountain *for the New York World's Fair of 1939, the light-hearted spirit and distinctive design of his fountains attracted wide attention and won innumerable awards. Orders from educational and other public institutions were carried out in his studios near the Cranbrook Academy of Art in Michigan, where he taught for a number of years. His works vary in mood from the impressive Cleveland War Memorial Fountain to the amusing* Saints and Sinners *for Oakland University, Rochester, Michigan. The* Gazelle *at Brookgreen is shown turning in a quick movement called "wheeling." It was first used for the Barbour Memorial Fountain at Detroit.*

The Development of Brookgreen Gardens

By Gurdon L. Tarbox, Jr.

The Purchase ON JANUARY 24, 1930, Archer Milton Huntington bought from the F.M.C. Corporation Hunting Club what were described in a real estate brochure as "Four Colonial Estates on the Waccamaw." This promotional brochure emphasized the value of the estates as a hunting and fishing reserve, and it illustrated and described the "winter" home on the Brookgreen Plantation site and the "summer home" on the beach. The sale price for the 6,635 acres involved was $225,000.00. Mr. Huntington was a good friend of Dr. Isaac Emerson of nearby Arcadia Plantation and had made his first visit to low-country South Carolina aboard Dr. Emerson's yacht *Queen Anne*. Upon their arrival in Georgetown, arrangements were made with garage owner J. P. Parrish to furnish a car and driver for the Huntingtons, an association which proved to be of long duration.

Archer Huntington bought this property because of its value for wildlife, its old gardens, and its favorable climate. He and his wife, Anna Hyatt Huntington, both great lovers of nature, must have been enticed by the land's potential for enhancement and decided to become involved with its future.

Written records, photographs, and conversations with people familiar with Brookgreen at the time of its purchase present a fascinating picture of the land and its inhabitants. The property, extending from the beach along the Atlantic Ocean, through the salt marshes, across the forested swamps and dry sandy ridges of the Waccamaw Neck, to the freshwater tidal swamps of the Waccamaw River, and onto Sandy Island, was interlaced on the uplands with a network of sandy trails followed by turpentine collectors. Inholdings and rural homes belonging to descendants of slaves were scattered across much of the property. Wildfires swept through the forest almost every winter, creating, except in the bays and branches, an open pine forest supporting a ground vegetation of grasses and herbaceous forbs. Cattle and hogs grazed

free-range in the area, and, throughout much of the year, hunting of all forms of wildlife provided food for the local residents. Moonshining was not uncommon even as late as 1960.

Transportation to Georgetown, Conway, and the plantations in between was by boat on the Waccamaw River, for the roads to Georgetown and Myrtle Beach were not paved and land travel was difficult and unreliable. There were four main routes along Waccamaw Neck: River Road, the route closest to the river; Kings Highway, established under the reign of George II, which generally followed the dry sandy ridge near the middle of Waccamaw Neck and often became impassable during dry weather; Savannah Road, which, passable in dry weather but impassable during the wet season, had developed as an alternate route to Kings Highway, detouring the sandy ridges and skirting adjacent ponds, bays, and savannahs; and S.C. Route 49, a sandy road close to the ocean that was later realigned and upgraded to become U.S. 17, the Ocean Highway. The four roads described were not separate throughout their entire lengths on Waccamaw Neck, for Kings Highway and Savannah Road were rather close and frequently ran together. There were no bridges on these roads between Waccamaw Neck and Georgetown, but the ferry boats *Cornwallis* and *Pelican* left opposite sides of the Bay each hour and crossed the combined waters of the Black, PeeDee, and Waccamaw rivers. In summer, the hot, rough ride on the unpaved roads of Waccamaw Neck was relieved by the pleasant, cool crossing on the ferry.

Although the real estate brochure indicated that the homes on the property had all conveniences, it failed to note that electricity was not available and that telephone service was limited to a private line between both homes and Conway. This line fell into disrepair and it was not until 1954 that regular telephone service was brought to the property.

Farming on the uplands included corn, cotton, peanuts, watermelons, peavine hay, and sugar cane. In addition, the Lachicotte family grew peppers to produce their widely distributed "Hot Southern Sauce" and "Yan Kee Sauce," which, according to the label, was suitable "for roast meats, steaks, chops, eggs, soups, stews, fish, oysters, crabs, shrimp, game, gravies and all kinds of dressings for salads." They also operated a large clam and oyster canning facility adjacent to the salt marshes of Murrells Inlet.

In the freshwater tidal swamps on both sides of the Waccamaw River, rice was still being produced in 1930 as it had been for the previous century and a half. Fields, created from the swamp forest and surrounding land by the use of dikes and trunk docks to control water levels, were plowed with oxen but cultivated and hand-harvested by local farmers such as Minrus Tucker, Aaron Young, Abraham Herriott, and the brothers Bob and Ross Weathers. This practice was continued here long after the market was dominated by highly

productive mechanized rice culture in Texas, Louisiana, and Arkansas; for the yield provided food for the local people and attracted waterfowl for the hunting clubs that owned the property.

Evidence of earlier human activity on the property was clearly visible. Indian mounds were present in the salt marshes near Drunken Jack Island; pottery, projectile points, and other artifacts were turned up in the fields; and remains of salt vats were found near the saltwater creeks. There were several cemeteries dating back to the 1760s, among them the Alston Cemetery at The Oaks and four Negro cemeteries, one for each of the four plantations: The Oaks, Brookgreen, Springfield, and Laurel Hill. Evidence of a once-flourishing rice culture included the ruins of rice mills on each plantation, with the large chimney at Laurel Hill of special note. Also nearby was a large wooden house, a tabby structure of unknown origin, and a fort prepared for two guns overlooking a curve in the Waccamaw River.

People living on the property when it was acquired by Archer Huntington included the Fulton family, caretakers for the former owner, who resided in what has now become the Small Sculpture Gallery. At the entrance to Brookgreen Plantation on the River Road near the present location of the Great Dane Gate lived Isaac and Martha Deas, who served as gatekeepers. The original gate posts were surmounted by a pair of decorative pineapples, an old symbol of hospitality, later given to Dr. Isaac E. Emerson of Arcadia Plantation. On the site now occupied by Youth Circle was Holy Cross Parochial School, run by the Episcopal Diocese of South Carolina under the direction of Archdeacon E. L. Baskervill and the Rev. J. E. H. Galbraith, rector of All Saints Church. This facility provided both academic and religious instruction for the local Negro children and was originally founded and operated by the Hasell and Willett families. The three mission buildings were of stucco painted pale yellow. The church had Gothic windows, beautiful wooden pews, and two tablets above the pulpit that were inscribed with the Ten Commandments. The school or parish hall had windows set in groups of three on each side, with a door on the west facing the river. There was also a six-room dwelling for the teacher. About fifty children regularly attended this school, which was taught by Benjamin B. Martin and his wife Violet. The Martins also taught at Faith Memorial, a similar mission at Pawleys Island.

On a high bluff overlooking the rice field southwest of Brookgreen was the landing used by the people who lived on Sandy Island. Here lived Dr. J. J. Ward Flagg, a descendant of Revolutionary War surgeon Henry Collins Flagg, and a survivor of the 1893 storm in which most of his family perished, who served the medical needs of the local residents. Malaria and other diseases were very common. In addition to being the local physician, Dr. Flagg

Original Brookgreen Plantation House, photographed before it burned in 1901.

served as postmaster for the Brookgreen Post Office. His manservant Tom Duncan lived nearby.

The "street," as the old slave village for Brookgreen Plantation was called, was east of the main house and in 1930 still numbered a church and several cabins, some occupied. Farther east of this "street" were numerous dwellings and small farms occupied by descendants of former slaves.

The magnificent but neglected old live oak avenue at Brookgreen Plantation was probably one of the major reasons Archer Huntington purchased the property. A boxwood garden, great old crepe myrtles, and other plantings near the house presented additional assets for utilization in his future plans.

The winter house, a two-story wooden structure built to replace the original plantation house that burned in 1901, stood at the head of the live oak avenue. The old kitchen and a deep, open well were situated to the southwest, and the caretaker's house was off to the northeast. Also to the northeast but a little farther away was the barnyard, including a garage, a farmer's house, another deep, open well, a barn, and a section of the old Brookgreen rice mill (now the location of the Dogwood Garden). Behind the house were two artesian wells capable of supplying water to the building under modest pressure through hydraulic rams. A flight of brick steps led from the high ground behind the house down to the edge of the old rice fields. During later reconstruction of the steps a newspaper dating from the 1850s was found underneath, along with a reference to "Wasdin," the name of a man thought to have been a landscape architect engaged by the owner in that period.

Concept CONSIDERING THE BRIEF PERIOD between the purchase of the property in 1930 and the founding of Brookgreen Gardens, A Society for Southeastern Flora and Fauna, on July 13, 1931, its concept must have been in mind at the time of acquisition or developed very quickly afterward. The purpose of the institution is best stated in the words of Archer Milton Huntington:

> Brookgreen Gardens is a quiet joining of hands between science and art. Its object is the presentation of the natural life of a given district as a museum, and as it is a garden, and gardens have from early times been rightly embellished by the art of the sculptor, that principle has found expression in American creative art. At first the garden was intended to contain the sculpture of Anna Hyatt Huntington. This has gradually found extension in an outline collection representative of the history of American sculpture from the nineteenth century, which finds its natural setting out-of-doors.

Also, in the dedication of the Gardens, Mr. Huntington said:

> It is the object of this venture to present the simple forms of nature and natural beauty together with such artistic works as may express the object sought. To these have been added, within the bounds stated, the verse of some of those writers who have taken pleasure in the beauty of nature and her living forms, now so rapidly being depleted

through ignorance and greed. In all due homage to science it may be well not to forget inspiration, the sister of religion, without whose union this world might yet become a desert.

On the one hand it seems impossible that the Huntingtons could have anticipated the future development of this area and its needs in light of conditions in 1930; but, on the other hand, because of the care and thoughtfulness devoted to the organization of Brookgreen Gardens, it seems obvious that they knew their creation would someday successfully face the responsibility and challenge of providing a resource of inspiration and education among both the works of nature and of man's artistry.

The old Brookgreen Plantation grounds, including the great live oak trees, provide a natural outdoor setting for works of sculpture that reflects the mood of the day and changes of the season. The wildlife, including both plants and animals, have sufficient space for exhibition and a wide variety of habitats in which to live and thrive.

The idea of combining three subjects of universal appeal on a common ground has great merit, and it attracts a wide variety of visitors. Of course the primary goal of Brookgreen Gardens is to create an awareness, interest, and appreciation of American sculpture, but in combination with indigenous wildlife it is seen by those who might not make the effort to visit a conventional art museum. Conversely, the art lover may better learn to appreciate the natural world and its delicate interrelationships.

Decade of Development

THE TASK OF ADAPTING and transforming the old plantation grounds into a garden museum of American sculpture required the services of a number of dedicated specialists who led a large body of craftsmen and laborers. This team was directed by Mr. Huntington and worked swiftly to prepare Brookgreen Gardens for its first visitors in early 1932, just two years from the time the land was acquired.

Initially, electric power was supplied by gasoline-operated electric generators, but by November, 1931, a distribution line, built under the supervision of Samuel Mercer, a local Georgetonian, was extended across the rivers east of Georgetown and along River Road to Brookgreen, a distance of approximately eighteen miles. It attached to an interior distribution system, mostly of modern underground design, prepared by Mayo McGill FitzHugh, an engineer with the Newport News Shipbuilding and Dry Dock Company, and laid by Bishop and Joel Parrish of Georgetown. The Parrish brothers, and other contractors, were instructed to use Waccamaw labor whenever possible.

A network of concrete roads was designed to provide all-weather routes from S.C. Highway 49 to the Gardens and nearby grounds. These roads, the first of their kind in Georgetown County, were built by J. L. Bull, Sr.,

Laurel Hill Plantation House, as it appeared in 1930.

and James E. McQuade of Georgetown using a hand-fired steam cement mixer. The materials for all construction, including millions of bricks and tons of cement, rock, and building sand, were brought up the Waccamaw River to Brookgreen from Georgetown, both on barges and the boats *Wave* and *Jeannette* owned by F. W. Ford. Early shipments were unloaded at the old landing on Springfield Creek, but later they were taken to a 100-foot-long concrete wharf designed by Mr. FitzHugh and built north of the Garden by Mr. McQuade. The boat *Brookgreen*, owned by Mr. Huntington, was used for regular trips to Georgetown until the mid-thirties, when roads were improved and overland travel became more reliable.

The creation of the garden proper, following the spread-wing butterfly design proposed by Mrs. Huntington, was done under the supervision of the horticulturist Frank Green Tarbox, Jr. A native of Georgetown and a graduate of Clemson College in agronomy, Mr. Tarbox was brought to Brookgreen Gardens by Mr. Huntington from a plant nursery in Florida.

The winter home at the head of the live oak avenue, deemed unimportant by Mr. Huntington, was torn down and replaced by a raised pool and fountain where river water could be collected to fill the lower pools through a system of lead-lined troughs. Two water systems were built: one employing deep well artesian water for domestic consumption and the other using fresh river water pumped to the fountains and pools. Three ponds outside the garden walls, Dogwood Pond, Opuntia Pond, and Jessamine Pond, were created from claypits dug by former owners.

The caretaker's residence was kept, but it was extensively altered to provide a reception building and entrance to the Small Sculpture Gallery built around an interior loggia. To provide balance to this building, the old kitchen was moved to a location directly across the garden and adapted to exhibit a small collection of plantation artifacts and local seashells.

The live oak avenue, in a long-neglected state, was cleaned up by removing dead limbs and interspersed weed trees. In addition, Irish ivy was established as a ground cover, so that the roots of the oaks would not be disturbed and that falling leaves would be incorporated into the soil.

Openwork brick walls and raised flower beds were constructed to outline the garden, and they offered sites for sculpture, decorative plantings, and places for display of verses inscribed in stone. Strollers could look through the open portions of these walls to the outside and not feel confined.

To balance an earlier set of brick steps on the slope to the rice fields, another identical flight was built to the south. Near the center of the garden a curved pergola was constructed to support a massive eleagnus vine that would create a shady bower under which visitors could rest. At the head of the live oak avenue a brick exedra was constructed to create a focal point as

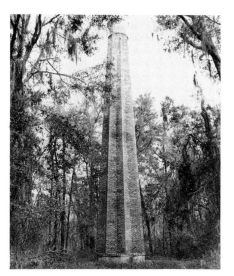

Brick chimney, all that remains of old rice mill on Laurel Hill Plantation.

well as a place to sit. To hide the huge trunk of a dead incense cedar, a west coast native probably planted in the early 1800s, a ventilated brickwork structure was built around it, covered by a camouflaging wisteria vine.

Near the entrance into the old plantation from River Road, a large pool was excavated and foundations were constructed to support one of the first major pieces of sculpture for Brookgreen Gardens. A two-ribbon concrete road was laid from the new concrete wharf to this foundation, enabling the heroic limestone sculpture *Youth Taming the Wild* to be rolled into place. The sculpture, created by Anna Hyatt Huntington and carved in Closter, New Jersey, by Robert A. Baillie and Howard Semino, was shipped to Georgetown by rail, brought to Brookgreen on a barge, and unloaded onto the wharf.

The preparation of planting beds and the establishment of a plant collection were done as structural work was completed. The assembling of the numerous indigenous plants was the accomplishment of Frank Green Tarbox, Jr., with the assistance of such distinguished botanists and horticulturists as John Kunkel Small, Roland Totten and David R. Coker, who contributed plant material and expertise to the effort. The purpose of the plant collection was not only to cultivate plants of the Southeast to be identified and studied by plantsmen and the public, but to enhance the beauty of the grounds and sculpture collection. Many rare and difficult-to-grow specimens were included in the collection.

To complement the sculpture and plant collections, a wildlife park was created to exhibit native animals. Its first location was east of S.C. 49, between the road and the swamps, but later a new site was developed within the hexagon-shaped roadway on the entrance drive. Willett Randall first oversaw this operation and was followed by Percy L. Hovey. Practically every animal species and many bird species native to this area were collected and kept in facilities where they could be seen and studied by artists, students, and the general public. This collection, always a favorite of children, certainly has been a significant factor in bringing families to the Gardens.

In the building of Brookgreen Gardens hundreds of local residents found employment. Many were able to develop marketable skills in the building trades, especially bricklaying and concrete work, and Mr. Huntington believed that this opportunity was one of the greatest contributions he could make to improve their well-being. However, he did help in other ways as well. A clinic was built so that nearby residents and employees could receive much-needed medical services. This facility was staffed by Dr. Henry Norris, owner of nearby Litchfield Plantation, who donated his services, and his nurse Miss Ellen Erwin. The services of Dr. John H. Porter and Dr. Herbert M. Hucks, a dentist, were secured for one day a week by Mr. Huntington.

Cemetery of The Oaks Plantation, where members of the Alston family are buried, including Governor Joseph Alston and his son Aaron Burr Alston.

Headstone for Frank in Laurel Hill slave cemetery, with incised image showing him killed in bed by lightning, May 31, 1848.

Two schools also were built by Mr. Huntington on the property, and the Brookgreen School was used by the Georgetown County Public School System until the early 1950s. After being abandoned by the county it was removed, but the Sandy Island building was used as a school until the system was consolidated in 1960. It serves today as a community center for the residents of Mont Arena. Brown Chapel Memorial Methodist Church was built by Mr. Huntington for a local congregation on a site he donated along a public road.

To consolidate the property and preserve the integrity of the rapidly developing Gardens, inholdings were acquired but residents were given lifetime use of their homes or were allowed to move into new homes built for them on a public road. Mr. Maham Ward Pyatt, an attorney, and Mr. Joseph L. Bull, Jr., a surveyor, both from Georgetown, were instrumental in carrying out this most important work.

When Dr. Ward Flagg died in 1938, the access route to Sandy Island across his property, which had been acquired by Brookgreen Gardens, was changed to the concrete wharf on Springfield Creek. A large brick maintenance barn had been built near this concrete wharf shortly after the work on the Gardens began. This facility provided the necessary support of various craft shops, including carpentry, machine, welding, electrical, and painting. This complex, built under the supervision of H. W. Beacham, has served with minor modifications to this very day.

Archer M. Huntington, at left, sitting with Dr. Joshua John Ward Flagg on steps of Flagg's home on Brookgreen Plantation, about 1935.

While the Gardens were being built early in the 1930s, work on Atalaya, the ocean-front home for the Huntingtons, was also completed, under the supervision of William Thomson, a Georgetown contractor. This massive concrete, steel, and brick building (with servants quarters, stables, and a garage included) was designed after the forts that guard the Mediterranean coast of Spain and was given the Spanish name for watchtower. While not a comfortable home, Atalaya served the Huntingtons well as a place to pursue their interests while staying in South Carolina. The building, constructed on the site of the old plantation's summer home, included a sculptor's studio for Mrs. Huntington, where "Rocinante" for her *Don Quixote* was modeled, and office space with a library in which Mr. Huntington could continue his studies of Spanish literature. While both the Huntingtons were living, Atalaya was kept ready for occupancy on short notice. Fully furnished, the house needed only ice and provisions for them to move in. During their stays at Brookgreen Gardens, Bernard Baruch and Mr. and Mrs. William Kimbel, owners of neighboring plantations, were frequent visitors.

The summer house formerly on this site was dismantled; portions were moved adjacent to S.C. 49 to make a gatehouse, and other sections were taken to the north side of Atalaya to make two buildings for the use of

servants. The latter were torn down in the late 1950s when no longer needed.

Two large freshwater ponds were formed, Mullet Pond and Mallard Pond, when a dam was built across the southern extremity of the salt marshes of Murrells Inlet. The freshwater inflow from Old Field and Rose branches, augmented by a free-flowing artesian well, was sufficient to keep the ponds fresh and attractive to a wide variety of waterfowl. For years a waterfowl banding study was conducted by P. L. Hovey and later by R. Grattan Mac-farlan on Mullet Pond. This study provided valuable information on the movements of local waterfowl, especially the redheaded duck.

The firm of C. L. Ford and Sons, under the leadership of Charles LaHue Ford, Sr., acted as agent for all Brookgreen purchases, shipments, and, for a while, provided cash for payrolls.

Three homes for employees were constructed during these years. The horticulturist's residence was built near Youth Circle for F. G. Tarbox, Jr., and his bride Sallie Walker Tarbox, who previously had resided on the second floor of the old caretaker's cottage in the Gardens. This two-story building, including an office, was made of brick and utilized many of the sashes and doors from the dismantled winter home in the Gardens. Two small residences were built several years later for the wildlife park superintendent and a security guard.

Brookgreen Gardens, being on a navigable stream connected to the Intracoastal Waterway, was made accessible to yachtsmen by the construction of a large wooden wharf on Springfield Creek near the Gardens. A sign with letters six feet high invited passing boaters to visit. Another wooden structure was constructed across Springfield Creek at the end of Canal Road. It supported a forty-foot steel watchtower to observe waterfowl concentrations.

Original rice-field steps on Brookgreen Plantation, photographed about 1900.

Mrs. Huntington had contracted tuberculosis in the mid-1920s and was advised to seek a dry climate. While in residence at Brookgreen Gardens it was thought that the drier air of Laurel Hill might be better for Mrs. Huntington rather than the moist salt air at Atalaya, so a prefabricated house was assembled on a beautiful site atop the bluff overlooking the Waccamaw River. A water tower and electric generator were installed and an underground telephone line was connected to Atalaya. When, after a short period, Mrs. Huntington's health did not improve, she sought a better climate in Arizona, and eventually found successful treatment in Switzerland. The Laurel Hill house was moved to Atalaya and attached to its southwest corner, and the water tower was taken down and reset at Goat Hill near the Garden.

The basic garden design as conceived by the Huntingtons, incorporating the magnificent live oak avenue, bounded by openwork brick walls with walks and pools in the shape of a butterfly with outstretched wings, was completed by the late 1930s. To accommodate additional sculpture, both

commissioned and purchased, a new area, the Dogwood Garden, was designed and laid out on the site of the old barnyard and rice mill. This garden, basically square with a raised central pool and four corner pools, was almost completed when the United States became involved in World War II and all construction ceased.

As the sculpture collection was being assembled by the Huntingtons, Robert Alexander Baillie arranged for its movement, placement, and ultimate care. A native Scot and a stone carver by profession, he also carved for various artists many of the limestone pieces placed at Brookgreen Gardens. Records of the sculpture collection were compiled by Beatrice Gilman Proske, Curator of Sculpture at The Hispanic Society of America in New York. She produced a comprehensive illustrated catalog of the collection with biographical data on the artists. Also additional publications about individual artists and other subjects of interest were prepared under her guidance. Genevieve Willcox Chandler of Murrells Inlet was engaged to be the receptionist in the Small Sculpture Gallery where she could meet visitors and answer questions about Brookgreen Gardens.

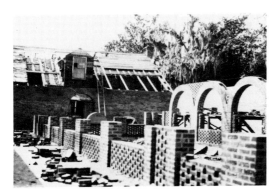

Old caretaker's house for Brookgreen Plantation being incorporated into Small Sculpture Gallery of Brookgreen Gardens, about 1930.

The War Years

BROOKGREEN GARDENS BECAME INVOLVED in the war effort when much of its property was made available to the United States Government as a gunnery range for the 455th Bombardment Squadron, U.S. Army Air Corps, stationed at nearby Myrtle Beach Air Field. Atalaya, the home on the beach, was occupied by troops who operated targets set up on the beach and patrolled the coast. The main building, fortified with machine guns, contained a radar station and served well as a military installation, having substantial rooms in which to billet men, and the attached prefabricated house from Laurel Hill served as a mess hall. A telephone line was extended from Myrtle Beach to this outpost, but when the war was over and the facility was released the phone line was taken up; regular telephone service to the Gardens had to wait a while longer.

The types of aircraft that used this range (B-25s with a 75-mm cannon and .50-caliber machine guns, and A-26s armed with an early type of air-to-surface rocket) approached the targets at low altitude from the west and fired at targets erected on the beach. The ocean just beyond provided a safe impact area, but, since weapons were often fired while the planes were directly over the Gardens, there were reports of machine gun fire hitting nearby buildings. Three planes crashed on the property during this training, two on the firelines and one in the forested sand dunes southwest of Atalaya.

The war effort greatly limited the men, material, and other resources available to maintain the Gardens, keep it open, and protect the sculpture collection. Nevertheless, a small staff stayed on enabling the Gardens, to

remain open and provide the local citizens and military personnel from Myrtle Beach with a recreational and cultural resource.

The Postwar Years

AT THE CONCLUSION OF WORLD WAR II, in 1945, manpower and supplies again became available to the Gardens. The Dogwood Garden, nearly complete in 1940, was finished by the placement of a heroic-size limestone sculpture called *Riders of the Dawn*. In 1950 the new Palmetto Garden was opened southeast of the live oak avenue, and in 1951 *Fighting Stallions*, a fifteen-foot-high aluminum group, was placed at the highway entrance of Brookgreen Gardens. A few years later, in 1954, *Pegasus*, the largest sculpture in the collection, was completed in place on the edge of the rice fields to the southwest of the Gardens.

Also in 1954, in October, Hurricane Hazel struck a devastating blow. Powerful west winds overturned and smashed trees along the exposed rice field banks. The live oak avenue suffered severely but has since regrown to nearly its original stature. On the beach, storm tides washed out the dam separating the salt marshes; Mullet Pond and the causeway between it and Mallard Pond were severely damaged. The beach dunes were leveled, and the ocean swept across the sand south of Atalaya to Mallard Pond while flood waters ruined supplies and equipment stored in the building. Utilities, including a newly installed telephone line, were out for weeks. The underground electric cable from the Gardens to Atalaya was damaged when the causeway washed out, and full service was not restored until a new overhead line was built to replace it. Later the dam and road were repaired and strengthened, and trees destroyed in the vicinity of the Garden, especially around the Diana Pool, were replaced.

On December 11, 1955, Archer Milton Huntington passed away at Stanerigg Farm in Bethel, Connecticut, bringing to an end the personal interest and support he had shown for Brookgreen Gardens since its inception.

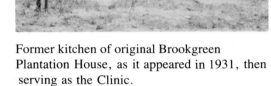

Former kitchen of original Brookgreen Plantation House, as it appeared in 1931, then serving as the Clinic.

Period of Adjustment

THE HUNTINGTON TOWNHOUSE on Fifth Avenue in New York City, where the Brookgreen Gardens administrative offices had been located, was sold since it was no longer needed and was too expensive to maintain. Space in the clinic building at the Gardens was prepared, and all of the records and office equipment were moved from New York in 1958-59. Miss Sara Alexander, the New York bookkeeper, came with the records and helped acquaint the local staff with the handling of administrative details. Also about that time, Mrs. Huntington, not expecting to use Atalaya again, requested that many of its furnishings be sent to her home in Connecticut or be incorporated into the newly established local office. Then, at Mrs. Huntington's behest,

Atalaya was leased to the Girl Scouts of Georgetown County for use as a recreational facility. In 1960, again with her blessings, the beachfront properties of Brookgreen Gardens were leased for fifty years to the South Carolina State Forestry Commission for use as a state park. The Girl Scouts, unable to manage Atalaya, abrogated their lease in favor of the Forestry Commission, which further opened the way for public recreational use of the beach. The park attracted large numbers of visitors to the area and also to Brookgreen Gardens.

On September 8, 1963, during the integration struggle, South Carolina closed all parks under state jurisdiction, leaving Brookgreen Gardens, a private property, practically the only place in South Carolina where any citizen, black or white, could go without charge. Attendance soared to the point where facilities were strained beyond capacity. The roads, parking lots, restrooms, and picnic areas at Brookgreen Gardens were overwhelmed, as were the security forces trying to maintain order and control. To accommodate the rising crowds, the water system was improved, roads and parking lots were reworked, and long range planning was undertaken.

During the mid-1950s a sculptor's studio for R. A. Baillie was constructed at the east end of the old woodshed, and a pointing machine, formerly owned by Frederick MacMonnies and used to enlarge the huge *Battle of the Marne*, was installed. Here Mr. Baillie carved the central figures for Mrs. Huntington's allegorical piece *The Visionaries*, and later he began carving Polášek's limestone sculpture *Man Carving His Own Destiny*.

Two security problems were resolved during the early 1960s. Boat traffic to the Gardens was terminated because of the increasing numbers of speedboats and waterskiers in the creeks. Brookgreen Gardens constructed a new canal and landing at the end of a road built by Georgetown County on its southern boundary, thus ending the Sandy Island residential traffic through the property and creeks. This change improved access to the island and shortened the long, dangerous water route that had claimed many lives over the years.

In 1965 gates were constructed across the main entrance at U.S. 17, and the security post was moved approximately two hundred feet south to a night entrance road. An admission charge was initiated in 1968 to regulate visitation and to produce much-needed income. In conjunction with the admission charge, Monday closings were discontinued and the Gardens were open every day of the year except Christmas.

The Brookgreen farm, which had been used to produce feed for the livestock and wildlife, called for manpower better spent in maintenance of the Gardens, so the livestock was disposed of and the farm was planted with pines in 1969.

Brookgreen school built by the Huntingtons, shown with pupils and teacher in 1932.

To guide future development and establish an orderly method for growth, professional consultants were engaged to offer their ideas. The concepts of two separate firms, Richard C. Bell Associates of Raleigh, North Carolina, and Clarke & Rapuano of New York, both landscape architectural firms, were incorporated into a long range plan which generally has been followed. In 1968 the Visitors Pavilion, which included a new reception area, gallery space, restrooms, and refreshment area, was completed. The parking lot and entrance to the Gardens were redesigned as the facility was built. The former reception area was converted to an open but covered Small Sculpture Gallery where new works could be exhibited until permanent locations were selected.

A membership program was established to create interest in Brookgreen Gardens and to identify those persons and corporations willing to support the institution. An annual membership event was initiated, and a quarterly publication called the *Brookgreen Bulletin* was produced.

The long range plan called for an area northeast of the existing Gardens to be developed into a new Wildlife Park, replacing outmoded facilities. This plan offered the opportunity to concentrate both of the native wildlife collections in the new area and open up the old area to a wide range of plant material, including all those taxa considered ''of the South'' and capable of growth here. Thousands of new plants previously overlooked were acquired and planted, creating longer periods of bloom at the Gardens and additional interest. An Herbarium, a scientific collection of plants dried and kept for study, was established to provide vouchers and references to plants growing in the Gardens. In addition the grounds were carefully mapped so that plants and other features easily could be located. Records were also placed with the Plant Sciences Data Center of the American Horticultural Society, to be available to anyone seeking information regarding plants growing in the area. Small greenhouses were constructed, and a nursery was established to propagate and grow plants (many unavailable from commercial sources) for use in the Gardens and for exchange with other specialized gardens and arboreta.

Because new sculpture continued to be placed in the Gardens, a revised catalog had to be prepared by Beatrice Gilman Proske in 1968 to include the new works and update the artists' biographical information. An active program to acquire additional sculptures was carried on through gifts, purchase of selected works, and competition.

To commemorate South Carolina's Tricentennial in 1970, Anna Hyatt Huntington's monumental *In Memory of the Work Horse* was unveiled and dedicated. A special American Revolution Bicentennial program was held in April, 1976. These two events brought attention to historical figures whose lives were intertwined with Brookgreen and surrounding plantations.

The last parcel of land within the present boundaries of the property was

acquired, permitting the closing of a community road bisecting the property. Alternate routes were designated and the final form of the property and public roads took shape. A new system of interior drives and parking lots conforming to the long range plan was laid out and stabilized. Following this, the building of the new Wildlife Park began. The first exhibit constructed was the twenty-three-acre Deer and Turkey Savannah, where visitors view the animals across a Rotterdam moat. Next came the Cypress Bird Sanctuary: a ninety-foot tall aluminum-and-steel-supported fabric net was stretched over the tops of an existing cypress-gum forest, where visitors cross a boardwalk over the tidal swamp housing about fifty native waterfowl. An Otter Pond and Alligator Swamp were then constructed on the edge of an old rice field along a foot trail from the Cypress Bird Sanctuary. Native wildflowers and shrubs were planted and labeled along the paths.

Brookgreen was honored by placement on the National Register of Historic Places in 1978, when a requirement of fifty years' existence was waived in recognition of the valuable and distinctive sculpture collection.

On the northern tip of Magnolia Beach, in Huntington Beach State Park, the Brookgreen Gardens Trustees made available to the federal government, at no cost, sufficient land on which to attach a major stone jetty to aid navigation in Murrells Inlet. Profound changes to the beach and the economy of the region will result from this contribution and subsequent activity. Also at Huntington Beach State Park, an historical marker commemorating the Hot and Hot Fish Club of antebellum days was placed through the combined efforts of Brookgreen Gardens and the Georgetown County Historical Society.

A Perpetual Members Memorial was dedicated and unveiled in April, 1979, to honor deceased contributors to the building of Brookgreen Gardens. Initially the memorial honored the founders and eight others, but as additional names are added this monument will serve as a lasting reminder of those who helped create Brookgreen Gardens.

Anna Hyatt Huntington died in 1973, leaving Brookgreen Gardens, which she and her late husband had founded more than forty years earlier, in the hands of the Trustees to perpetuate the dream they had created. The Trustees have accepted the challenge and are dedicated to continuing the fulfillment of Brookgreen Gardens' purpose as stated in its constitution:

> To exhibit the flora and fauna of South Carolina and objects of art; to acquire land, and acquire, build or maintain a suitable building or buildings and equipment for such exhibition and preservation, and for all other purposes contributing to the foundation and upkeep of such institution and the promotion of public welfare with respect to such purposes, and to furnish instruction upon and promote the advancement of learning with regard to such subjects.

Historical Background of the Plantations
Comprising Brookgreen Gardens

By Robin R. Salmon

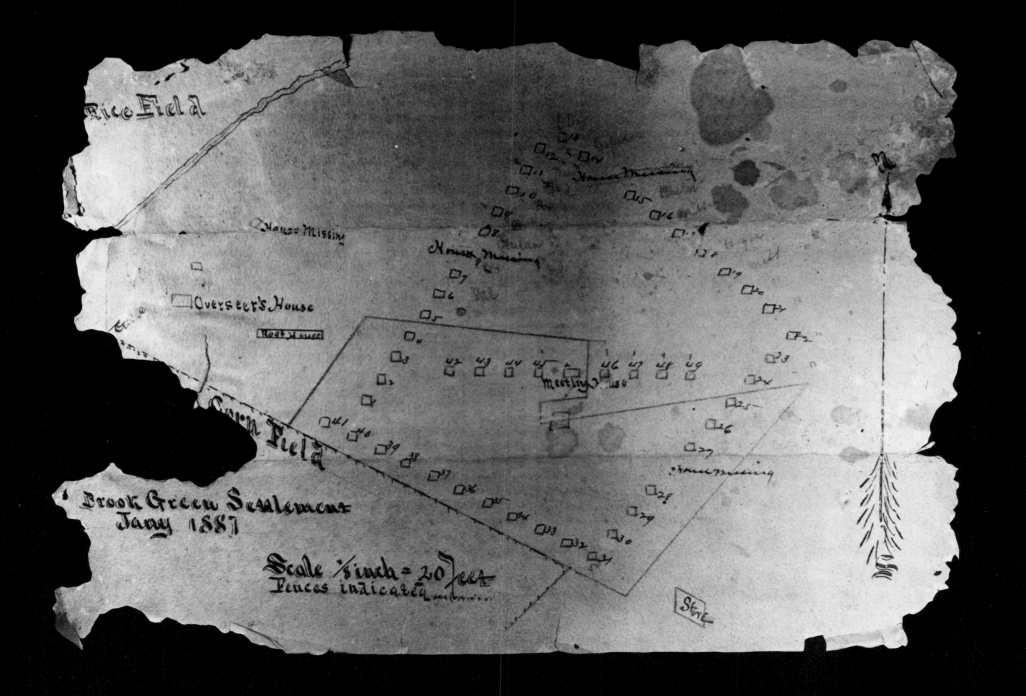

Rice Field

House Missing

Overseer's House

Root House

Corn Field

Brook Green Settlement
Jany 1887

Scale ½ inch = 20 feet
Fences indicated

Store

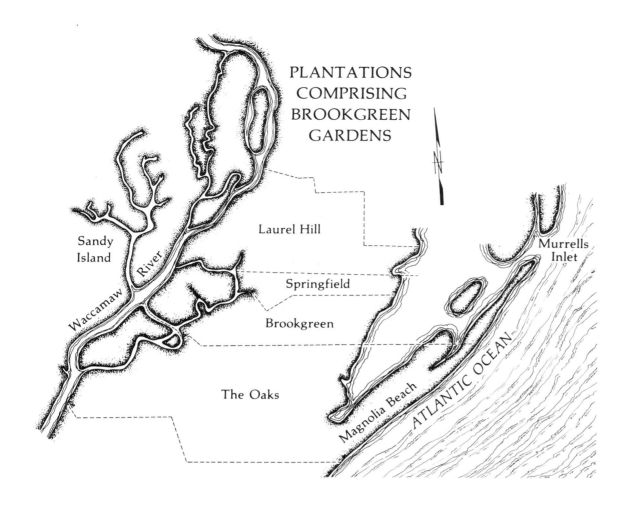

PLANTATIONS COMPRISING BROOKGREEN GARDENS

Sandy Island

Waccamaw River

Laurel Hill

Springfield

Brookgreen

The Oaks

Murrells Inlet

Magnolia Beach

ATLANTIC OCEAN

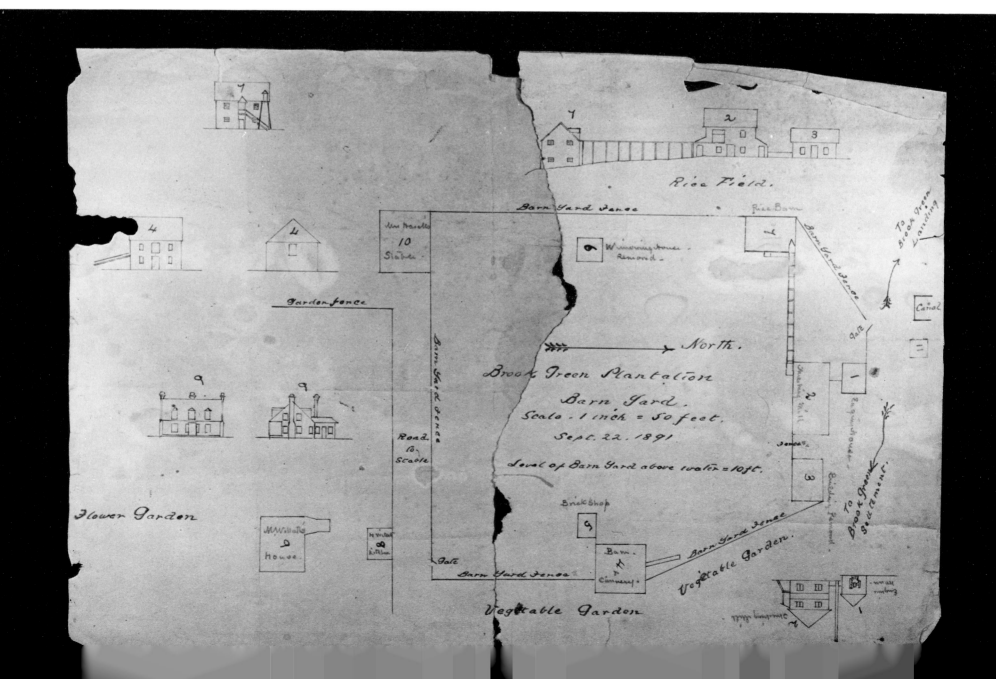

Laurel Hill Plantation

Home of the Waties, Marion, Weston, and Jordan Families

ON FEBRUARY 15, 1732, William Waties, Jr., registered in the memorial book of quit-rents to the crown, 1,300 acres granted originally to Robert Daniel and then sold to Thomas Smith, then to Samuel Eveleigh, and finally to himself. This plantation, called "Lorrill Hill" on the Waccamaw River, bore a quit-rent of twelve pence per 100 acres.[1] Waties also received land grants totalling 4,289 acres, mainly on the Waccamaw River, in the years 1735, 1736, 1737, 1739, and 1740.

In 1721 Waties, the son of the Welsh Indian trader William Waties, had been elected to represent St. James Santee in the Assembly. In March, 1724, he asked to be excused as a representative since his plantation was so distant from Charleston that he found it inconvenient to attend sessions.[2] Prince George Winyah Parish elected him as one of two members from 1725 to 1736.[3] In 1728 he accepted his election to the Third Assembly in order to represent the region beyond the Santee Rivers. Although he spent most of the 1730s extending his properties, he did accept public service on three occasions. In the spring of 1731, after a band of Tuscaroras had stolen slaves and cattle from planters around Winyah Bay, Waties followed them to North Carolina and met with their chiefs to settle the matter. He once again accepted a seat in the Assembly in 1733. In 1734 he served as a commissioner to run the boundary line between North and South Carolina.[4] In addition he was one of the leaders of a group of Winyah Bay men who long wanted to have a port at Georgetown. The group talked with acting governor Arthur Middleton but became so incensed that they threatened to march into Charleston and upbraid the members of the Council, whom they particularly blamed for the problem. They had petitioned to make Georgetown a port as early as 1723, but nothing had resulted. However, because of their efforts, Georgetown did become a port in 1731.[5]

Waties also was included in a list of Georgetown lot owners attached to the deed of June 29, 1737, that settled the dispute between John and Mary Cleland and Elisha and Hannah Screven over the ownership of land on which the city of Georgetown had been planned.[6] William Waties probably built a house on his lot. He contributed £50 to the erection of the parish church of Prince George Winyah, as noted on a subscription list of January 1, 1736.[7]

When he died in 1743 he left 123 slaves, 16 horses, 109 head of cattle, 55 head of sheep, one pettiauger, one ferry boat, five canoes, one set of surveying instruments, half ownership in a sloop, and bonds and notes valued at £18,311 currency.[8] Obviously rich in lands, his three sons, William,

John, and Thomas, and his daughter, Ann, were established as principal landowners. Each of the three sons later sat in the Assembly.

Laurel Hill Plantation stayed in the Waties family until 1750, when it was bought by Gabriel Marion, brother (or, possibly nephew) of General Francis Marion, the Swamp Fox.[9] In 1775 he sold it to Plowden Weston (1739-1827) who had come from Warwickshire, England, to Charleston and established himself in trade. In 1777 Weston bought lands adjoining Laurel Hill from William Allston of Brookgreen Plantation.[10] During the American Revolution, produce from Laurel Hill supplied the troops of Colonel Peter Horry, who served under Francis Marion.[11]

On March 26, 1775, Plowden Weston (1739-1827) married his second wife, Mary-Anne Mazyck, the daughter of his partner, who owned lands on the Santee River.[12] The Charleston firm of Weston and Mazyck served the Wando, Santee, and Waccamaw rice planters as factors for many years. By the time of his death in 1827, Weston had accumulated a great fortune, most of which he left to his two surviving sons, Francis Marion Weston (1783-1854) and Dr. Paul Weston (1784-1837). The first son inherited Laurel Hill and personal property worth $70,000, along with 258 slaves.[13]

F. M. Weston married in succession Mildred (1774-1822) and Mary (1779-1856), the daughters of his uncle Charles Weston of Kursley in Warwickshire, England. Weston, who also had bought Hagley Plantation from one of the Alstons, produced 1,603,800 pounds of rice in 1850, although he is listed as only owning 196 slaves.[14]

He was the principal patron of All Saints' Parish Church during its great days and brought Alexander Glennie over from England in 1828 as tutor for his son Plowden (1819-1864). When the Westons went abroad in 1831 for seven years, Glennie became the rector at All Saints.[15] In 1838, after Mrs. Mary Huger left $5,000 to the parish, the vestry decided to build a new brick church. The building committee was composed of Weston, E.T. Heriot, Joshua John Ward, T. P. Alston, and J. H. Tucker. The new church was erected between December, 1843, and October, 1844, and was consecrated on April 8, 1845.[16] This third church was of colonial style with massive columns in front and galleries on the side. Alexander Glennie wrote, "A suitable and fine toned organ has been presented to it by one of our Wardens (J. J. Ward). Mrs. Francis M. Weston presented a Bible, prayer book and a chancel chair, a marble font and a carpet for the chancel desk and pulpit. Mr. Plowden C. J. Weston supplied the furniture."[17] In *All Saints' Church, Waccamaw 1737-1968*, the Rever-

end H. D. Bull noted the relationship between Glennie and Weston: "The circumstances were ideal; a young, energetic, consecrated priest, and with him working hand in hand a devout layman of great ability and tremendous wealth, both devoted to the same ideal—the upbuilding of the Church and the conversion of souls, white and black, to Jesus Christ."[18]

A clergyman who visited the Waccamaw around 1843 described the Laurel Hill Plantation chapel, which was used by everyone living on the property:

It is embowered in live oaks and other evergreens, as beautiful in situation and as neat in its structure, as many a country church in our land. It is nicely plastered, has a chancel and desk, an arched ceiling, and tablets with the Ten Commandments. It will seat more than two hundred persons. . . .[19]

The house at Laurel Hill stood upon a high bluff above the Waccamaw River, and from it rows of live oaks radiated outward. These trees probably were planted by Plowden Weston, since it is unlikely that Waties or Marion had been interested in landscaping the surroundings. The name, "Lorrill Hill," had been used prior to 1732,[20] when Waties bought the plantation, and probably came from the abundance of magnolias on the property mistakenly thought to be laurels.[21]

When Bishop Davis made a visit to All Saints' Parish in 1855 he wrote in his journal:

April 1st (Sunday)—Morning Service in the Parish Church. . . . In the afternoon we visited the plantation of the late Mr. F. M. Weston [who died in 1854], Laurel Hill.

2nd—Having spent the night at Laurel Hill. . . between 11 and 12 o'clock we proceeded nearly two miles beyond Laurel Hill to Wachesaw. . . .[22]

Originally there were plans to build another church to serve the planters of the northern Waccamaw Neck, a "branch" of the first All Saints' Parish Church. Alexander Glennie wrote in the report of the Convention of 1855 that "preliminary steps have been taken to erect another Church about eight miles above the Parish Church. (This would be the Church at Laurel Hill)." In 1855 the plantation was owned by Plowden C. J. Weston, son of F. M. Weston, but the sanctuary was never built there. "On December 24, 1854, the vestry resolved to build a church at Wachesaw about eight [ten] miles north of the Parish Church, this being near 'Laurel Hill,' and a building committee was appointed to carry the plan into effect." Of course Plowden C. J. Weston was a member of that building committee, carrying on the work begun by his late father. The church was named Saint John the Evangelist.[23]

In those days an important aspect of church business was the selling of pews, upon which the church depended for support. Francis Marion Weston is listed in All Saints' records as "owning" pew number 5,[24] and from 1844 until his death in 1854 he was a member of the church vestry. Mural tablets that were destroyed when the third church

burned on December 12, 1915, included one to both of Weston's wives:

In Memory
of Mildred
Born 4th July 1777—died 1st Aug:1822
and of
Mary
Born 13th Nov. 1779
died 19th Ap. 1856 Daughters of Charles Weston
of Kursley, Warwickshire, England
and wives of Francis M. Weston Esqrs.
of Laurel Hill in this parish.[25]

A memorial tablet also had been erected to him by his second wife, Mary:

In Memory
of Francis Marion Weston
of Laurel Hill in this Parish
Born June 1783: Deceased Nov:21, 1854
Erected by his widow and son[26]

Weston was an original member of the Planter's Club, which was formed in 1839 and lasted until the Civil War.[27] In the *Rules and History of the Hot and Hot Fish Club of All Saints Parish, South Carolina,* compiled by Plowden C. J. Weston, a list of members, "as far as can be remembered, before 1845 whose names are not down on the roll..." included F. M. Weston.[28] Some historians believe that the Hot and Hot Fish Club was not formed until 1845, but according to the *Rules,* the club was first started before the War of 1812 even though it did not have written rules until 1845. The foreword to this booklet was entitled "Reminiscences of Ex-Governor R. F. W. Allston," and in it he wrote:

The members, as I remember them, were Major Ward, Mr. F. M. Weston, Mr. Ben Allston, Mr. Robert Withers, Mr. John H. Tucker and his brother William, Mr. J. Barrington Thomas, Mr. John Green, and Major W. A. Bull. These gentlemen were all my friends, and I remember them gratefully.[29]

In 1844 the board members of All Saints' Academy petitioned the Senate and the House of Representatives for permission to incorporate. Weston was then President of the Board. This school was an arm of All Saints' Parish Church and under direct supervision of the Reverend Alexander Glennie.[30]

In a note written on November 19, 1854, F. M. Weston summoned his physician Dr. Arthur B. Flagg to Laurel Hill:

Dear Sir,
I was attacked with a stricture about 3 o'clock this morning and will ask you to ride over to relieve me as soon as you can. I remain,
Yours respectfully,
Francis M. Weston

Dr. Flagg's records reveal that he returned to Laurel Hill everyday for a week to administer to Weston but that he died on November 24, 1854. Flagg noted in his ledger that the total bill for his services was $70.00.[31]

Weston was a member of that group born just after the American Revolution who died before the catastrophe of the Civil War. His entire estate passed to his son by his first marriage. Plowden Charles Jennett Weston, who was married to Emily Frances Esdaile in 1847. She was the sister of the poet William Clement Drake Esdaile, who attended Harrow and Cambridge with Weston.[32]

In addition to his father's vast estate. Plowden C. J. Weston bought additional properties between 1850 and 1860, making him one of the area's richest planters (his lands yielded 1,252,000 pounds of rice in 1860).[33] An illustration of Weston's immense wealth comes from *The History of Georgetown County:*

The Georgetown Rifle Guards, which was Company A of the Tenth Regiment, selected Private Plowden Weston as company commander. Weston proceeded to outfit his entire company at his own expense with English Enfield rifles, all gear, as well as summer and winter uniforms, treating his men somewhat as feudal retainers. Captain Weston also uniformed four of his slaves as a pioneer corps to precede the company clearing away the underbrush. Three drummers and one fifer supplied military music.... On one occasion . . . there was a report of the enemy landing on Waccamaw Neck. . . . It was a false alarm, but on the return march, although totally unprepared, Captain Weston entertained his entire company of 150 men at Hagley with a seated full-course meal, served in crystal and silver by the family retainers, and washed down with rare wines from his cellar. As one soldier recorded later it was "on a par with the feudal entertainments of the great lords of Europe."[34]

Plowden Weston was considered a good master, seeing to the wants, needs, and protection of his slaves. He had three criteria by which to judge the performance of an overseer: first, the well-being of all the blacks (appearance and health in particular); second, the condition of plantation animals, buildings, tools, and land; and last, the crop yield.[35] A great many of the plantation owners of his time regarded the last item as most important, which reveals a great deal about the way Weston ran his plantations.

Many holidays were observed on the Waccamaw Neck plantations, but Christmas was the most important. On the Weston plantations Christmas lasted three days, December 25-27, and was described in some detail in the diary of Emily Weston and the memoirs of her English housekeeper Elizabeth Collins. Each day time was set aside for visiting the slave cabins and giving out sweets and fruit to the children. On Christmas Eve she wrote: "Dined early and Plowden gave out Xmas to the whole of men, women and children, which took 2½ hours. Hector looked over the meat, Prince the salt, Caesar the rice, Jimmy and Jack the molasses, and Frank the tobacco."[36] On Christmas Day many of the slaves, including some of the house servants, had tickets to visit other plantations and to stay overnight. These tickets had to be kept in their possession at all times, be signed by the overseer or master at the plantation they were visiting, and then be returned to their own overseer or master. Elizabeth Collins described the slaves as having "a jolly time" at Christmas, enjoying themselves with "singing and dancing, both of which the Negro can do well." The slaves also enjoyed "a ham, turkey, goose, plum pudding, gingerbread, apples, oranges, etc. . . ."[37]

Sunday was also a special day. Weston allowed no work to be done and even Sunday food had to be cooked on Saturday.[38] During the week his slaves were served communal breakfast at 9:00 AM and lunch at 3:00 PM. The plantation cook was responsible for feeding approximately 200 adult slaves, and the children's cook prepared food for approximately 130 youngsters.[39] Weston's overseer followed a "Table of Allowances" which was stated in his contract. One of the clauses required that "great care should be taken that the Negroes should never have less than their regular allowance: in all cases of doubt, it should be given in favour of the largest quantity. The measure should not be *struck,* but rather heaped up over."[40] Weston also gave a piece of land to each person for a garden; as Emily Weston wrote, "He walked over the area while the people all followed us and each received his or her own, so there should be no mistakes."[41] When a group of his slaves was sold in December, 1859, Weston purchased $1,200 worth of household furnishings from them.[42] Each of his male slaves was annually given a coat and a red jacket, which were valued possessions.[43] According to all accounts the Westons, a loving, happy couple, never had any children, which may explain the great interest they took in their slaves.

When Laurel Hill was being vacated in 1859, Emily Weston described some of the problems of moving in her diary:

Tuesday, March 15. Hector and Caesar went to Laurel Hill to pack up all those things Plowden has determined to buying out of the house, and also the wine.

Wednesday, March 16. Plowden off early to Laurel Hill to see after the things there to be sent down in flats. These arrived at 4:00 and very busy we were having them brought up—not finished until half past 8. Such a collection of articles I scarcely knew where to stow them.

Thursday, March 17. Busy putting things a little in order, unpacking china, glass, etc. and about 4 another flat came with the portion of wine already packed. Had it put into baskets and deposited in the new-made cellar under the portico.

Monday, March 21. Off early to superintend the packing up the remainder of the Laurel Hill wine, Hector and Jack going with me. All was in the flat by 4:00, and quite a business it was! . . . Hector staid to mind the wine and the flat started for Hagley in the evening.

Tuesday, March 22. The flat with wine arrived and began to unload about 10. I and Margaret, with one of the boys, put up the wine as it was brought in baskets and tired enough I was when the business was over.[44]

One can imagine what a job this must have been since the Westons had enough china, crystal, and silver to have served 150 at a time, and their wine cellar was quite well stocked! The flats referred to were large rafts poled or rowed along the Waccamaw River, the main "highway" of the Waccamaw Neck residents.

In 1862 Plowden Weston was elected lieutenant governor of South Carolina and returned home from Knoxville where he had been stationed with the Tenth Regiment.[45] As the Reverend H. D. Bull wrote of him in his history of All Saints' Church: "Colonel Weston was of delicate physique and could not stand the life of the Army . . . he died January 25, 1864, in his 44th year. His body lies in an honored grave a few yards from the church he loved and served so well."[46] According to J. Motte Alston, Plowden had "the interest on nearly, if not quite, $1,000,000 to live on."[47] He was a member of the S. C. Historical Society, Maryland Historical Society, New-York Historical Society, and in 1855 published in London a fine edition of documents on the early history of South Carolina. At his death his library was valued at $15,000 and his wine cellar contained 1,320 bottles of wine.[48]

During the late 1850s or early in 1860 Weston had sold Laurel Hill to Colonel Daniel W. Jordan, a North Carolinian who owned extensive holdings in Horry District.[49] At the outbreak of the Civil War the main job for planters had been to build defenses along the coast and acquire cannon, rifles, shot, powder, and ammunition. On Waccamaw Neck, Captain Thomas West Daggett had come to South Carolina from Massachusetts, trained as an engineer, and served as miller for Francis M. Weston at Laurel Hill prior to the war. In command of the Waccamaw Light Artillery, he tried to lodge it in Fort Randall (overlooking the entrance to Little River) and Fort Ward (Murrells Inlet). In a letter to his superior officer he asked whether he should bring the "12-pounders" presently stored in the mill yard at Laurel Hill down to Fort Randall.[50] During the war all planters exploited the facilities of their plantations to build fortifications. Even today gun mounts can be found on Laurel Hill Plantation, on a bluff at the bend of the Waccamaw River commanding a view from both directions. This may have been the site of Fort Ward, for its highly strategic location, the storage of the artillery in the mill yard, and Daggett's association with Laurel Hill lend credence to this supposition.

During the late spring and early summer of 1862, the planters began to move their slaves inland. Emily Weston in a letter to Benjamin Allston written from Conwayboro, July 4, 1862, said that Plantersville was full to overflowing with planter refugees and that only the Jordans and Rosas were left on Waccamaw.[51] On July 29 a group of Feder-

als headed up the Waccamaw River for Laurel Hill to make trouble for Colonel Jordan. For some unknown reason they passed Laurel Hill and anchored at the next plantation, Richmond Hill, owned by Dr. John Magill, a violent secessionist with two sons in the Confederate Army. Dr. Magill narrowly missed having a ten-inch shell thrown at his home. Shortly after this Jordan decided to move his family farther inland, away from the river and the Federals. At this time he had 261 slaves who cultivated 900 acres of the large plantation.[52] Jordan moved his family, possessions, and loyal servants to Camden, South Carolina, where he eventually bought a home and opened a general store. A family account tells how the procession was held up each day by a flock of turkeys that set the pace for the evacuation; when the turkeys roosted in the evening, the entire group halted and spent the night.[53] By 1865 the situation on abandoned plantations had become so bad that those planters who remained in their homes wanted the refugees to return. Charles Alston, Jr., wrote to Colonel Jordan urging him to come back to Laurel Hill so that he might use his influence "to keep some law and order on it," since it had become "a positive injury to all of us who are near."[54] But Jordan never returned to Laurel Hill. He wrote in his diary, January 1, 1868:

Whilst thinking on this war, made on us for no cause whatsoever, the changed situation of the people of this, our Parish of All Saints, is brought forcibly to my mind. . . . The writer of this journal had, when the war began, settled on Laurel Hill Plantation and engaged in making turpentine in the pine woods, 300 Negroes, 100 of whom were able men; and also a half interest in 14 men working with E. I. Parker, who he took as an overseer for $200, about A.D. 1850. The Negroes are now all gone, and the mill (Rice Pounding & Barrel Machines) which cost $29,000 burnt by the Yankey—So I consider my losses about a quarter of a million dollars. . . .[55]

Daniel W. Jordan had been a member of the Hot and Hot Fish Club, joining with the second group who became members just prior to the Civil War. In 1850 he was elected unopposed to the House of Representatives for All Saints' Parish.[56] In 1865, after the war, when many planters successfully sought individual pardons from President Johnson, Colonel Jordan's petition revealed that he was fifty-six years old, had removed permanently from Laurel Hill to Camden during the war, and had taken no part in the fight.[57]

According to the Parish Register of All Saints' Church, Emily Tuttle Jordan, wife of Daniel W. Jordan, was baptized at Laurel Hill Chapel on March 24, 1861, sponsored by Mrs. Eliza C. LaBruce. Emily's daughter Margaret Elizabeth was also baptized the same day. Another daughter, Cora Rebecca, was baptized on April 14, and the proceedings were witnessed by her mother.[58] On April 3, 1861, Mrs. Jordan was confirmed by the Right Reverend Thomas F. Davis, D.D., and it is noted that she entered the parish in 1861 and re-

moved in 1864.[59] Apparently the Jordans did not think their stay in Camden would be permanent when they left in 1862. Cora Rebecca Jordan was admitted to the parish in 1863, removed in 1864, and then returned in 1870 as Mrs. Ralph Nesbit. She lived out her life on the Waccamaw Neck, passing away on June 23, 1919, at the age of seventy-three years and seven months, and was buried in All Saints' church yard.[60] Her daughter Emily Jordan Nesbit was married to Charles J. Shannon of Camden at All Saints' Church on April 30, 1895. Emily Nesbit had been confirmed and admitted to the parish in 1880 at All Saints' Church, but apparently moved to Camden after the marriage. The parish register reveals that she died in Camden.[61]

A newspaper article circa 1902 gives an account of a dance held at Pawleys Island that included among its guests Valentine ("Val") Nesbit and his brother Ralph Nesbit, Jr., sons of Ralph and Cora Jordan Nesbit. It read in part: "The Pawleys Island German Club gave its second dance last evening at the 'Barracks.' . . . At 12 o'clock the german was danced, being gracefully led by Mr. Ralph Nesbit, Jr. with Miss Janie Lachicotte. . . ."[62] Both Val and Ralph died in 1938 and were buried in the All Saints' cemetery.

While Daniel W. Jordan stayed in Camden and never returned to his home at Laurel Hill, his children came back, married, lived, and died on the Waccamaw Neck. Most likely the plantation stayed in the Jordan family, but the home there probably was uninhabited. Photographs of the dilapidated house taken in the 1930s indicate that it had been unused for many years. Probably Emily Jordan Nesbit Shannon or other Jordan heirs sold the property to the owners of the Waccamaw Club and Dr. J. A. Mood of Sumter, South Carolina. Dr. Mood was the first to consolidate the four properties called Laurel Hill, Springfield, Brookgreen, and The Oaks plantations, which paved the way for Archer Milton Huntington several years and other owners later.

NOTES

1. George C. Rogers, Jr., *The History of Georgetown County, South Carolina* (Columbia, S.C., 1970), pp. 24, 26; "William Waties," Pre-Revolutionary War Plats and Index to Grants, S.C. Archives; Memorial Book, I (1731-32), 422, 423; II, Part 1, 42; IV (1732-33), 42-43, S.C. Archives.

2. Rogers, *op. cit.*, p. 57; Commons House Journal, No. 7, Part 1, (1723-25), p. 162, S.C. Archives.

3. Rogers, *op. cit.*, p. 57; "The Waties Family of South Carolina" compiled by H. D. Bull, *S. C. Historical Magazine*, XLV (1944), 12-16.

4. Rogers, *op. cit.*, p. 57.

5. *Ibid.*, pp. 30-32; Commons House Journal, No. 6 (1722-24), p. 171, S.C. Archives; British Public Records Office, XII (1725-27), 211-14, S.C. Archives, XIII (1728-29), 31, 44-47, 292-300, S.C. Archives.

6. Rogers, *op. cit.*, p. 35; Miscellaneous Records, II (1751-54), 276-79, S.C. Archives; Henry A. M. Smith, "The Baronies of South Carolina," *S.C. Historical Magazine*, XVIII (1912), 95-101.

7. Rogers, *op. cit.*, pp. 81-82; Frederick Dalcho, *An Historical Account of the Protestant Episcopal Church, in South Carolina* (Charleston, S.C., 1820), p. 305.

8. Rogers, *op. cit.,* p. 57; "Inventory of the Estate of William Waties," recorded July 30, 1743, Inventories, KK (1739-44), pp. 264-68, S.C. Archives.

9. Rogers, *op. cit.,* p. 257; Gabriel Marion was a nephew according to Rogers (p. 133) and an historical marker on Highmarket Street in Georgetown. There are accounts that Francis Marion's father, brother, and nephew were all named Gabriel.

10. Rogers, *op. cit.,* p. 257; Register of Mesne Conveyance Records, A-5, pp. 449-53; P-4, pp. 246-50; T-4, pp. 261-64, S.C. Archives; Weston Collection, S.C. Historical Society.

11. Rogers, *op. cit.,* p. 257; "Plowden Weston," Audited Accounts, S.C. Archives.

12. Rogers, *op. cit.,* p. 257; *Gazette,* March 27, 1775.

13. "Will of Plowden Weston," dated Sept. 18, 1819, proved Jan. 25, 1827, Charleston County Wills, XXXVII, Book A (1826-34), 165-85 S.C. Archives; Mary James Richards, "Our McDowell Ancestry," p. 27, typed copy in the South Caroliniana Library, University of South Carolina, Columbia, S.C.

14. Rogers, *op. cit.,* pp. 258, 524. Rogers writes that Weston bought Hagley from either John Ashe Alston or his brother, Joseph Alston.

15. Rogers, *op. cit.,* p. 272; *Pee Dee Times,* Aug. 27, 1856; H. D. Bull, *All Saints' Church, Waccamaw 1739-1968* (Columbia, S.C., 1968), p. 19.

16. Rogers, *op cit.,* p. 272; Bull, *op. cit.,* p. 33.

17. Bull, *op. cit.,* p. 34.

18. *Ibid.,* p. 19.

19. *Ibid.,* p. 24; "Recollections of a Visit to the Waccamaw," *Living Age,* Aug. 1, 1857, pp. 292-96.

20. Rogers, *op. cit.,* p. 25; Memorial Book, I (1731-32), 422-23; II, Part 1, 42; IV (1732-33), 42-43, S.C. Archives.

21. Conversation with Gurdon L. Tarbox, Jr., Director of Brookgreen Gardens, Winter, 1976.

22. Bull, *op. cit.,* p. 27.

23. *Ibid.,* p. 36-37.

24. *Ibid.,* p. 34.

25. *Ibid.,* p. 111.

26. *Ibid.*

27. Rogers, *op. cit.,* pp. 288-90; Record of Planters Club on Pee Dee, Sparkman Papers, 2732, Vol. 1, Southern Historical Collection, University of North Carolina, Chapel Hill, N.C.

28. *Rules and History of the Hot and Hot Fish Club of All Saints Parish, South Carolina,* compiled by Plowden C. J. Weston (Charleston, S.C., 1860), pp. 15-16.

29. *Ibid.,* p. 7.

30. Rogers, *op. cit.,* pp. 306-7; *The South Carolina Rice Plantation,* ed. J. H. Easterby (Chicago, 1945), pp. 80-81, 83, 86; *Georgetown American,* Dec. 4. 1839; Petition of F. M. Weston (president), E. J. Heriot (vice-president), and A. Glennie (secretary) to Senate and House, 1844, S. C. Archives.

31. Francis Marion Weston to Dr. Arthur B. Flagg, Nov. 19, 1854; Medical Accounts of Dr. Arthur B. Flagg, Hasell-Flagg Manuscripts, S.C. Historical Society; Rogers, *op. cit.,* p. 258n.

32. Rogers, *op. cit.,* p. 258; *Rice Planter and Sportsman,* ed. Arney R. Childs (Columbia, S.C., 1953), pp. 48, 111; *Winyah Observer,* Sept. 29, 1847; "Esdaile of Cothelestone," Sir Bernard Burke, *Landed Gentry* (London, 1898), 1, 467.

33. Rogers, *op. cit.,* pp. 258-59.

34. *Ibid.,* p. 391; C. I. Walker, *Rolls and Historical Sketch of the Tenth Regiment, So. Ca. Volunteers, in the Army of the Confederate States* (Charleston, S.C., 1881), pp. 70, 74; S. Emanuel, *An Historical Sketch of the Georgetown Rifle Guards and as Co. A. of the Tenth Regiment, So. Ca. Volunteers, in the Army of the Confederate States* (n.p., 1909), pp. 8, 9-10.

35. Rogers, *op. cit.,* p. 326; "Rules on the Rice Estate of P. C. Weston; South Carolina, 1856," *De Bow's Review,* XXI (January 1857), 38-44; Charles W. Joyner, "Slave Folklife on the Waccamaw Neck: Antebellum Black Culture in the South Carolina Lowcountry" (PhD dissertation, Univ. of Penn., 1977), pp. 17-18; "Ben Horry" in *Slave Narratives: A Folk History of Slavery in the United States from Interviews with Former Slaves,* typewritten records prepared by the Federal Writers Project, 1936-38, Vol. 14, Part 2, p. 317 (Rare Book Room, Library of Congress).

36. Joyner, *op. cit.,* p. 101; Emily Weston Diary, December 22-28, 1859.

37. Joyner, *op. cit.,* pp. 101-2; Elizabeth Collins, *Memoirs of the Southern States* (Taunton, England, 1865), pp. 17, 61.

38. Joyner, *op. cit.,* p. 194; Plowden C. J. Weston, "Rules and Management for the Plantation, 1859," p. 107; John Beese interviewed by Charles W. Joyner.

39. Joyner, *op. cit.,* p. 190; 1860 Census, Slave Schedules.

40. Joyner, *op. cit.,* p. 203; Weston, "Rules and Management," appended to Elizabeth Collins, *Memories of the Southern States,* p. 105.

41. Joyner, *op. cit.,* p. 194; Emily Weston Diary, April 3,1859; Wyndham Malet, *An Errand to the South in the Summer of 1862* (London, 1863), p. 57; Ben Sparkman Plantation Record, Southern Historical Collection, University of North Carolina; James R. Sparkman to Benjamin Allston, March 10, 1858, Robert F. W. Allston Papers, S.C. Historical Society, Charleston.

42. Joyner, *op. cit.,* p. 224; Emily Weston Diary, December 13, 1859.

43. *Ibid.,* p. 215.

44. Joyner, *op. cit.,* p. 77; Emily Weston Diary, March 15-17, 19-22, 1859.

45. Rogers, *op. cit.,* p. 398.

46. Bull, *op. cit.,* p. 40.

47. Rogers, *op. cit.,* p. 259; Childs, *op. cit.,* pp. 110-11.

48. Rogers, *op. cit.,* p. 259; memberships listed on title page of Plowden C. J. Weston, *An Address Delivered in the Indigo Society Hall, Georgetown, South Carolina, on the Fourth Day of May, 1860* (Charleston, S.C., 1860); *Documents Connected with the History of South Carolina,* ed. Plowden Charles Jennet Weston (London, 1856); Emily F. Weston to Ordinary, April 12 (1864), file 448, Office of Probate Judge, Georgetown, S.C.

49. Rogers, *op. cit.,* p. 258; Anthony Q. Devereux, *The Rice Princes, A Rice Epoch Revisited* (Columbia, S.C., 1973), pp. 90-91; C. B. Berry to Brookgreen Gardens, Nov. 24, 1978, Brookgreen Gardens Archives.

50. Rogers, *op. cit.,* p. 389; Daggett to Col. Charles Alston, Jr., March 23, 1861, Board of Ordnance Papers, S.C. Archives; Childs, *op. cit.,* p. 125.

51. Devereux, *op. cit.,* p. 112; Robert F. W. Allston Papers, S.C. Historical Society.

52. Rogers, *op. cit.,* p. 402; *O. R. Navy,* Series I, XIII, 213-15; Joyner, *op. cit.,* pp. 13-14; 1860 Census, Slave Schedules and Agriculture Schedules.

53. Rogers, *op. cit.,* p. 403; C. B. Berry to Brookgreen Gardens, Nov. 24, 1978, Brookgreen Gardens Archives; "Waite House Fine Example Neo-Classic Architecture," *Camden Chronicle,* 1968 (Our Historic Homes No. 2).

54. Rogers, *op. cit.,* p. 422; Jordan Papers, Sept. 1, 1865, Duke University Library.

55. "Colonel Daniel W. Jordan." C. B. Berry, *The Independent Republic Quarterly,* Winter 1979, 12-15.

56. Rogers, *op. cit.,* pp. 270, 372; Berry letter, Nov. 24, 1978, Brookgreen Gardens Archives.

57. Rogers, *op. cit.,* p. 426; "Daniel W. Jordan," RG 94, National Archives.

58. Bull, *op. cit.,* p. 66.

59. *Ibid.,* pp. 81, 88.

60. *Ibid.,* pp. 88, 106.

61. *Ibid.,* pp. 96, 89.

62. Charlotte K. Prevost and Effie L. Wilder, *Pawleys Island, A Living Legend* (Columbia, S.C., 1972), pp. 71-72.

The Oaks Plantation

Home of the Alston Family

JOSEPH ALLSTON (1733-1784), known as Joseph of The Oaks, was a son of William Allston and Esther LaBrosse de Marboeuf. He married Charlotte Rothmahler in 1755, and they owned what are now four plantations: Turkey Hill, Willbrook, Oatland, and The Oaks. In 1768 and 1769 Allston was elected to represent All Saints' Parish in the Assembly.[1] He also was elected to serve in the First Provincial Congress, which met at Charleston in 1775. After the Boston Tea Party in 1774 he had contributed money toward relief efforts, along with other planters in the district.[2] Allston was a militant colonial patriot in an area where loyalties to the king of England were strong. His membership in the "Committee of Observation and Inspection" for Prince George Parish bears this out, since this group demanded a commitment to rise up against the king if ordered by Congress.

Josiah Quincy in 1773 described his visit with Joseph Allston at The Oaks:

Spent this night with Mr. Joseph Allston, gentleman of immense income all of his own acquisition. He is a person between 39 & 40, and a very few years ago begun this world with only 5 negroes—has now five plantations with an hundred slaves on each. He told me his neat income was but five or six thousand pounds sterling a year, he is reputed much richer. His plantation, negroes, gardens, etc., are in the best order of any I have seen! He has propagated the Lisbon and Wine-Island grapes with great success. I was entertained with more true hospitality and benevolence by this family than any I had met with. His good lady filled a wallet with bread, biscuit, wine, fowl and tongue, and presented it next morning. The wine I declined, but gladly received the rest. At about twelve o'clock in a sandy pine desert I enjoyed a fine regalement, and having met with a refreshing spring, I remembered the worthy Mr. Allston & Lady with more warmth of affection and hearty benizons, than ever I toasted King or Queen, Saint or Hero.[3]

At his death in 1784 he left to his elder son, Captain William Allston (who later dropped an "l" from his last name), Clifton Plantation, and to his younger son, Thomas, Prospect Hill.[4] The Oaks was left to his grandson, Joseph, son of William of Clifton. Joseph Alston, at the tender age of five, became a rich young man. His grandfather left him approximately 1,300 acres and one hundred slaves to be attained when he was twenty-four. Until he reached that age he received all the rents and income from the plantation.[5]

Joseph's father, "King Billy," had great ambitions for the boy and planned his education around these goals. As Joseph himself wrote: "From my father's plan of education for me, I may properly be called a hot-bed plant. . . . Before seventeen I finished my college education; before twenty I was admitted to the bar."[6] There is no evidence that he ever practiced law, however. When he first came North and met Theodosia Burr, daughter of Aaron Burr, at the end of the 1790s, he was an immensely rich and talented young man with the prospects of enormous political influence in South Carolina, which was one of the key states in the Union. While Theodosia may have fallen in love with his personal characteristics, her father undoubtedly wanted to use his money and control his political destiny. Joseph must have enjoyed the admiration lavished upon him.[7]

He was aware of the great changes marriage to him would make in Theodosia's life, and to reassure her wrote a long letter portraying his society. It said in part:

With regard to our manners, if there is any state which has a claim to superior refinement, it is certainly South Carolina. Generally speaking, we are divided into but two classes, very rich and very poor; which, if no advantage in a political view, is undoubtedly favourable to a polished state of society. Our gentlemen haveing large fortunes, and being very little disposed by the climate to the drudgery of business or professions, have full leisure for the attainment of polite literature, and what are usually called accomplishments; you therefore meet with few of them who are not tolerably well informed, agreeable companions, and completely well bred. The possession of slaves renders them proud, impatient of restraint, and gives them a haughtiness of manner which, to those unaccustomed to them, is disagreeable; but we find among them a high sense of honour, a delicacy of sentiment, and a liberality of mind, which we look for in vain in the commercial citizens of the northern states.

He also provided a character analysis of southern manhood:

The genius of the Carolinian, like the inhabitants of all southern countries, is quick, lively, and acute; in steadiness and perseverance he is naturally inferior to the native of the north; but this defect of climate is often overcome by his ambition or necessity; and, whenever this happens, he seldom fails to distinguish himself. In this temper he is gay and fond of company, open,

generous, and unsuspicious; easily irritated, and quick to resent even the appearance of insult; but his passion, like the fire of the flint, is lighted up and extinguished in the same moment. I do not mention his hospitality and kindness to strangers, for they are so common they are no longer esteemed virtues; like common honesty they are noticed only when not possessed. Nor is it for the elegance of their manners only that the South Carolinians are distinguished; sound morality is equally conspicuous among them. Gaming, so far from being a fashionable vice, is confined entirely to the lower class of people; among gentlemen it is deemed disgraceful. Many of them, it is true, are fond of the turf; but they pursue the sport of it merely as an amusement and recreation, not a business. As to hunting, the country gentlemen occasionally engage in it, but surely there is nothing criminal in this! From my education and other pursuits I have seldom participated in it myself; but I consider it, above all exercises, the most manly and healthful.[8]

Notice how he explained the "sport of kings," or horse racing, to Theodosia. Since it was one of the Alston family's prime passions he neatly condoned it under the label of "amusement," neglecting to say that considerable purses had been won by the horses from his father's own stables.

They were married in Albany, New York, in February, 1801. Alston was twenty-two and his bride was seventeen. The last stop on their honeymoon was Washington, where they saw the inauguration of Thomas Jefferson as president and Aaron Burr as vice-president of the United States. After their return to South Carolina, the young couple lived with Joseph's brother, John Ashe Alston, at Hagley Plantation until their home at The Oaks was ready. The Alstons moved into The Oaks house in March of 1804. The birth of Aaron Burr Alston in 1802 had inspired hope in both families for a lasting union.[9] The boy, next to Theodosia, was the dearest thing on earth to Aaron Burr. Theodosia filled entire letters with narratives of the boy's exploits and sayings. Burr wrote back: "You are a dear, good little girl to write me so, and of dear little Gampy too, so much; yet never enough."[10] Gampy was the child's way of pronouncing Grandpa, and Burr never called him by any other name, unless it was some variation of the same word.

In November, 1802, Burr had pushed Alston to go early to the opening of the legislature. Someone had implied in a newspaper article that the Alston family had no influence in South Carolina, and Burr thought it best that Joseph be ready to defend his position as a district representative. Burr also thought he should buy or build a summer residence in the upcountry of South Carolina (Alston eventually bought a place in Greenville), both to provide a healthful climate for his family during the summer and to increase Alston's influence and "Connexions."[11] During this time many other planters were purchasing summer homes in the upcountry. The subtle manipulation of Joseph's career had begun. While Alston did follow most of Burr's suggestions, he had enough ambition of

his own to gain prominence in the political arena. He kept in touch with South Carolina statesman Benjamin Huger and shared his state sovereignty views. In his Fourth of July oration in 1806 at Georgetown, Alston stated that he would consider the U. S. Constitution "perfect" with "a single alteration—the house of representatives formed like the senate—in other words, equal influence in the general government preserved to every state."[12]

Within the state he was a dominant figure in the movement to unite the lowcountry with the backcountry, which culminated in the constitutional amendment of 1808. Backcountry farmers had become planters, and, although Alston and some other planters were against reopening the slave trade, the introduction of slaves into the backcountry spread the planters' lifestyle. Alston argued in favor of more representation for the backcountry, because he saw no reason to discriminate against these people "when . . . they have assimilated so nearly to the privileged districts below. . . ."[13]

Before his duel with Alexander Hamilton, Aaron Burr wrote a last letter to Theodosia giving her instructions about the disposition of his papers. He also requested that she give certain tokens of his remembrance to his stepson Frederic, to his ward Natalie (Mrs. Thomas Sumter, Jr.), and various friends. His letter concluded with these words:

> I am indebted to you, my dearest Theodosia, for a very great portion of the happiness which I have enjoyed in this life. You have completely satisfied all that my heart and affections had hoped or even wished! . . . Let your son have occasion to be proud that he has a mother.[14]

In a postscript he gave her a seal of George Washington's which he possessed and advised her to "keep it for your son, or give it to whom you please."[15] In a long letter to Joseph, he wrote:

> If it should be my lot to fall, yet I shall live in you and your son. I commit to you all that is most dear to me—my reputation and my daughter. Your talents and your attachment will be the guardian of one—your kindness and your generosity of the other.[16]

There are differing views of Alston's involvement in Burr's westward plans. Joseph did lend him money, traveled to the west with him in the summer of 1806, and publicly approved of his plans: which were to revolutionize Mexico and to settle the lands that Burr had acquired.[17] One Burr biographer wrote:

> Who were his confederates? Before all others, his daughter, who was devoted to the scheme heart and soul. To achieve a career, and a residence, which she, her husband, and her boy could share, were the darling objects with which Burr had gone forth to seek a new country. She caught eagerly at his proposal. . . . Her husband . . . who tenderly loved Theodosia, entered into the enterprise with energy.[18]

After Aaron Burr had been apprehended, Alston wrote a public letter to Governor Charles Pinckney (February 6, 1807) denying that he was a conspirator and trying to explain Burr's actions. During the trial for treason, Theodosia Burr Alston was her father's housekeeper and companion. Joseph was with her and sat by her father's side when he was arraigned.

Following his acquittal, Aaron Burr traveled to Europe. In November, 1808, Theodosia, who never had adjusted to the climate of South Carolina and had become frail after her son's birth, was having another bout with sickness. Burr consulted the most celebrated physicians of London, and they recommended that Theodosia take a voyage to Europe. Preparations were made for her reception: Jeremy Bentham, the great writer and critic, offered her his house; General Sir Samuel Bentham, brother of the author, was to take Gampy home to be educated with his own children. The most minute directions were forwarded to Theodosia, and Burr wrote to Joseph offering to pay half the expense. The project was never carried out though, since Theodosia's sickness took a favorable turn. In the spring her health seemed to be permanently improved, and Burr's fears for her life were assuaged. Because of her fate four years later, one wonders what might have occurred had she taken the voyage to see her father in 1808.

In Paris Burr wrote in his diary:

> It is now so cold that I should be glad of a fire; but to that I have great objections; for what would become of the 50 plays, and something, I won't tell what, which I meditate to buy for Gampillo, that will make his little heart beat.

And,

> I never spend a livre that I do not calculate what pretty thing it might have bought for you [Theodosia] and Gampillo.[19]

Unfortunately, during his residence in Paris, nearly a year passed without Burr's receiving a letter from her; one packet of letters reached him twenty-three months after posting. Yet father, daughter, and grandson sent letters by every ship that sailed. The embargo and nonintercourse acts had paralyzed the industry of the United States, and Theodosia wrote that the country was in an awful state. Joseph had "offered the two lower plantations for sale, but everybody was trying to sell, and no one would buy." Even Joseph "condemned the present measures of government, and joins in the almost universal cry of free commerce or war."[20]

In another letter to Burr, Theodosia wrote that someone had written to Joseph accusing him and Burr of "plans that never entered the heads of either," and threatening immediate exposure unless Mr. Alston would purchase his silence with $35,000.[21] This was Harman Blennerhassett, former compatriot of Burr's in the westward expansion scheme, who reportedly lost his fortune when the plans fell through. He said he had the pamphlet already written and that its revelations would blast the character of Joseph Alston forever. "To Mr. Alston," said Theodosia, "he used such language as a low-bred coward may use at a distance of many hundred miles." She added that her husband had paid no attention to the "audacious swindling trick."[22]

These hard times were bearable only because Burr and the Alstons had bright hopes for their young heir Aaron Burr Alston. Theodosia's will to live had been severely drained when her father left the country, but when her child died from malaria in June, 1812, it seemed like the beginning of the end for her. About six weeks after his return to New York Burr received Theodosia's reply to the news that he was back:

> A few miserable days past, my dear father, and your late letters would have gladdened my soul; and even now I rejoice at their contents as much as it is possible for me to rejoice at any thing; but there is no more joy for me; the world is blank. I have lost my boy. My child is gone for ever. He expired on the 30th of June. My head is not now sufficiently collected to say any thing further. May heaven, by other blessings, make you some amends for the noble grandson you have lost.[23]

Alston added these lines to the sad note:

> One dreadful blow has destroyed us; reduced us to the veriest, the most sublimated wretchedness. That boy, on whom all rested; our companion, our friend—he who was to have transmitted down the mingled blood of Theodosia and myself—he who was to have redeemed all your glory, and shed new luster upon our families— that boy, at once our happiness and our pride, is taken from us—is dead.[24]

The eloquently expressed grief of Joseph and Theodosia was equalled by that of Aaron Burr, who had been extremely attached to his namesake. A month after the child's death, Theodosia wrote again to her father:

> Whichever way I turn, the same anguish assails me. You talk of consolation. Ah! you know not what you have lost. I think Omnipotence could give me no equivalent for my boy; no none— none.[25]

Alston's political career had not been affected by his personal grief, since he was elected governor of South Carolina in December, 1812. But worse had yet to come. Theodosia had waited several months for a safe and suitable opportunity to travel to New York to see her father. Since Joseph was now governor as well as general of the militia, and the country was at war with Great Britain. He could not leave the state to accompany her. One source wrote that Theodosia was too ill to stand the trip over land, and, anyway, her coachman was a drunkard who needed male supervision; so it was decided that she would travel by sea on a small schooner named the *Patriot,* "which, after a privateering cruise, had put into Georgetown and was about to return to New York with her guns stowed below."[26] Traveling along was her maid and Timothy Green, a physician and friend of her father. According to legend, Theodosia, Dr. Green, and

William Algernon Alston, her brother-in-law, walked down the old rice-field steps of Brookgreen Plantation (at the rear of Brookgreen Gardens today) to board a small boat that took them to Georgetown where the *Patriot* was docked. However, it is unlikely that this ever happened, since Brookgreen at that time was owned by the Ward family, which had no close ties to the Alstons, and The Oaks had its own private dock. Also, workers restoring the steps for Archer M. Huntington found a newspaper inside a bottle beneath the steps, and the date on the paper cast doubts that the steps had existed in 1812.[27]

Theodosia sailed on December 30, 1812, and was supposed to reach New York in five or six days, but the *Patriot* was never heard from again. One can imagine the agony suffered by Alston and Burr; all the eager letters written between the two, hoping for some news of the *Patriot*. No one knows exactly what happened, but most historians believe the ship went down in a violent storm off the coast of North Carolina near Cape Hatteras. Some say the ship was heavily loaded when she docked in Georgetown and that Governor Alston had added to the weight by sending along a cargo of rice to be sold in New York. The combination of poor maneuverability and a terrible storm prevented the *Patriot* from righting herself in heavy waves. Another theory was that one of the guns stored below broke loose and caused the ship to list excessively and eventually to go under. Some offered the explanation that an English warship had attacked and sunk the *Patriot,* but Theodosia, as South Carolina's First Lady, had with her a letter signed by her husband that assured her amnesty and safe passage if stopped. As a matter of fact, a British ship actually did intercept the *Patriot* shortly after she left Georgetown, but permitted her to proceed unmolested after the captain spoke with Theodosia. And then there were other stories:

It was long before Burr could relinquish the idea that some outward-bound ship might have rescued the passengers, and carried them away to a distant port, whence soon the noble Heart would return to bless her father's life. By-and-by some idle tales were started in the newspapers, that the *Patriot* had been captured by pirates, and all on board murdered except Theodosia, who was carried on shore a captive.[28]

Some versions of this particular tale relate that pirates on their deathbeds confessed they were present when the *Patriot* was taken and that all on board were forced to walk the plank, including Theodosia who walked into the sea with her head held high. Burr wrote to Alston that he felt "severed from the human race."[29] On February 25, 1813, Joseph Alston wrote back: "This then, is the end of all the hopes we had formed. . . . Oh my friend, if there be such a thing as the sublime of misery, it is for us that it has been reserved."[30] Alston had hoped to serve as general of the militia on the Canadian front to occupy his mind, but as governor he still could not leave the state. Even with the immense Alston family around him Joseph was

left alone in his pain, and his personality underwent a change for the worse.

Three years later Burr contacted Alston, who was then a state senator, to lead South Carolina against the caucus that was preparing to nominate James Monroe as president. He wrote to Alston:

If, then, there be a man in the United States of firmness and decision, and having standing enough to afford even a hope of success, it is your duty to hold him up to public view: that man is Andrew Jackson. Nothing is wanting but a respectable nomination, made before the proclamation of the Virginia caucus, and Jackson's success is inevitable. If this project should accord with your views, I could wish to see you prominent in the execution of it. It must be known to be your work. Whether a formal and open nomination should now be made, or whether you should, for the present, content yourself with barely denouncing, with a joint resolution of both Houses of your legislature, congressional caucuses and nominations, you can only judge. . . .[31]

Unfortunately Alston died that year, on September 10, 1816, at the age of thirty-seven. He was buried in the Alston family cemetery at The Oaks, which members of the family called "God's Acre."[32] Little Gampy also had been buried there along with William Alston of Clifton Plantation (Joseph's father), Joseph Allston of The Oaks (his grandfather), and other members of the Allston-Alston family who owned plantations in the area. The epitaph to Joseph Alston, Theodosia Burr Alston, and Aaron Burr Alston reads:

Erected to the Memory
of
Joseph & Theodosia Burr Alston
and of their son
Aaron Burr Alston
This last died in June 1812 at the age of 10 years
and his remains are interred here.
The disconsolate Mother perished a few
months after at sea.
And on the 10th Sept. 1816 died the Father
When little over 37 years of age whose remains
rest here with his Son's.
The loss of this Citizen was no common one to
the State. To its service he devoted himself from
his early years.
On the floors of its legislature, he was
distinguished for his extensive information and
correct decisions: And everywhere, he was
distinguished for his zealous attachments to
republican principles.
In the capacity of Chief Magistrate of the
State, when both the honor and the responsibility
of the trust were heightened by the
difficulties and dangers of the War of 1812,
he by his indomitable activity and his salutary
measures earned new titles to the respect and the
Gratitude of his fellow citizens.
This great man was also a good one.
He met death with that fortitude with which

his ancestor did from whom he received his name and this estate and which is to be found only in the good hoping to rejoin those whose loss had left in his heart, 'an aching void' that nothing on earth could fill.[33]

At Joseph's death The Oaks passed to his nephew and namesake, Joseph Alston, eldest son of William Algernon and Mary Alston. He was married to Helen Mason, a great beauty from New York, and continued to plant rice at The Oaks until his death in 1855. This Joseph Alston was a member of the Parish Church of All Saints, Waccamaw. In 1845, Alexander Glennie, rector of the church, reported that $1,820 had been made from the sale of pews, of which $130 was contributed by Joseph Alston, Jr., for pew number 14.[34] It is possible he may also have inherited Hagley Plantation, since some records list Governor Joseph Alston as owner of both Hagley and The Oaks. Another source states that Francis M. Weston bought Hagley from either the governor or his brother John Ashe Alston.

The sons and grandsons of William of Clifton had the best homes and lots in Charleston. Joseph lived first at 9 East Battery and later at 24 Pitt Street.[35] Governor and Mrs. Alston also had resided in splendor during certain months of the year at the Miles Brewton House, home of Joseph's father "King Billy." The social season was in February, and the planters also sought to escape the "fever vapours" during the summer at their Charleston homes and seaside residences.

The younger Joseph Alston was a member of the Hot and Hot Fish Club, joining the group sometime between 1845 and his death in 1855. He was a charter member (1839) of the Planters Club. In the *Records of the Planters Club on Pee Dee* he is listed as "Colonel Joseph Alston, Waccamaw,"[36] but it is not known how he acquired this military rank.

Joseph and Helen Alston had one child, William Algernon Alston, named for his grandfather. There is a story that Joseph and Helen were interred in a vault in All Saints churchyard and that for many years one could see the embalmed form of Helen, but the vault was later sealed.[37]

Josephine Alston, Joseph's beautiful and accomplished sister, married her cousin Thomas Alston on May 5, 1833. They also had a son Joseph, called "Jose" by the family, who was born June 13, 1834. According to family stories "Jose" was ill-mannered and undisciplined but was permitted to act that way since his mother had died shortly after his birth. His father also passed away when he was but a few years old, and "Jose" grew into a rebellious young man who scorned authority. He married a girl from the north, of whom little was ever known, lived a few years at The Oaks, which he supposedly inherited, then went north again where he died, leaving no children. After this, The Oaks was destroyed by fire.[38] Very little is known of this Joseph, who may never actually have inherited The Oaks since his cousin William Algernon Alston II was the last known owner.

Because all the sons of William A. Alston, Sr., died before him, their properties came back into his estate. At his death in 1860 these lands passed to William Algernon Alston II, Joseph and Helen Alston's son, and The Oaks was enfolded into the vast Clifton estate. This William Alston reportedly weighed three hundred pounds and lived well as an absentee landlord on Cherry Street in New York City.[39] In addition to Clifton and The Oaks he inherited eight other plantations: Michaux, Calais, Strawberry Hill, Friendfield, Marietta, Youngville, Rose Hill, and Forlorn Hope. These plantations comprised almost all the land on the southern portion of Waccamaw Neck, except for The Oaks, making the rotund William Alston the second wealthiest rice planter in the district.

A letter from Mrs. R. F. W. Allston of Chicora Wood Plantation to her daughter Jane, August 1, 1865, revealed that Helen Alston was still living in the area: "We hear that Helen Alston has to cut wood and bring it in from the woods, cook and wash and labour in every way."[40] So even though her son lived in New York, she remained on the plantation during the Civil War.

In November, 1865, Alston's Clifton estate (including The Oaks) was tilled under the direction of the Freedman's Bureau until December when the rice was sold. Half the proceeds went to the government and half to the freedmen. These lands had been considered abandoned plantations, so it was essential that Alston obtain a pardon from the President. On October 31, 1865, in Charleston at the age of thirty-one he took the oath.[41]

In a will dated November 14, 1860, William Alston left Marietta and Friendfield to Thomas P. Alston, Jr., and left Strawberry Hill, Calais, and Michaux to his cousins Algernon and Rowland Alston, sons of John Ashe Alston. The will was not proven until November, 1867, after William died leaving no wife or children.[42]

It is odd that no record can be found of the marriage of Joseph Alston and Helen Mason, the birth of their son William Algernon, or the deaths of father, mother, and son in the Parish Register of All Saints' Church. Perhaps the Alstons were married in New York, and probably the son was buried

there since that was where he died. Because all the previous owners of The Oaks had been buried at the cemetery there, it would seem that these Alstons should have been interred there also. Despite the family story of the "open" vault of Helen Alston, the grave cannot be found in All Saint's cemetery, and the interment is not recorded in the Parish Register.

After William's death in 1867[43] The Oaks remained in the Alston family as part of the Clifton estate even though the plantation probably was uninhabited. While The Oaks was not specifically mentioned in the will, William gave the remainder of his real and personal estate to Thomas Pinckney Alston, Jr., who died a year after him, in 1868. Dr. J. A. Mood of Sumter, South Carolina, must have purchased The Oaks from one of the Alston heirs when he bought the property in 1920 as sponsor of the Waccamaw Club.

NOTES

1. George C. Rogers, Jr., *The History of Georgetown County, South Carolina* (Columbia, S.C., 1970), p. 99.
2. *Ibid.*, p. 107; Edward McCrady, *The History of South Carolina Under the Royal Government 1719-1776* (New York, 1899), pp. 743-44.
3. Rogers, *op. cit.*, p. 99; "Journal of Josiah Quincy Junior, 1773," *Proceedings of the Massachusetts Historical Society*, XLIX (1915-16), 453.
4. Rogers, *op. cit.*, pp. 187-88; "Will of Joseph Allston," Allston and LaBruce Family Records, South Caroliniana Library, Columbia.
5. Susan Lowndes Allston, *Brookgreen Waccamaw in the Carolina Low Country* (Charleston, S.C., 1956), pp. 20-21.
6. Rogers, *op. cit.*, p. 188; Matthew L. Davis, *Memoirs of Aaron Burr* (New York, 1836), I, 425-26.
7. Rogers, *op. cit.*, p. 188.
8. *Ibid.*, p. 189; Davis, *op. cit.*, pp. 430-32.
9. Rogers, *op. cit.*, p. 190.
10. James Parton, *The Life and Times of Aaron Burr* (New York, 1858), p. 299.
11. Rogers, *op. cit.*, p. 191; Davis, *op. cit.*, pp. 183-84.
12. Rogers, *op. cit.*, pp. 191-92; *An Oration for The Fourth of July 1806; Delivered by The Hon. Joseph Alston, Esq. in the Episcopal Church . . .* (Georgetown, S.C. 1806), p. 10.
13. Rogers, *op. cit.*, p. 192; *Speech of Joseph Alston, Member of the House of Representatives, for Winyaw, in a Committee of the Whole, to which was referred the bill for amending the third and seventh sections of the first articles of the Constitution of this State* (Georgetown, S.C., 1808), p. 16.
14. Parton, *op. cit.*, pp. 351-52.
15. *Ibid.*
16. *Ibid.*
17. Rogers, *op. cit.*, p. 196; Davis, *op. cit.*, p. 379; Joseph Alston to Charles Pinckney, Feb. 6, 1807, Charleston *Courier*, Feb. 14, 1807.
18. Parton, *op. cit.*, p. 410.
19. *Ibid.*, p. 556.
20. *Ibid.*, p. 564.
21. *Ibid.*, p. 566.
22. *Ibid.*
23. *Ibid.*, p. 597.
24. *Ibid.*
25. *Ibid.*, p. 598.
26. *Ibid.*
27. Conversation with Gurdon L. Tarbox, Jr., Director of Brookgreen Gardens, Winter, 1976.
28. Parton, *op. cit.*, p. 599.
29. *Ibid.*
30. Rogers, *op. cit.*, p. 197; Davis, *op. cit.*, II, pp. 428-32.
31. Parton, *op. cit.*, pp. 607-8.
32. *Rice Planter and Sportsman*, ed. Arney R. Childs (Columbia, S.C., 1953).
33. "The Oaks Cemetery—Inscriptions on Tomb Stones," Brookgreen Gardens Archives, 1971, II.
34. The Rev. Henry D. Bull, *All Saints' Church, Waccamaw 1739-1968* (Columbia, S.C., 1968), p. 35.
35. Rogers, *op. cit.*, p. 319; Childs, *op. cit.*, pp. 106-7.
36. Rogers, *op. cit.*, p. 288; "The Secretary's Records of the Planters Club on Pee Dee," Sparkman Papers, 2732, Vol 1, Southern Historical Collection, University of North Carolina, Chapel Hill, N.C.
37. Elizabeth Deas Allston, *The Allstons and Alstons of Waccamaw Neck* (privately printed, 1936), p. 17.
38. *Ibid.*, p. 18.
39. Charles Winston Joyner, *Slave Folklife on the Waccamaw Neck: Antebellum Black Culture in the South Carolina Lowcountry* (PhD dissertation, University of Pennsylvania, 1977), p. 11.
40. *The South Carolina Rice Plantation*, ed. J. H. Easterby (Chicago, 1945), p. 212.
41. Rogers, *op. cit.*, p. 426; Letter, William A. Alston to Andrew Johnson, October 31, 1865, Amnesty Papers, S.C., RG94, National Archives.
42. Rogers, *op. cit.*, p. 268; "Will of William Algernon Alston," written in New York City and dated Nov. 14, 1860, proved Nov. 4, 1867, Charleston County Wills, LI (1862-68), 762-64, S.C. Archives.
43. Joyner, *op. cit.*, p. 11; Rogers, *op. cit.*, p. 523.

Brookgreen and Springfield Plantations

Home of the Allston, Flagg, Ward, Hasell, and Willett Families

JOSEPH A. GROVES in *The Alstons and Allstons of North and South Carolina* gives this character analysis of the family:

In personal appearance they were tall, erect, muscular, with florid complexion, blue eyes, and brown or flaxen hair. . . . Strong in their attachments and unyielding in their antagonisms, they have ever been ready to make common cause with a friend, defend injured innocence, befriend the weak, or fight against whatever they conceived to be injustice, wrong or oppression, and as masters were kind and considerate to their servants. Their own conduct being open and above board, they held in abhorrence all sham or pretense of every kind, or anything that savored of dishonesty or meanness, preferring death to dishonor.[1]

Perhaps the reader should take these noble descriptions with more than the customary grain of salt, but at least some general idea of the family can be formed.

The land of Brookgreen and Springfield was originally granted to the eight Lords Proprietors, who remained the supreme landlords until the crown bought their rights in 1729.[2] Under the Proprietors a system of land grants had developed, which, with few changes, was followed later by the royal authorities. The text of a royal grant to John Allston during the reign of George II reads:

Did give and Grant unto Mr. John Allston all that parcel & tract of land . . . Reserving to US, and our Heirs . . . all white pine trees, 1/10 part of mines of silver & gold only & John Allston yielding and paying to us, our heirs & successors, or to our Receiver General . . . at the rate of 3 shillings sterling or 4 shillings proclamation money . . . for every hundred acres . . . provided they clear & cultivate at the rate of one acre for every 500 acres.[3]

Two of John's sons, John and William, were pioneers on the new frontier opened up beyond the Santee River in the future Georgetown District (north of Charleston). Between the years of 1732 and 1739 they received grants of 6,500 acres.[4] This land, along with later acquisitions, was passed on to their children (nine sons and seven daughters) who survived them. Their family intermarried with the Belins, LaBruces, Marions, Simonses, Moores, Atchisons, Watieses, and Rothmahlers. It has been said that at one time or another four-fifths of the rice plantations on Waccamaw Neck were owned by their descendants.[5]

The Waccamaw planters were beginning to frequent the balls and races of Charleston by the mid-1700s. A race was held in Georgetown as early as March 2, 1743, when "a very fashionable Piece of Silver Plate" valued at £150 currency was "to be run for."[6] The Georgetown horses were so good that they dominated the racing in Charleston. Dr. John Murray's horse Skim won one race at Charleston in 1765 and Thomas Lynch's Havana another. In 1769 William Allston's horse Tryal won.[7] Susan L. Allston wrote in *Brookgreen Waccamaw:*

A patron of Agriculture and Justice of the Peace . . . William was also a patron of the turf. The *South Carolina Gazette* for February 9, 1769, says: "Last Tuesday the following horses started at Newmarket for the Charles Town Subscription Plate, carrying weight for age, and came in, viz; William Allston, Esqr.'s chestnut horse Tryal, got by Cade, 5 yrs. old, weight 9 st. 4 lb." came in first. The paper continues, "The second heat afforded good sport . . . but Tryal's bottom brought him through victorious."

Miss Allston also described the bowl Tryal won:

The etching on the old white silver of a race horse in full action is entrancing. This bowl was made to order in London by Abram Portal as proved by the silver mark. It was sent to the Smithsonian Institute in Washington in a loan exhibit and was . . . pronounced by Dr. Marcus Benjamin to be the finest piece of Paul Revere's work he had ever seen. . . . That would lend color to the probability that though there were a number of silversmiths in Charleston at that time, the bowl was sent on to Boston to be marked, and the beautiful etching was done there.[8]

Miss Allston cited this as a possible reason why the date on the bowl was 1768 and the date of the paper reporting the race was 1769.

The two sons of the immigrant John Allston, William and John, secured grants in 1734 and 1735 on the Waccamaw River.[9] John married first Deborah Simons, then Sarah Belin, leaving at his death in 1750 four sons (John, Josias of Turkey Hill, William of Brookgreen, and Samuel) and one daughter, Martha, the wife of Benjamin Marion. William of Brookgreen was the founder of the most famous branch of the double "l" Allstons, since John had no sons, Samuel never married, and Josias moved to North Carolina temporarily.[10] The other branch of the family, established by the first William, later dropped an "l" from its name to prevent confusion. It is also believed that the original family name in England was Alston, derived from the old and honored Alstane family. The immigrant John, for unknown reasons, added an "l" either on the voyage to Charleston or after he reached South Carolina. William of Brookgreen was known as William Allston, the younger, or William Allston, Jr., to distinguish him from his uncle as well as his first cousin William of Clifton Plantation, who dropped the "l" in 1791, just before George Washington's visit.[11]

William Allston of Brookgreen had a brother John and a sister Martha. John married Esther Marion and Martha married Benjamin Marion, who were sister and brother of General Francis Marion, the Swamp Fox. Besides serving under Marion as a captain, William also used his wealth during the Revolution to support the patriots in North Carolina and at Snow's Island, Marion's hideout.

Along with thirty-three other planters in Prince George and Prince Frederick parishes, Allston contributed £732.5 for the relief of Boston after the Tea Party on July 6, 1774. Also, he was paid for slave labor contributed from his own work force for the fortification of Georgetown in 1782.[12] Apparently Allston was still considered head of the household, even though he had died in 1781.

On January 9, 1775, Captain Allston married his second wife, Rachel Moore, who was a beautiful woman from one of the best families in Charleston.[13] At this time he had two children (Elizabeth and Benjamin) from his first marriage, to Anne Simons who died in 1773. Rachel had been pressured into the marriage by her parents. John Moore, Rachel's father, was a very rich aristocrat and staunch patriot. He lent the government the large sum of £14,000 in gold to help in the war.[14] William and Rachel had five more children: Mary, Washington, and William living to adulthood, and a son and a daughter dying in infancy. In *The Life of Marion* William Allston was called ". . . a firm patriot and good soldier . . . he may well be enumerated among the martyrs to the cause of his country, for having been seized with a fever in camp, he had scarcely time to reach his home, where he expired at a middle age."[15]

His death date is unclear. Inscribed on Allston's tombstone in the cemetery at Turkey Hill is "July 31, 1780, aged 42 years," whereas all other written accounts list the year of his death as 1781.[16] The popular story relates that William became mysteriously ill at the Battle of Cowpens in the northwestern part of the state, rode hard all the way to Brookgreen, and collapsed and died a few days later. The battle took place January 17, 1781.[17] Another source gives Allston's death date as July 31, 1781.[18] If the Battle of Cowpens story is true then he was ill for a little over six months before his death. Also puzzling is the fact that his last child was born September 25, 1781, a few months after his death.[19] Because the child must have been conceived sometime in December of 1780, this completely refutes the death date on the tombstone. Most probably, the stone was not placed at the grave until several years later; since stone does not occur naturally in this area it had to be ordered. With the high rate of infant mortality at the time, most families waited

until more than one stone was needed to place an order. Either the carver made a mistake, or the actual death date had been forgotten by the time the order was filled.

William Allston also was elected to the legislature after his death. The infamous elections for the Jacksonborough Assembly, held on December 17th and 18th in 1781, were characterized by ballot boxes stuffed with the names of voters and candidates who were deceased or fictitious. The Assembly was the first legislative body to meet in South Carolina since February 12, 1780, and the need for revenge against the Tories was strong. Captain William Allston, Jr., was elected, along with Nathaniel Dwight, to represent All Saints' Parish.[20]

In the period before June, 1776, Georgetown and the surrounding area had played a minor role, except in one important instance. As the British Navy began to patrol the entrances to Charleston harbor, Georgetown became an important port of entry for munitions ships. Because of these imports Georgetown soon had a surplus of powder and began to supply neighboring areas. In January, 1776, an urgent request came from Cornelius Hartnett, president of the Wilmington Committee of Safety. He had written Paul Trapier of the Georgetown Committee for two or three thousand pounds of powder, since loyalists were known to be rallying at that time in Guilford County in preparation for a march on Wilmington. Trapier, after consulting with the leaders in Charleston, shipped seven hundred pounds of powder to Brookgreen Plantation on the Waccamaw, which was received there by a detachment of men from Wilmington. In this way the Georgetown committee helped the patriots keep the loyalists in check.[21]

After the skirmish at Georgetown on December 28, 1780, where Sergeant McDonald bayonetted Major Micajah Ganey, the next confrontation came near Brookgreen Plantation.[22] In January, 1781, Lieutenant Colonel George Campbell, Tory officer in command at Georgetown, sent out detachments to secure horses and salt on the Waccamaw Neck. At the same time, General Francis Marion sent Colonel Peter Horry to collect boats and drive off cattle at Brookgreen Plantation. Horry came upon a group of twenty British by surprise and chased them. But he soon met up with Campbell, himself, and about thirty-six men. Since Horry had only a handful of men, he was forced to retreat, but he did manage to capture two dragoons. Another source listed one man wounded and two horses killed on the patriot's side, and British casualties included three men dead, four horses killed, and two men captured.[23]

According to a local legend, Brookgreen Plantation was seized in the spring of 1781 by Lord Cornwallis, who set up headquarters there.[24] The plantation that spring was occupied by Rachel Moore Allston, widow of Captain William Allston. Supposedly, a short time after Allston's death Cornwallis and his troops moved into Brookgreen, taking over the house and requiring Mrs. Allston to entertain them. The duration of Cornwallis's stay at the plantation and his business there are

not part of the legend. The only available account of this visit comes from Jared Flagg's book, *The Life and Letters of Washington Allston.* According to the book Cornwallis and his officers were extremely kind and courteous and acted more like gentlemen visiting friends than hostile soldiers occupying an enemy's house. Nothing was destroyed and Mrs. Allston was pleased with their considerate behavior. When Cornwallis learned from servants that there was a young boy named Washington in the household, he asked Mrs. Allston to present the child, whom he nicknamed the "Little General." She did, and Washington was carried around the table while the British officers made quite a fuss over him.[25] Since the only written account of the visit is in Flagg's book, its authenticity is doubtful.

Letters between Cornwallis and Colonel Nisbet Balfour indicate that in the spring of 1781 Lord Cornwallis was in North Carolina at the Battle of Guilford Court House. At that time he had the alternatives of returning to South Carolina, marching toward Wilmington, or heading for Virginia. For several reasons he decided on Wilmington; however, Balfour had to keep open a possible escape route for him along the coast of South Carolina. He placed provisions at Georgetown in case Cornwallis should come that way.[26] This rules out the story that Cornwallis, himself, was at Brookgreen, but it is likely that Balfour arranged to use the plantation as a resting place for Cornwallis if he would have to escape to Georgetown. Another possible explanation is that soldiers actually were quartered and entertained at Brookgreen, and, over the years, rumor or misinformation enlarged the story to include the presence of Cornwallis. His lordship did not change his mind and decide to come to South Carolina, for letters show that he and Tarleton went to Virginia in early May, after leaving Wilmington.

Following the death of William Allston, his young wife married again. Dr. Henry Collins Flagg, a member of a well-known Rhode Island family, born August 21, 1742, had come south as chief surgeon on General Nathaniel Greene's staff during the Revolution[27] He continued in the army until the end of the war, and saw plenty of hard service. At one time he was captured and held prisoner in Charleston. On another occasion, at the Battle of Savannah, he took part in the fighting (doctors were not permitted into battle unless medical services were needed), and for this he was disciplined. He became a member of the Society of the Cincinnati, in which he enjoyed the friendship of both Lafayette and Pulaski. He supposedly amputated the leg of General Pulaski during the siege of Charleston. After the surrender at Yorktown, Flagg practiced for awhile in South America before returning to Charleston.[28]

One of the South Carolina patriots who had befriended Henry Flagg was William Allston, who told him of his home, Brookgreen, and extended an invitation to visit. Unfortunately, Flagg did not arrive until after the death of Captain Allston, but he stayed to express sympathy to the widow and

her children. Rachel Allston and Henry Flagg became good friends; and as this bond grew Flagg's affection for Captain Allston extended to his children, particularly the sickly child Washington.

Rachel's family objected strongly to a marriage on the grounds that Flagg was nothing more than a "northern adventurer" after her fortune. To them, the officers of General Greene's staff were all Yankee soldiers of fortune and from a lower social class than their own; the fact that Henry Collins Flagg was a grandson of one governor of Rhode Island and nephew of another, made no difference. Nevertheless, they could not object to his personality, for he was a gentleman of character and good breeding.

Rachel remained firm, however; and in a now-famous phrase informed her father that she had married William Allston to please the family, and now she wanted to marry Dr. Flagg to please herself. As a last resort the family denied Rachel her inheritance, but this did not change her mind. They were married December 5, 1784, and lived at Brookgreen until around 1800, when they moved to a plantation Flagg had purchased near Charleston.[29] At the time of their marriage she was twenty-seven and he was forty-two years old.

Henry Flagg's life was now very different from his Puritan upbringing. South Carolina society presented at that time almost the nearest approach to a true landed aristocracy, and it is easy to understand how such a life might have fascinated Dr. Flagg. Another big change occurred in his religious life when he became a member of the Episcopal Church, which for five generations had been denounced by his family. Two of his grandchildren even became Episcopal clergymen.[30]

Letters to Flagg from his stepson Washington while at Harvard reveal the extent of affection between the two. On October 21, 1796, Allston wrote:

The gratitude which I feel toward you for your paternal solicitude, I hope the future conduct of my life will evince. The Doctor with whom I live has shown a friendship for me that I wish may never be forgotten. . . . In short, I want nothing but your company in Carolina. . . .

In a letter to his mother, August 12, 1800, he wrote:

It is needless to express my feelings on account of the Doctor's illness. You know my heart and its numerous obligations to that honored man. . . . I know not . . . how it will be in my power to return his services. In all aspects and at all times has he acted toward me with the affection of a father; I cannot therefore repay him but with the affection of a son. . . .[31]

From these letters it is evident that Henry Collins Flagg took William's children as his own. From his marriage to Rachel came three other children: Ebenezer, Elizabeth, and Henry Collins, Jr.

President George Washington's Southern Tour in 1791 included an overnight stay at Brookgreen Plantation on Thursday, April 28th. Washington wrote in his diary:

. . .being met on the Road and kindly invited by

a Dr. Flagg to his house, we lodged there, it being 10 miles from Pawley's and 33 from Vareen's. . . . We left Dr. Flagg's at 6 and arrived at Captain William Allston's to breakfast. . . .[32]

Henry Collins Flagg died in Charleston, April 1, 1801, and was buried at the "Brick Church" in St. Thomas and St. Denis Parish near Charleston.[33] His obituary in the *South Carolina Gazette,* April 3, 1801, stated:

Died on Wednesday last, at the age of 55 years Henry Collins Flagg, an eminent physician and inhabitant of this city and a member of the Cincinnati. A native of Rhode Island but had long resided in this state and had acquired the friendship and esteem of a large circle of respectable citizens. In the late contest with Great Britain, he took an active and decided part with his countrymen, and accepted the appointment as surgeon to the first South Carolina Continental Regiment, in which capacity he continued until the close of the war, when he recommenced the exercise of his profession in the line of a private citizen, which, however, he declined for some years past and attended closely to agriculture and literary pursuits, and to the discharge of all the duties of a good citizen, husband, father and friend, in all which several capacities, his immediate relatives and acquired friends, bear testimony to his great worth and merit.[34]

It was written of Rachel Moore Allston Flagg: "Self reliance, tender-heartedness, frankness, generosity and firmness were characteristics she bequeathed to her progeny."[35] Born August 10, 1757, she died December 27, 1839, at the age of eighty-two. She also was buried at the "Brick Church."[36]

Brookgreen Plantation had been left by Captain William Allston to his son Benjamin, Washington's half-brother and the father of Governor Robert F. W. Allston. Washington Allston had inherited Springfield Plantation, adjoining Brookgreen, but sold it to help finance his art studies abroad. Benjamin lost his plantation, however, by pledging security for a friend. Apparently two brothers, Robert and Francis Withers, helped Benjamin in the crisis when the note came due by purchasing part of his holdings in 1800. In their honor, Benjamin named his second son, born in 1801, Robert Francis Withers Allston.[37] According to Miss Susan L. Allston no one knows who Benjamin's friend was, but when his lawyer told him he was not of age when the note was signed and, therefore, not legally responsible, he replied, "I was old enough to know what I was doing."[38] The South Carolina historian J. H. Easterby wrote:

. . . he was not in possession of Brookgreen nor was he a wealthy man when he died in 1809 at the age of 43. His estate included, it is true, two plantations—one on the Waccamaw several miles above Brookgreen and another on the PeeDee—and a hundred or more slaves; but this property was heavily encumbered.[39]

Benjamin's wife was Charlotte Ann Allston, daughter of his father's cousin William Allston, Sr., and Sabina Atchison.

Washington Allston, born November 5, 1779, was sent to Rhode Island as a child since the South Carolina climate did not agree with him.[40] He was educated at Harvard and returned to South Carolina, where he painted a few religious compositions. In 1801 he went with Edward G. Malbone, the miniature painter, to England and studied under Benjamin West, who had made a careful study of the Italian painters, particularly Titian, and their methods. In the following year Allston exhibited three pictures at Somerset House and sold one of them. Three years later, he traveled with the portraitist and history painter John Vanderlyn (who previously had been patronized by Aaron Burr and had painted Theodosia Burr's portrait). They went to France where Allston immersed himself in the art treasures Napoleon had collected and began to develop the richness of color that came to characterize many of his paintings, earning him recognition as "The American Titian." Next they visited Italy, living for awhile in Rome. Allston came back to America in 1809 and married Ann Channing. Together they debarked for England in 1811, taking with them Samuel F. B. Morse as a pupil.[41] After the death of his wife in 1815, he returned to Cambridge, a success on both sides of the Atlantic Ocean. In 1830 Washington Allston married Martha K. Dana and lived in Cambridge until his death on July 9, 1843.[42] Perhaps his best known paintings in the United States are *Jeremiah, Belshazzar's Feast,* and *Saul and the Witch of Endor.* His painting entitled *Dead Man Restored to Life* belongs to the Pennsylvania Academy of Fine Arts, and a self-portrait and a portrait of William Ellery Channing, his brother-in-law, are in the Boston Museum of Fine Arts. The Carolina Art Association of the Gibbes Art Gallery in Charleston has in its collection *David Playing Before Saul* and *Moses and the Serpent.*[43]

Joshua Ward seems to have been the purchaser of all or part of the Brookgreen acreage, probably in 1800, since the tombstone of Colonel Joshua John Ward, his son, states that he was born at Brookgreen in the autumn of that year.[44] Anne Allston Porcher, in a letter to Archer M. Huntington in 1937, said that John Ward actually bought the property, then passed it on to his nephew Joshua.[45] Miss Porcher was a granddaughter of Joshua John Ward; her father, Dr. Francis Peyre Porcher, married J. J. Ward's youngest daughter Margaret. Springfield, the land bought by the Withers brother, was reunited with Brookgreen in 1847 when Francis Withers died. He had willed this property to his niece Mary Wilkinson Memminger, wife of C. G. Memminger, later first Confederate Secretary of the Treasury, and when she came into her inheritance in 1847 she sold it to Colonel Ward.[46]

This land, known now as two separate plantations, Brookgreen and Springfield, may have been combined into one called Springfield until the early 1800s when the Ward family owned it. Miss Susan Allston wrote that the first "Brook Green" was in Hammersmith, John Alston's early home in Eng-

land, for which, she theorized, the plantation was named, as was often done in South Carolina.[47] The record books of Dr. Andrew Hasell who served the rice planters from the early 1800s until the 1850s reveal that the largest account belonged to Joshua John Ward and was listed under the heading "Brook Green." Another account book concerned with Springfield Plantation had the names "F. Withers" and "J. J. Ward" written on the front cover. "F. Withers" appears to have been written first, with "J. J. Ward" added later, beneath it. The earliest date recorded in this book was 1832, which was during Francis Withers' ownership.[48] Still others relate that Joshua John Ward gave Brookgreen its name because "Brook Green" appeared in the heading of a letter he wrote to R. F. W. Allston in 1843.[49] Apparently this was the first official use of the name, for the land always had been referred to previously as "the plantation" or "my property."

Joshua John Ward was definitely the rice king in Georgetown District. In 1841 he was described as making $360 clear profit from every hand that hoed.[50] In 1850 he produced 3,900,000 pounds of rice with 1,092 slaves on six plantations and adjacent lands. At his death, February 27, 1853, he owned more than 1,100 slaves who cultivated nine plantations. These included 7,000 unimproved and 3,117 improved acres, the latter producing besides the rice, 7,000 bushels of corn, 2,000 bushels of oats, 1,000 bushels of peas and beans, 66,000 bushels of sweet potatoes, 500 pounds of butter and 600 pounds of wool. The cash value of his farm in 1850 was $527,050. The farm implements and machinery were worth $2,500. His 51 horses, 49 mules, 285 milch cows, 200 working oxen, 400 other cattle, 519 sheep, and 450 swine were valued at $34,808.[51] All of this combined made him the wealthiest and largest slaveholder in any county in the nation. He served in both houses of the state legislature and as lieutenant governor. Ben Horry, one of his Brookgreen slaves, called him "the head rice Cap'n in dem time," when interviewed for the W. P. A. Slave Narratives in the 1930s.[52]

Ward was born at Brookgreen on November 24, 1800, the son of Joshua and Elizabeth Cook Weston Ward.[53] His father, from a family of Charleston merchants and lawyers, had married the widow of Charles Weston, who had died in 1798.[54] J. J. Ward was a self-made man in the sense that he put together his own vast estate, although he started with at least one plantation in his name. His father's estate was appraised at $55,839, excluding $20,000 in bank stock.[55] He consistently reinvested his profits in more land and slaves. Brookgreen served as a homebase from which he governed Springfield, Prospect Hill, Alderly, Rose Hill Island, Clifton Island, Mitchell's Island, Longwood, and Oryzantia. He also owned some lands along the PeeDee River.

Joshua John Ward was sent to Scotland for his education, and in 1825 he married Joanna Douglass Hasell (1805-1878), daughter of George Paddon Bond Hasell of Edinburgh and either the sister or first cousin of Dr. Andrew Hasell.[56] In Ward's

will she received the home at Brookgreen with the gardens, buildings, grounds, furniture, plate, carriage (and horses she might choose), house servants, and the summer residence on the shore called Magnolia (now part of Huntington Beach State Park), and almost all of his personal property except his wines and liquors. To his eldest son Joshua (1827-1867) he left Springfield and Brookgreen and a summer place known as The Retreat. Mayham (1837-1866), his second son, received Alderly, Oryzantia, and 100 acres of Rose Hill Island. His third son, Benjamin Huger (1841-1903), who was named for Ward's friend and neighbor, received Prospect Hill and Clifton Island. Mayham and Benjamin were jointly to own Longwood, the lands on the PeeDee, and a lot of ten acres on Pawleys Island. Some 1000 slaves were divided equally among the three brothers. The property of the brothers was valued at $300,000 apiece. Each of Ward's seven daughters was to be left a dowry of $40,000, to paid out of the estate.[57] The effects of the Civil War, however, required that these provisions be changed, with the result that part of the land was sold to offset the loss of the slaves, and two unmarried daughters got no dowry. The remaining property was then equally divided among the widow, her surviving sons and daughters, and the families of those who had died since Ward made his original will.

Ex-slaves told W. P. A. interviewers in 1930 that in general Colonel Ward was a good master. It seemed that his overseer was the main problem, and some of the slaves described atrocities at his hands. But they always added that if "Marse Josh" had known about these occurrences, they never would have happened.[58]

Most of the plantation festivities revolved around family events. At the marriage of Georgeanna Ward to Dr. Arthur Belin Flagg in 1849, to which all of the planter families were invited, there was an old-fashioned country dance.[59] One of Ward's slaves remembered that his uncles, Daniel and Summer, were the musicians, who made "music for his daughter and the white folks to dance . . . great fiddlers and drummers. . . ."[60]

Besides rice, Ward was also proficient in growing sweet potatoes. He won an award from the Winyah and All Saints' Agricultural Society for a yield of 700 bushels from one acre.[61] He also won awards for rice cultivation methods and the development of the golden big grain rice. In 1849 his fields had the highest yields per acre: 89½ bushels of rice and 73 bushels of corn.[62] Thirty bushels per acre was considered average.

During the Civil War, Ward's Light Artillery helped protect the Waccamaw Neck. Captain Daggett was the first commander, but he was replaced by Captain Joshua Ward. The first lieutenant was Mayham Ward and the second lieutenant was Benjamin Huger Ward, all sons of Joshua John Ward. This battery, like Plowden Weston's company, was dominated by one family. The Wards most probably paid for the necessary equipment and supplies. Throughout the war Ward's Light Artillery performed well.

Joshua Ward, eldest son of J. J. Ward, inherited Brookgreen and Springfield in 1853.[63] Interviews with former slaves, who remembered this Joshua as a master, revealed much about plantation life. Their references to "Miss Bessie" indicate that Elizabeth Mortimer Ward, Joshua's first wife, was mistress of the plantation at the time. The former slaves recalled that Ward had four full-time cooks just to prepare food for the more than four hundred slave children on his plantations.[64] Besides receiving a portion of rice every Saturday, the people were required to scour every house on that day. An inspector went around each night to make sure that the houses and their wooden and tin ware were cleaned. When slaves broke into the rice barn at Brookgreen Mrs. Ward told the overseer that they should be given a higher quota of rice instead of being punished for stealing. She reasoned that they would not have tried to take the rice if they were receiving enough to feed their families. There were several accounts of Mrs. Ward's intervention when the overseer would punish a slave. All of the ex-slaves spoke fondly of "Miss Bessie," who every Sunday morning, when the children had dressed up and come to the yard of the "big house," would give them candy. Ben Horry recalled that at these times Joshua Ward checked to see how their clothes fit. He said:

> They bought a great deal of this cloth they call blue drilling to make a suit for every boy big enough to wear a suit of clothes and a pair of shoes for everyone. I thought that the happiest "set up" I had in boyhood . . . blue drilling pants and coat and shoe.[65]

Ellen Godfrey related that her master "send slam to England gie me good clothes and shoe."[66] Shoes were also prized possessions and many were carried rather than worn for this reason. As late as the 1930s Ben Horry, then in his eighties, would, as he said, "take my foot in my hand" and walk the thirty-mile round trip from his home to Conway about once a week.[67] One of the ex-slaves told a W.P.A. interviewer that there had been a black overseer at Brookgreen Plantation, but no other evidence can be found, oral or written, of black overseers on the Waccamaw Neck during this period. However, there may have been a *de facto* overseer who actually was a head driver.[68] Drivers were the highest ranked slaves, and they usually worked closely with the overseer.

After the Civil War Ward took the oath of allegiance to the United States in Greenville on August 12, 1865.[69] He was thirty-seven years old at the time and had resigned his commission and gone to England. During January, February, and March, 1866, he made contracts with his freedmen that stipulated that half of the rice, corn, pea, and potato crops be given to the laborers after deducting one-fifth for plantation expenses. Ward was to furnish implements, wagons, and mules, and the people were to keep the fences and ditches in repair.[70]

For all planters 1866 was a crucial year. Many of them had gone to Charleston, borrowed money at

high interest rates, and returned home to find that the Negroes would not work their contracts. On April 10, 1866, Ward sent a letter of complaint to Colonel B. H. Smith, the officer in charge of the Union troops in Georgetown, urging that a guard ensure that the former slaves do their work.[71] Evidently no aid was given since, after an immense struggle to keep the labor force together, the crop of 1866 was another failure at Brookgreen and Springfield and other Waccamaw plantations. After vainly trying to resurrect the previous glory of Brookgreen, Joshua Ward died in 1867.[72] Like his grandfather and father, he had been active in All Saints' Parish Church, serving on the vestry and contributing large sums of money to the church. His son Samuel Mortimer Ward was only nine or ten years old at the time of Joshua's death, and so he was unable to manage the plantation.

In 1869 Dr. Lewis Cruger Hasell leased Brookgreen from the estate of Joshua John Ward, and the following year he bought it for the ridiculously low price of $10,000.[73] His first wife was Catherine Ward, a daughter of J. J. Ward, who had died in 1862. Clemence Willett, his second wife, was from New York. In the 1880s her brother Marinus Willett came from New York with his family to stay at the plantation. He purchased the Springfield property and built himself a cottage there for his wife and their two daughters. Willett continued to plant rice and experimented with mechanical systems to drain and cultivate the rice fields. In 1885 Mrs. Willett (Edith Morgan) established a mission for the Negroes of the plantations. There services were conducted in the Brookgreen chapel by the rector of All Saints' Parish, Dr. Arthur B. Flagg dispensed free medicines until his death in the hurricane of 1893, Mrs. Willett held sewing classes for the women, and Dr. J. J. Ward Flagg and Dr. L. C. Hasell attended the sick at a small hospital.[74]

The mistress of Brookgreen, Clemence Willett Hasell, was a devoted churchwoman. For years she made it possible for All Saints' Church to continue its work by contributing $500 yearly to the rector's salary.[75] It was during the Hasells' ownership that the original Brookgreen home burned, in 1901, and that another dwelling was built in its place, which Archer Huntington ultimately had removed in 1931.[76]

Also living at Brookgreen during this time was Dr. Joshua John Ward Flagg, son of Dr. Arthur B. Flagg and Georgeanna Ward. He, his servant Tom Duncan, and a niece, Ann Weston, were the only persons on Magnolia Beach to survive the hurricane of 1893, which devastated the Waccamaw Neck, Pawleys Island, and North Island. To this day the storm is referred to as "The Flagg Flood" because so many members of that family lost their lives.[77] Dr. Flagg lived on a portion of the Brookgreen estate known as Spring Hill, which was left to him by his mother who was a daughter of Joshua John Ward. He never married, but continued his charitable medical work to white and black throughout his life. His medical account books reveal that many of his patients paid with food goods: a dozen eggs, three chickens, or a pound of

rice. He also served as the Brookgreen postmaster for many years. Tom Duncan stayed with "Dr. Wardie," as he was affectionately known, all those years until Flagg's death in 1938. According to a newspaper story, Tom Duncan was given the place of honor, in front of the family, in the funeral procession because of the forty-five years he had spent serving Dr. Flagg. Oldtimers relate the touching story of how Tom Duncan followed his master, even to the grave.[78] The death of Joshua John Ward Flagg signaled the end of an era. He was among the last who remembered when rice was king, planters were wealthy, and life was good. A great-grandson of Henry Collins Flagg and Rachel Moore Allston on his father's side, and a grandson of Joshua John Ward on his mother's side, he had been Brookgreen's last living link with the Ward and Allston families. Flagg had one brother left, Charles E. B. Flagg, but he had left South Carolina before 1893 to live in Vancouver, Washington.[79]

L. C. Hasell died in 1889, and his wife passed away in 1909, leaving Brookgreen to her sister-in-law Edith Willett.[80] The mission established by Mrs. Willett at Brookgreen continued throughout the years and eventually became the Holy Cross Parochial School administered by the South Carolina Episcopal Diocese.[81]

In 1920 heirs to the estate sold Brookgreen to Dr. J. A. Mood of Sumter, South Carolina, who was a sponsor of the Waccamaw Club, which used the land for hunting.[82] Dr. Mood also purchased the lands of Laurel Hill and The Oaks, combining the four plantations under the auspices of the club. Mood's daughter Julia Peterkin, whose frequent visits to Brookgreen made literary history, used the general locality as settings for three books: *Green Thursday* (1924), *Black April* (1927), and the Pulitzer Prize-winning *Scarlet Sister Mary* (1928).[83]

The Brookgreen Club took the place of the Waccamaw Club in 1924, and in 1926 W. S. Griffin of Greenville, South Carolina, became owner of the plantation.[84] Griffin's interests were sold by the F.M. Credit Corporation to Archer Milton Huntington in January, 1930.[85] And this is where the second chapter of the story of Brookgreen begins.

NOTES

1. Joseph A. Groves, *The Alstons and Allstons of North and South Carolina* (Atlanta, Ga., 1901), pp. 24-25.

2. George C. Rogers, Jr., *The History of Georgetown County, South Carolina* (Columbia, S.C., 1970), p. 21; Robert K. Ackerman, "South Carolina Colonial Land Policies" (PhD dissertation, University of South Carolina, 1965).

3. Susan Lowndes Allston, *Brookgreen Waccamaw in the Carolina Low Country* (Charleston, 1956), p. 10; Book of Royal Grants, Vol. I, S. C. Archives.

4. Rogers, *op. cit.*, pp. 21, 187; Grant Book AA (1731-1734), pp. 63, 124, 298-99, 333-34, S. C. Archives.

5. Groves, *op. cit., passim.*

6. Rogers, *op. cit.*, p. 95; *South Carolina Gazette,* Feb. 28, 1743.

7. Rogers, *op. cit.*, pp. 95-96; *Gazette,* March 2, 1765, Feb. 9, 1769.

8. Allston, *op. cit.*, p. 13.

9. Rogers, *op. cit.*, p. 187; Index to Royal Grants, S. C. Archives; "John Allston," Pre-Revolutionary War Plats, S. C. Archives.

10. Rogers, *op. cit.*, p. 187; "Will of John Allston," dated March 24, 1750, proved May 11, 1750, Charleston County Wills, VI (1747-52), 358-61, S. C. Archives; "Will of Josias Allston," dated April 18, 1774, proved n.d., Charleston County Wills, XVII, Book B (1774-79), 527-32, S. C. Archives.

11. Rogers, *op. cit.*, pp. 187-88; Allston, *op. cit.*, p. 20.

12. Rogers, *op. cit.*, pp. 107, 154; Edward McCrady, *The History of South Carolina under the Royal Government 1719-1776* (New York, 1899), pp. 743-44; "William Allston, Jr.," Audited Accounts, S. C. Archives.

13. Rogers, *op. cit.*, p. 521; Allston, *op. cit.*, p. 18; "Washington Allston," *Brookgreen Bulletin* (Winter, 1975), p. 1; C. B. Berry, "Some Allstons and Flaggs of Brookgreen," *Brookgreen Bulletin* (Spring, 1974), p. 1; Rev. H. D. Bull, *All Saints' Church Waccamaw,* p. 9, and Jared Flagg, *Life and Letters of Washington Allston,* say January 19, 1775; Ernest Flagg, *Genealogical Notes on the Founding of New England* (Hartford, Ct., 1926), p. 138.

14. Jared B. Flagg, *The Life and Letters of Washington Allston* (New York, 1892), p. 2. Ernest Flagg (p. 102) says £14,000 sterling rather than gold.

15. William Dobein James, *A Sketch of the Life of Brig. Gen. Francis Marion and a History of his Brigade from its Rise in June 1780 until Disbanded in December 1782* (Marietta, Ga., 1948).

16. "Inscriptions of Tombstones in Turkey Hill Cemetery," typewritten copy of six inscriptions, Brookgreen Gardens Archives.

17. Rogers, *op. cit.*, p. 138; Letter, Balfour to Campbell, Jan. 25, 1781, Cornwallis Papers, Public Record Office, London, 30/11/109.

18. Berry, *op. cit.*, p. 1.

19. *Ibid.*, p. 2. This child was William Moore Allston; Rogers, *op. cit.*, p. 521; Groves, *op. cit.*, p. 33.

20. Rogers, *op. cit.*, p. 145; *Journal of the House of Representatives of South Carolina, January 8, 1782—February 26, 1782,* ed. A. S. Salley, Jr. (Columbia, S.C., 1916), p. 3; Writs of Election for the Jacksonborough Assembly, Legislative System, S. C. Archives.

21. Rogers, *op. cit.*, p. 117; Georgetown Committee of Safety to Council of Safety in Charleston, Jan. 20, 29, Feb. 12, 1776, to Committee of Safety in Wilmington, Feb. 20, 1776, "South Carolina Council of Safety, 1775-1779," New York Public Library.

22. Rogers, *op. cit.*, p. 135; Robert D. Bass, *Swamp Fox, The Life and Campaigns of General Francis Marion* (New York, 1959), pp. 120-23.

23. Rogers, *op. cit.*, p. 136; Bicentennial Edition, *The Field and Herald,* Conway, S.C.

24. Flagg, *Washington Allston . . . ,* p. 5; "Washington Allston," *Brookgreen Bulletin* (Winter, 1975), p. 1.

25. Flagg, *Washington Allston . . . ,* p. 5.

26. Cornwallis to Balfour, 1781, Cornwallis Papers, Public Records Office, London; Rogers, *passim.*

27. Flagg, *Genealogical Notes . . . ,* p. 138; Rogers, *op. cit.*, pp. 172-73.

28. Flagg, *Washington Allston. . . .* p. 158; Flagg, *Genealogical Notes . . . ,* p. 101; Lillian Rose Willcox, "The Flagg Family of S.C. 1784-1938"; "Washington Allston," *Brookgreen Bulletin* (Winter, 1975), p. 1.

29. Berry, *op. cit.*, p. 2; Flagg, *Genealogical Notes . . . ,* p. 138; Rogers, *op. cit.*, pp. 172-73.

30. Flagg, *Genealogical Notes . . . ,* p. 103.

31. Flagg, *Washington Allston . . . ,* pp. 15-16, 19-20.

32. Rogers, *op. cit.*, p. 173; Bull, *op. cit.*, p. 11; Anthony Q. Devereux, *The Rice Princes, A Rice Epoch Revisited* (Columbia, S.C., 1973), p. 21; Archibald Henderson, *Washington's Southern Tour, 1791* (Boston and New York, 1923), p. 126.

33. Flagg, *Genealogical Notes . . . ,* p. 138; Berry, *op. cit.*, p. 2.

34. Flagg, *Genealogical Notes . . . ,* p. 372; *South Carolina Gazette,* April 3, 1801.

35. *Ibid.*, p. 104.

36. *Ibid.*, p. 138; Berry, *op. cit.*, p. 1.

37. Rogers, *op. cit.*, p. 276; Allston, *op. cit.*, pp. 21-22, 27.

38. Allston, *op. cit.*, pp. 21-22.

39. *The South Carolina Rice Plantation,* ed. J. H. Easterby (Chicago, 1945), p. 12.

40. Allston, *op. cit.*, p. 23; Berry, *op. cit.*, p. 3; "Washington Allston," *Brookgreen Bulletin* (Winter, 1975), p. 1; Rogers, *op. cit.*, p. 251.

41. Mantle Fielding, *Dictionary of American Painters, Engravers and Sculptors* (Stratford, Ct., 1971), p. 7.

42. *Ibid.;* "Washington Allston," *Brookgreen Bulletin* (Winter, 1975), pp. 3-4; Flagg, *op. cit., passim.*

43. Fielding, *op. cit.*, p. 7; Flagg, *op. cit., passim; Selections from the Collection of the Carolina Art Association,* ed. Martha R. Severens (Charleston, S.C., 1977); pp. 8-9.

44. Rogers, *op. cit.*, p. 259; Flagg, *op. cit.*, p. 27.

45. Anne Alston Porcher to Archer Milton Huntington, Feb. 26, 1937, Brookgreen Gardens Archives.

46. Rogers, *op. cit.*, p. 259; Allston, *op. cit.*, pp. 27-28; Alberta M. Lachicotte, *Georgetown Rice Plantations* (Columbia, S.C., 1955), p. 56.

47. Allston, *op. cit.*, pp. 9-10.

48. Hasell-Flagg Manuscripts, S.C. Historical Society, Charleston.

49. Allston, *op. cit.*, pp. 28-29; Lachicotte, *op. cit.*, p. 58.

50. Joyner, *op. cit.*, p. 27; Letter, Francis W. Pickens to John C. Calhoun, Oct. 2, 1841, Calhoun Papers, Clemson University; *The Plantation South,* ed. Katherine M. Jones (Indianapolis, 1957), p. 149.

51. Rogers, *op. cit.*, p. 259.

52. Joyner, *op. cit.*, pp. 22-23; "Ben Horry," Slave Narratives, 14, ii, 309, National Archives.

53. Rogers, *op. cit.*, p. 259; Allston, *op. cit.*, p. 27.

54. *Ibid.;* Ward Family Notes, Charlotte K. Prevost, Georgetown, S.C.

55. Rogers, *op. cit.*, p. 260; "Our McDowell Ancestry." Mary James Richards, p. 27 (copy in South Caroliniana Library, University of South Carolina).

56. Rogers, *op. cit.*, p. 260; Marriage Settlements, IX, 142-45, S.C. Archives; Allston, *op. cit.*, p. 28; Hasell Family Notes, Hasell-Flagg Manuscripts, S.C. Historical Society, Charleston. Susan L. Allston and Anne Alston Porcher say Joanna Hasell Ward and Andrew Hasell were brother and sister; Rogers says they were cousins.

57. Rogers, *op. cit.*, pp. 260-61; "Will of Joshua Ward," dated Dec. 22, 1848, copy attached to bill filed in Court of Equity in Charleston on April 10, 1868, in the case of *Arthur B. Flagg and wife et al. v. Joanna D. Ward et al.,* D. V. Richardson Papers, in private possession, Columbia, S.C.

58. Joyner, *op. cit.*, p. 23; "Ben Horry," Slave Narratives, 14, ii, 305, 311.

59. Rogers, *op. cit.*, p. 269; Childs, *op. cit.*, pp. 12, 105.

60. Joyner, *op. cit.*, p. 99; "Ben Horry," Slave Narratives, 14, ii, 309.

61. Childs, *op. cit.*, p. 45; Joyner, *op. cit.*, p. 47.

62. Rogers, *op. cit.*, p. 340; see Allston, *op. cit.*, pp. 29-30 for the letter concerning Ward's discovery of big grain rice.

63. Rogers, *op. cit.*, p. 260.

64. Joyner, *op. cit.*, p. 193; "Ellen Godfrey," Slave Narratives, 14, ii, 159.

65. Joyner, *op. cit.*, pp. 214-215; "Ben Horry," Slave Narratives, 14, ii, 310.

66. Joyner, *op. cit.*, p. 208; "Ellen Godfrey," Slave Narratives, 14, ii, 159.

67. Joyner, *op. cit.*, p. 217; Interviews with Genevieve Willcox Chandler, Murrells Inlet, S.C., August, 1969; January, 1972; August, 1975, all by Charles W. Joyner.

68. Joyner, *op. cit.*, p. 59; "Ben Horry," Slave Narratives, 14, ii, 305-10; Eugene D. Genovese, *Roll, Jordan, Roll: The World the Slaves Made* (New York, 1974), p. 366; Robert William Fogel and Stanley L. Engerman, *Time on the Cross: The Economics of American Negro Slavery* (Boston, 1974), pp. 210-11.

69. Rogers, *op. cit.*, p. 426; "Joshua Ward," RG 94, National Archives.

125

70. Rogers, *op. cit.,* p. 434; RG 105, National Archives.
71. Rogers, *op. cit.,* p. 434; Joshua Ward to Col. Smith, April 10, 1866, RG 98, National Archives. Rogers wrote that the planters were borrowing money at rates of 2½ to 3% per month and that these were acts of desperation.
72. Gravestone inscriptions, All Saints' Parish Church.
73. Allston, *op. cit.,* p. 31; Lachicotte, *op. cit.,* pp. 55-63. Bull, *op. cit.,* p. 51.
74. Allston, *op. cit.,* p. 32; Bull, *op. cit.,* pp. 50-51; Mission Records, Hasell-Flagg Manuscripts, S.C. Historical Society, Charleston.
75. Allston, *op. cit.,* p. 32; Bull, *op. cit.,*; All Saints' Parish Accounts, Hasell-Flagg Manuscripts; S.C. Historical Society, Charleston.

76. Allston, *op. cit.,* p. 35; Activity Reports, Brookgreen Gardens Archives.
77. Allston, *op. cit.,* p. 31; Bull, *op. cit.,* pp. 53-54; Groves, *op. cit.,* pp. 410-12 (From the Diary of Flora MacDonald Bryce LaBruce); Rogers, *op. cit.,* p. 488; *Family Records of the Descendants of Gersham Flagg....* compiled by N. G. Flagg and L. C. S. Flagg (Quincy, Ill., 1907), p. 128; newspaper clippings in the W. D. Morgan Scrapbook, Winyah Indigo Society Collection, 1, 272-74, 317, Georgetown County Library.
78. *The Georgetown Times,* May 13, 1938; *The State,* Columbia, S.C.; *The Myrtle Beach News,* May 12, 1938.

79. *Ibid.*
80. Bull, *op. cit.,* pp. 104-5 (parish register); Allston, *op. cit.,* p. 33.
81. Letter, The Rt. Rev. Richard B. Martin to Gurdon L. Tarbox, Jr., August 23, 1979, Brookgreen Garden Archives.
82. Allston, *op. cit.,* p. 33.
83. Allston, *op. cit.,* pp. 33-34.
84. Allston, *op. cit.,* p. 35.
85. *Ibid.;* Rogers, *op. cit.,* pp. 489-90, 495, 496, 497; Lachicotte, *op. cit.,* pp. 55, 59, 61-62; *News and Courier,* June 7, 1931; Bull, *op. cit.,* p. 12.

Bibliography

"All Saints' Churchyard Inscriptions," compiled by Robin R. Salmon, Brookgreen Gardens Archives, Murrells Inlet, S.C.

Allston, Elizabeth Deas, *The Allstons and Alstons of Waccamaw,* privately printed, 1936.

Allston, Susan Lowndes, *Brookgreen Waccamaw in the Carolina Low Country,* Nelson's Southern Printing & Publishing Co., Charleston, S.C., 1956.

Brookgreen Bulletin, Spring 1974, Winter 1975, Brookgreen Gardens, Murrells Inlet, S.C.

Bull, H. D., *All Saints' Church, Waccamaw 1739-1968,* The R. L. Bryan Company, Columbia, S.C., 1968.

The Camden Chronicle, "Our Historic Homes No. 2," 1968.

Childs, Arney R., ed., *Rice Planter and Sportsman, The Recollections of J. Motte Alston, 1821-1909,* University of South Carolina Press, Columbia, S.C., 1953.

Devereux, Anthony Q., *The Life and Times of Robert F. W. Allston,* Waccamaw Press, Inc., Georgetown, S.C., 1976.

Devereux, Anthony Q., *The Rice Princes, A Rice Epoch Revisited,* The State Printing Co., Columbia, S.C., 1973.

Easterby, J. H., ed., *The South Carolina Rice Plantation,* University of Chicago Press, Chicago, 1945.

The Field and Herald, Bicentennial Edition, Conway, S.C., 1976.

Fielding, Mantle, *Dictionary of American Painters, Engravers and Sculptors,* John Edwards Publisher, Stratford, Ct., 1971 (reprinted from 1926 edition).

Flagg, Ernest, *Genealogical Notes on the Founding of New England,* Genealogical Publishing Co., Inc., Baltimore, Md., 1973.

Flagg, Jared B., *The Life and Letters of Washington All-* *ston,* Charles Scribner's Sons, New York, 1892 (reprinted by DaCapo Press, Kennedy Galleries, Inc., New York, 1969).

Groves, Joseph A., *The Alstons and Allstons of North and South Carolina,* The Franklin Printing and Publishing Co., Atlanta, Ga., 1901 (revision made by the Rev. S. Emmett Lucas, Jr., Southern Historical Press, Easley, S.C., 1976).

Hasell-Flagg Manuscripts, S.C. Historical Society, Charleston, S.C.

Historical Files, Brookgreen Gardens Archives, Murrells Inlet, S.C.

The Independent Republic Quarterly, Winter 1979, Horry County Historical Society, Conway, S.C.

"Inscriptions of Tombstones in Turkey Hill Cemetery," compiled by Mr. and Mrs. G. L. Tarbox, Jr., Brookgreen Gardens Archives, Murrells Inlet, S.C.

Jones, Lewis P., *South Carolina: A Synoptic History for Laymen,* Sandlapper Press, Inc., Columbia, S.C., 1971.

Joyner, Charles Winston, *Slave Folklife on the Waccamaw Neck: Antebellum Black Culture in the South Carolina Lowcountry,* PhD dissertation, University of Pennsylvania, 1977.

Lachicotte, Alberta M., *Georgetown Rice Plantations,* The State Printing Co., Columbia, S.C., 1955.

"The Oaks Cemetery—Inscriptions on Tombstones," compiled by Winifred Rodgers and G. L. Tarbox, Jr., Brookgreen Gardens Archives, Murrells Inlet, S.C.

Official South Carolina Historical Markers, A Directory, S.C. Dept. of Archives and History and S.C. Local Historical Societies, The R. L. Bryan Co., Columbia, S.C., 1978.

Parton, James, *The Life and Times of Aaron Burr,* Mason Brothers, New York, 1857.

Pharo, Elizabeth B., ed., *Reminiscences of William Hasell Wilson (1811-1902),* Patterson & White Co., Philadelphia, 1937.

Prevost, Charlotte K., Wilder, Effie L., *Pawleys Island, A Living Legend,* The State Printing Co., Columbia, S.C., 1972.

Rice, James Henry, Jr., *The Aftermath of Glory,* Walker, Evans & Cogswell Co., Charleston, S.C., 1934.

Rogers, George C. Jr., *The History of Georgetown County, South Carolina,* University of South Carolina Press, Columbia, S.C., 1970.

Rogers, James A., *Theodosia and Other Pee Dee Sketches,* The. R. L. Bryan Company, Columbia, S.C., 1978.

Rules and History of the Hot and Hot Fish Club of All Saints' Parish, South Carolina, compiled by Plowden C. J. Weston, Evans & Cogswell, Charleston, S.C., 1860 (reprinted by All Saints' Church, 1967).

Severens, Martha R., ed., *Selections from the Collection of the Carolina Art Association,* Charleston, S.C., 1977.

Smith, Elsdon C., *American Surnames,* Chilton Book Company, Philadelphia, 1969.

Vaughan, Celina McGregor, *Pawley's... As It Was,* The Hammock Shop, privately printed, Pawleys Island, S.C., 1969.

Wallace, David D., *South Carolina, A Short History, 1520-1948,* University of North Carolina Press, Chapel Hill, N.C., 1951.

Willcox, Clarke A., *Musings of a Hermit at Three Score and Ten, With Historical Sketches of Places on the Waccamaw Neck,* Walker, Evans & Cogswell Co., Charleston, S.C., 1973.